Clyde Coast Piers

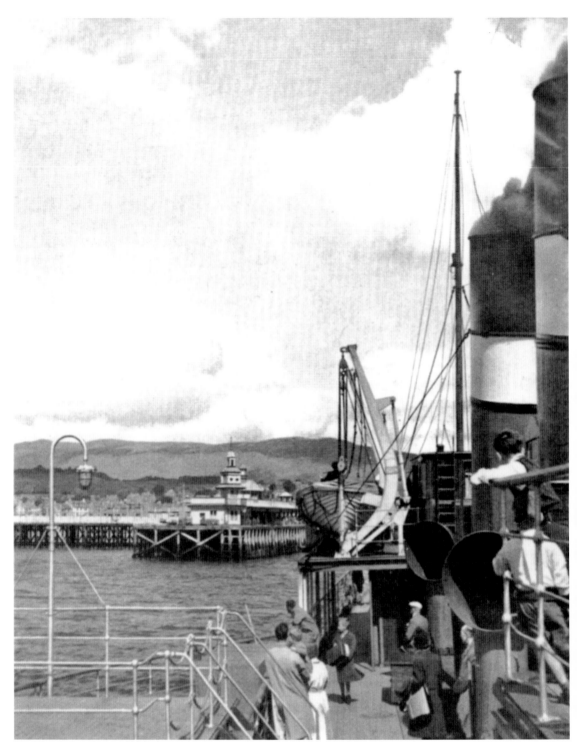

A classic scene of Dunoon Pier from the upper deck of *Jeanie Deans* in the 1946 or 1947 season.

Clyde Coast Piers

ALISTAIR DEAYTON

AMBERLEY

Acknowledgements

Thanks are given to the Clyde River Steamer Club for the use of photographs published by them and taken by the late Hamish Stewart, Edward Quinn, George Fairbairn, Robin B. Boyd, David Scott, Donald McColl, Margaret Skee, Alistair Young, and Graeme Dunlop. Thanks are due to Iain Quinn for much useful information and identification of piers.

First published 2010

Amberley Publishing Plc
Cirencester Road, Chalford,
Stroud, Gloucestershire, GL6 8PE

www.amberleybooks.com

Copyright © Alistair Deayton, 2010

The right of Alistair Deayton to be identified as the Author
of this work has been asserted in accordance with the
Copyrights, Designs and Patents Act 1988.

British Library Cataloguing in Publication Data.
A catalogue record for this book is available from the British Library.

ISBN 978 1 84868 427 0

Typesetting and Origination by Amberley Publishing.
Printed in Great Britain.

Contents

Introduction

During the expansionist years of the nineteenth century, a pier was built at every town, village and even hamlet around the Firth of Clyde, with a ferry service by large rowing boats provided at places that did not have a pier.

By 1914, there were around seventy piers in use and up to thirteen ferries, while a further six piers had already closed. Some were closed in the years following the First World War, and by 1939, there were still fifty-three piers in operation. By 1945, there were thirty-four, and the years of the fifties and sixties saw a steady attrition until the end of the majority of the excursion services in 1972.

The main reasons for the decrease in operating piers were the advent of the motor vehicle and new and improved roads in the first half of the twentieth century and a change in holiday habits in the fifties and sixties with the advent of cheap foreign holidays.

At present, there are six older piers converted for roll-on roll-off operation, eight ferry slipways and fourteen piers and harbours used regularly by *Waverley*, of which only five are traditional wooden piers and three also have vehicle ramps, giving a total of twenty-five.

The traditional single-berth wooden pier had all but disappeared by the early 1990s, with only Tighnabruaich and Kilcreggan remaining, but since then, Lochranza has been rebuilt and Blairmore reopened.

The sixties and seventies saw a series of enthusiast charters, both by large vessels such as *Duchess of Hamilton* and *Waverley*, and by small vessels such as *Countess of Breadalbane* and *The Second Snark*, incorporating calls at long-disused piers, but high charter fees and the unpredictability of passenger numbers on the day leading to unacceptable losses have made these almost impossible to operate in the present day.

This volume gives a pictorial tour of the Clyde piers with steamers old and new berthed at them with images dating from the early years of steam navigation to the present day.

1
Piers of Glasgow and the Clyde

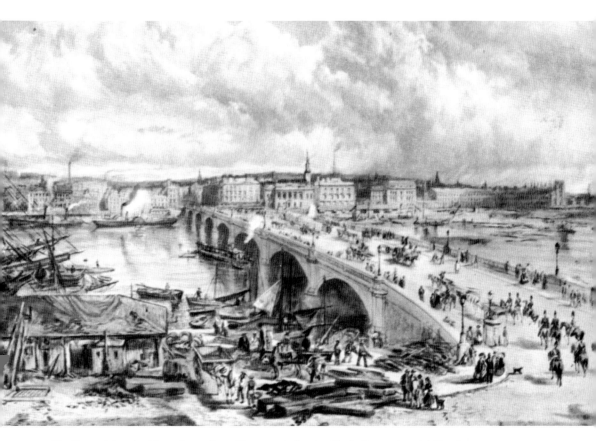

The Broomielaw had been in use by sailing vessels for the Clyde Coast since 1662, when a quay, with a weigh house and crane was built. *Comet*, the first Clyde steamer, sailed from here to Greenock in August 1812, and the rapidly expanding Clyde steamer fleet was based here. At that time, before the Central Station Bridges were built, the quay extended right up to Glasgow Bridge, also known as Jamaica Bridge, and a steamer can be seen here in this panting from 1820 by Sam Bough.

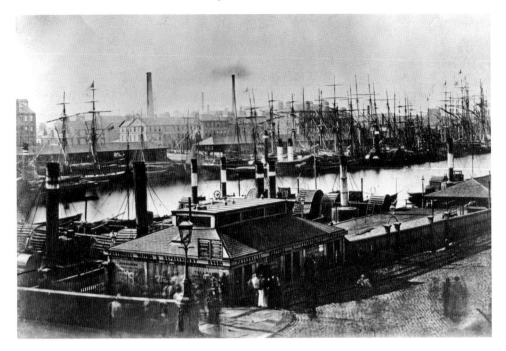

By 1853, when this well-known photo was taken by James Kibble, the steamer trade was thriving, over 200 having been built since the *Comet*. Half a dozen steamers can be seen here berthed at the Broomielaw, with more moored at the south bank of the river.

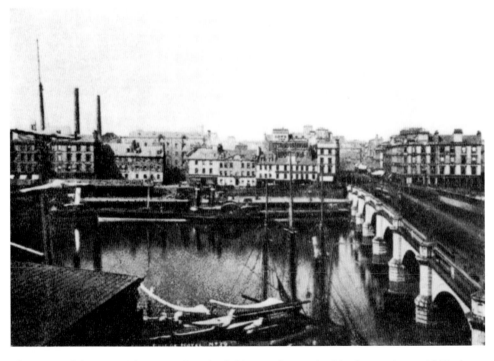

The extent of the Broomielaw up to Jamaica Bridge can be seen in this photo, taken *c.* 1865 of Captain Alexander Williamson's *Eagle*, which ran to Rothesay.

The building of Central Station Bridge from 1876-78 and a second bridge to the station from 1889-1905 moved the berths downstream, and the Broomielaw can be seen here between 1896 and 1899 with a Clutha sailing upriver, *Benmore* at the quay and *Sultana* turning in mid-river. *Iona* can just be seen berthed downstream in this tinted postcard based on a T. & R. Annan photo.

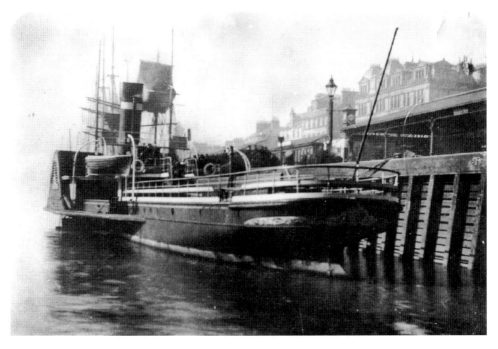

A water-level view of *Benmore* at the Broomielaw prior to 1898. Note the clock tower on the shed in the background. This was moved to Bridge Wharf when the berth there was opened in 1929, and the framework survived until the building there was demolished in recent years.

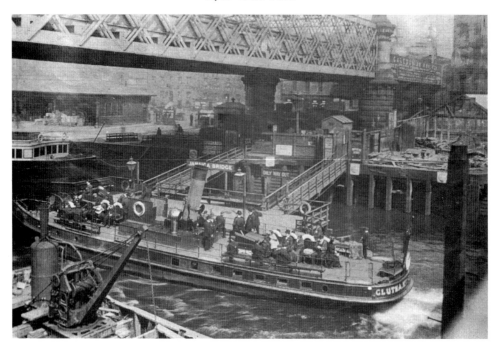

From 1884 to 1903, a river service was operated on the Clyde in Glasgow by a fleet of small steamers known as Cluthas. A pontoon berth was built at the original Broomielaw, underneath Central Station Railway Bridge.

In 1989, a new pontoon was built underneath Central Station Bridge for a waterbus service to serve the Glasgow Garden Festival. The two waterbuses *Sir William Wallace* and *Robert the Bruce* continued for a few more years on charter work, and the pontoon was used from 2001 to 2007 by *Pride o' the Clyde* and in 2010 by Clyde Marine's *Fencer* and *Rover* on a service to and from Braehead. *Sir William Wallace* is seen here in autumn 1990 on her return from the Paddle Steamer Preservation Society charter to Paisley.

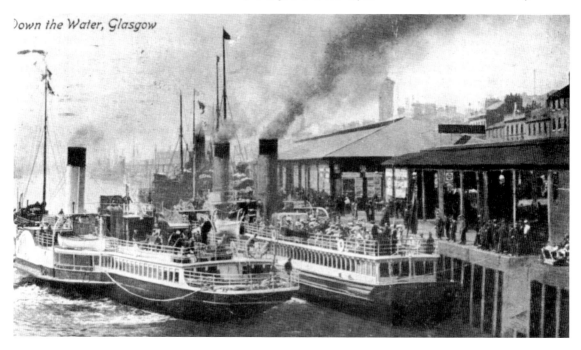

Down the Water, Glasgow

After the opening of the rail links to the coastal railheads, the Broomielaw continued to be used by MacBrayne on the Royal Route to Ardrishaig with *Columba* and *Iona* (seen here) and by the fleets of captains Williamson and Buchanan. *Strathmore* is seen departing here post-1898.

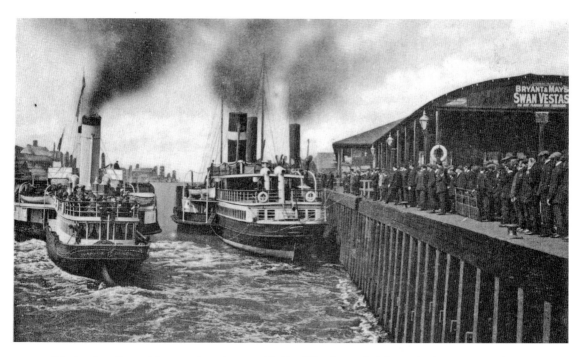

The berth at Broomielaw was latterly named Bridge Wharf (North Side), as in the caption to this postcard dating from 1911 depicting a busy scene with the teetotal steamer *Ivanhoe* just leaving and Williamson's *Isle of Arran* at the berth.

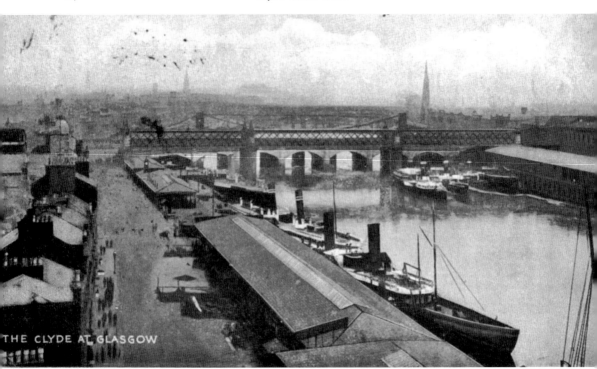

THE CLYDE AT GLASGOW

A postcard view of the Broomielaw from the sailor's home, posted on 31 May 1904, looking eastward before the second Central Station Bridge was built. *Columba* and *Lord of the Isles* are at the Broomielaw, and a trio of steamers are at the lay-by berth on the south side of the river, Buchanan's *Isle of Arran*, the Lochgoil steamer *Carrick Castle* and probably Buchanan's *Vivid*.

Opposite below left: In 1929, following the completion of King George V Bridge, seen in the background, the Clyde 'doon the watter' sailings of what had in 1919 become Williamson-Buchanan Steamers were moved to a new berth on the south bank of the river, initially known as Bridge Wharf (South Side) where *Eagle III*, with *Queen Mary II* behind her, is lying in this thirties shot.

Opposite below right: *Queen Mary II* and *King Edward* berthed at Bridge Wharf, *c.* 1947.

Right: Bridge Wharf continued to be used by *Queen Mary II*, seen there in 1969, until the end of that season, when the completion of the Kingston Bridge, seen under construction in the background, and the lack of dredging made berthing there impossible. The masts of the surviving steamers were shortened to enable them to pass under the bridge, but none ever did.

Below: Kingston Dock, on the south side of the river was filled in to form the southern approaches to the Kingston Bridge. Seen here are MacBrayne's *Lochgorm* and the Clyde and Campbeltown Company's *Marie*. This was the Glasgow berth for the MacBrayne cargo steamers until closure in 1966.

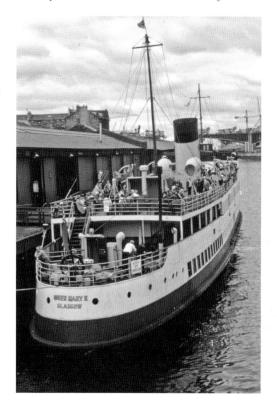

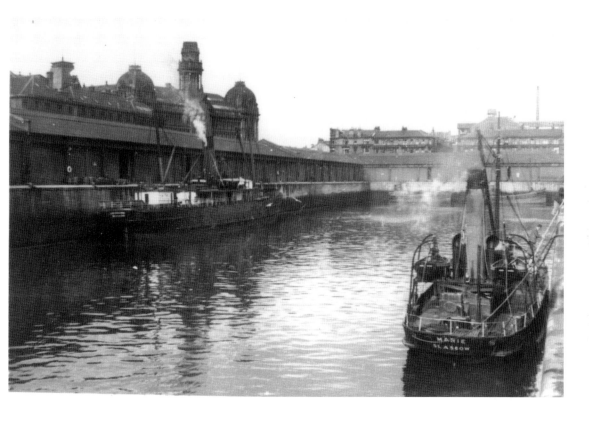

MacBrayne continued the cargo service from a river berth just downstream of the Kingston Bridge until it ceased in 1976, in which year *Loch Carron* is seen here.

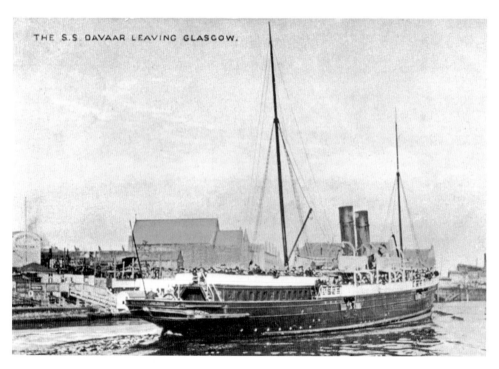

From 1929, the Campbeltown steamers moved from the south bank of the river to the Broomielaw. The Campbeltown steamer *Davaar* is shown here leaving Glasgow, *c*. 1910.

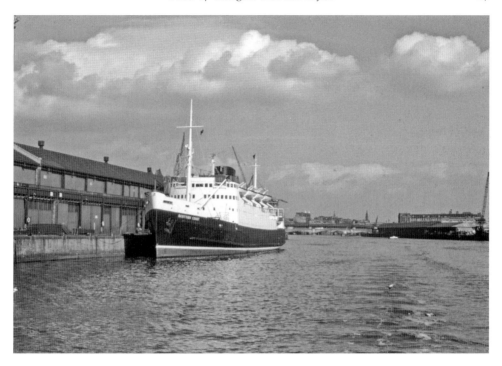

The Burns & Laird Irish boats continued to use Lancefield Quay on the north bank until the cessation of the Belfast service in 1969. *Scottish Coast* is seen there during the previous summer.

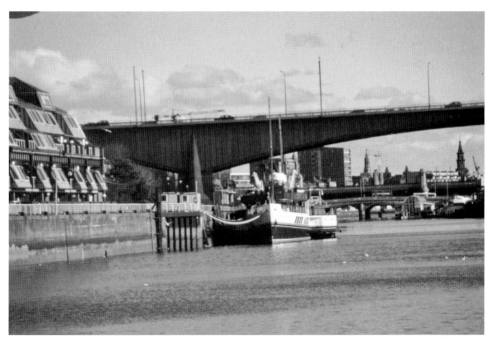

Lancefield Quay, known as Anderston Quay, was used by the preserved paddle steamer *Waverley* from 1975 to 1978 and from 1984 to 2005. Lancefield Quay has continued to be used as the headquarters and admin centre of Waverley Steam Navigation Co.

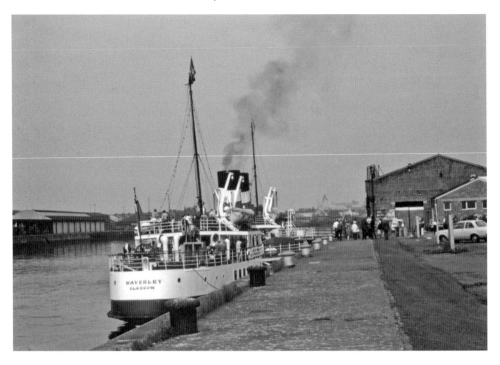

From 1978 to 1983, *Waverley* berthed further downriver at Stobcross Quay, where she is seen in 1979.

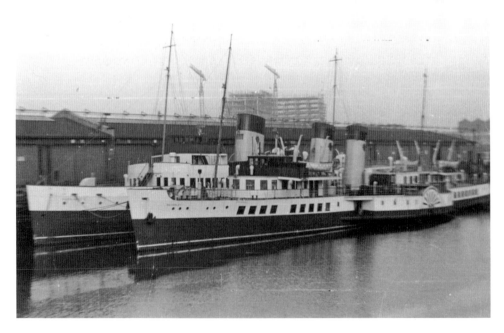

Queens Dock, built between 1872 and 1880, was closed in 1969 and is now infilled and the site of the Scottish Exhibition and Conference Centre. It was the location for the winter lay up of the Clyde steamer fleet in the 1968/69 winter, with *Waverley* and *Queen Mary II* to be seen here prior to the pruning of their masts.

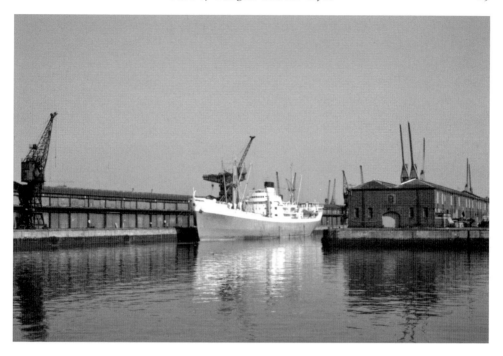

The equivalent dock on the south side of the river was Princes Dock, seen here in 1968 with an Ellerman City liner berthed. Princes Dock had three basins compared to the two of Queens Dock and was built between 1893 and 1897, closed in the 1970s, and infilled for the site of the Glasgow Garden Festival in 1989. It is now the site of Glasgow Science Centre.

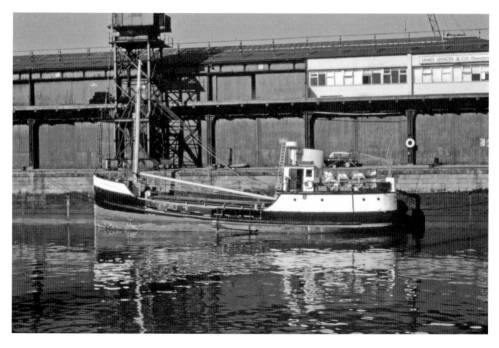

Princes Dock was also the berth for the diesel puffer *Pibroch*, which brought cargoes of whisky from Islay to the city.

Plantation Quay, on the river wall of the Princes Dock, outside Glasgow Science Centre is where
Waverley now berths, forced downstream by the building of the Clyde Arc Bridge (the squinty bridge).

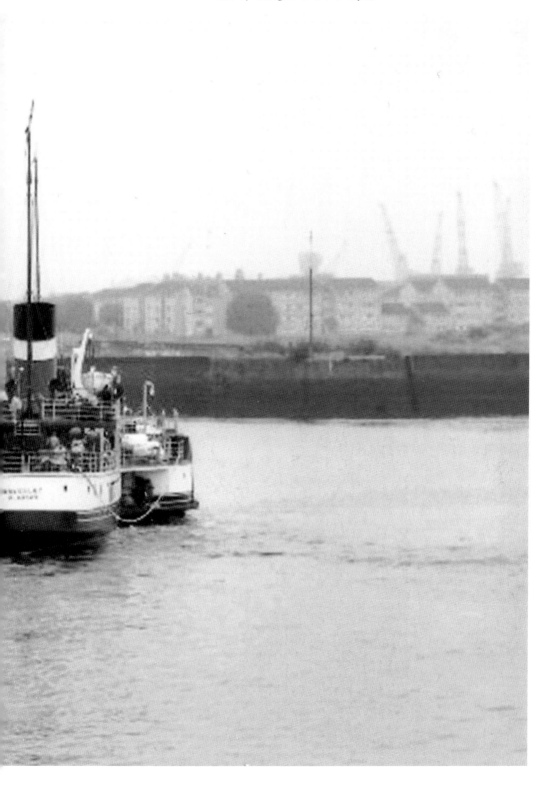

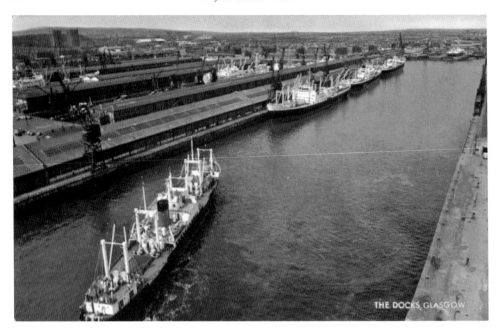

The same location in a 1950s postcard view, when the docks were still busy with cargo ships before the advent of containerisation made the conventional cargo ship obsolete. Burns & Laird's *Lairdsglen* can be seen in the river.

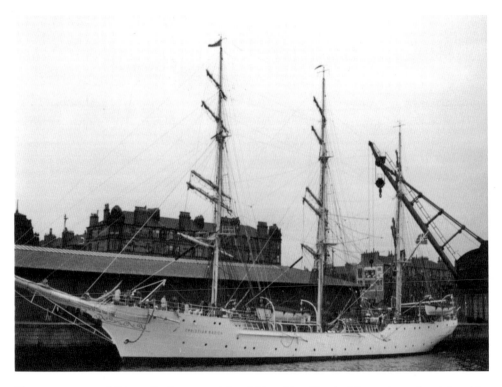

The western quay of Princes Dock was used for visiting ships, like the Norwegian sail training ship *Christian Radich*, seen there in the mid-sixties.

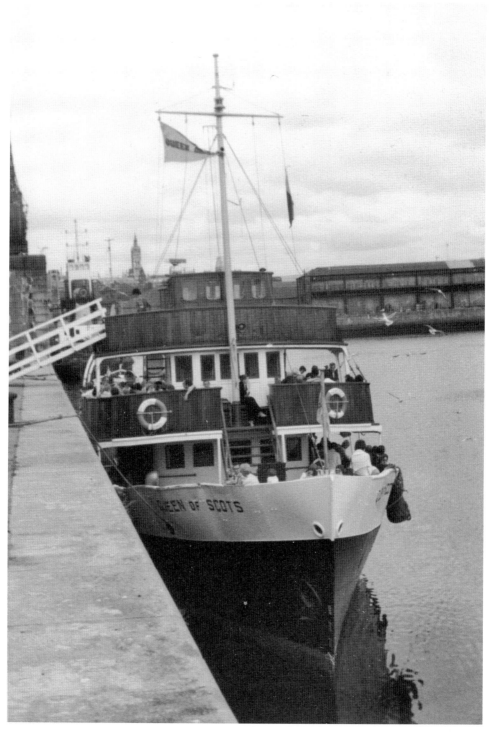

Following the closure of Bridge Wharf, the western quay of Princes Dock was used by the Clyde
Steamers for charters, and in 1978, *Queen of Scots*, operated by BB Shipping, ran from here to the
lower Firth. Although the majority of Princes Dock was filled in in 1988 to form the site for the
Glasgow Garden Festival, the canting basin still survives.

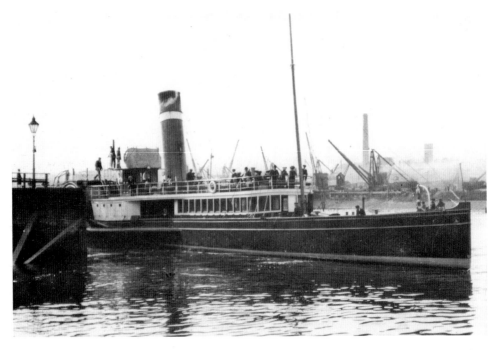

There was a wharf at Govan used by the all-the-way steamers, seen here with *Isle of Arran* berthed in the evening on her homeward voyage to the Broomielaw. It closed to scheduled service in 1953, latterly having been served by *Queen Mary II* on her outward journey only. The final call was made by Waverley in 1962 whilst attending a launch at Fairfield's yard. There was also a pier at Partick, which was closed in 1906.

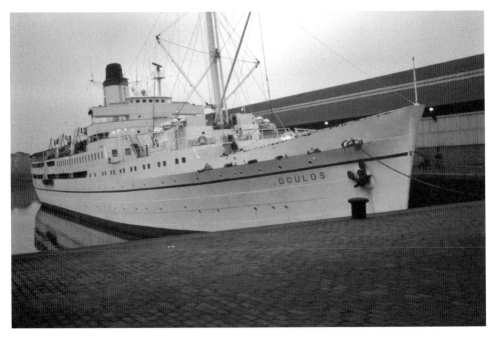

Yorkhill Basin, on the north bank, was used for visiting ships until filled in the late noughties. Here is Operation Mobilisation's missionary ship *Doulos* (1914), there in 1980.

King George V Dock has occasionally been used for visiting ships, as with British India Line's educational cruise ship *Uganda* in 1977.

Braehead Shopping Centre has a pontoon which is used by museum ships from the maritime museum there and was also used, from 2001 to 2007, by *Pride o' the Clyde*, and in 2010 by *Fencer* and *Rover*, both of which operated a service to the city centre. The year 2010 also saw calls by Clyde Marine's *Cruiser* on a service from the Science Centre to Clydebank. There have been plans to build a larger pier so that *Waverley* can call, but these have not come to fruition at the time of writing.

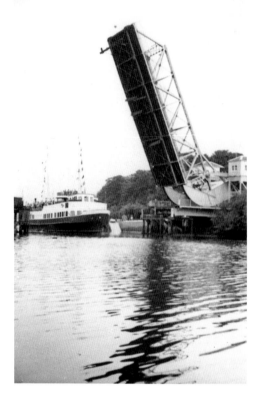

Left: There have been four passenger vessel sailings through the Bascule Bridge at Inchinnan and on up the White Cart since it was built in 1923, replacing an earlier swing bridge. This shows the second of these, a Clyde River Steamer Club charter with *Maid of Argyll* on 17 September 1966, *Countess of Breadalbane* having visited on a similar charter on 8 May 1959. *Maid of Argyll* made a cruise from Paisley to Dunoon and Loch Striven.

Below: On 5 December 2009, Clyde Marine's *Cruiser* made a trip up the White Cart, although due to the river not having been surveyed for many years above Babcock's Wharf at Renfrew, she did not proceed beyond there. By this time, the bridge had been repainted in dark red and yellow.

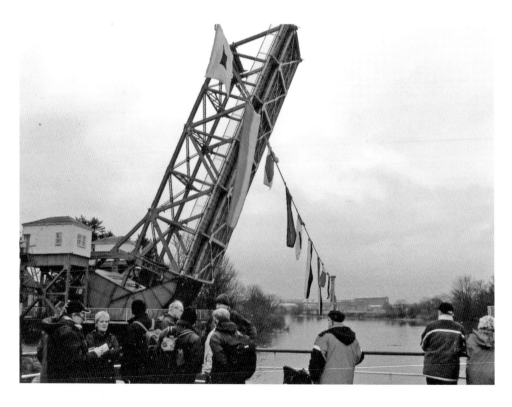

Paisley saw its first steamer service on 25 June 1815 with *Prince of Orange*. The opening of the new harbour in 1891 was celebrated by sailings to Rothesay by the paddle steamers *Shandon*, *Vivid* and *Guinevere*. Occasional excursions were operated on local Monday holidays from 1884 to 1898, and the harbour continued in use for ships built by Paisley shipyards such as Bow McLachlan and Fleming & Ferguson until the latter's closure in 1969 and also for puffers and small coasters until 1966, after which the river ceased to be dredged. This is the diesel puffer *Raylight* at Paisley Harbour in the mid-sixties.

Paisley Harbour in the late sixties with the diesel puffer *Limelight*.

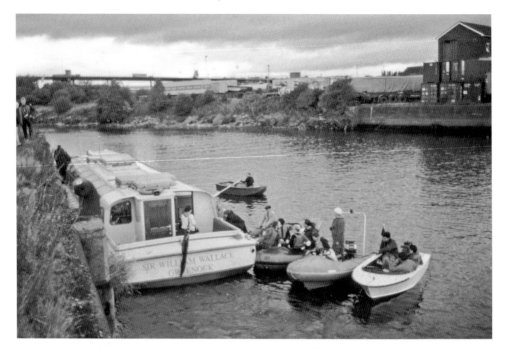

In autumn 1989, a Paddle Steamer Preservation Society charter brought the waterbus *Sir William Wallace* to Paisley, where passengers landed on a derelict, overgrown quayside. She is attended by small boats of the short-lived Paisley Canal & Waterways Society.

In 2009, a new pontoon known as Queens Quay was built at Clydebank for a summer service in that year to the preserved Titan Crane by Clyde Marine from a pontoon at the Crowne Plaza Hotel near the SECC, and in 2010 from the Science Centre, with *Cruiser*.

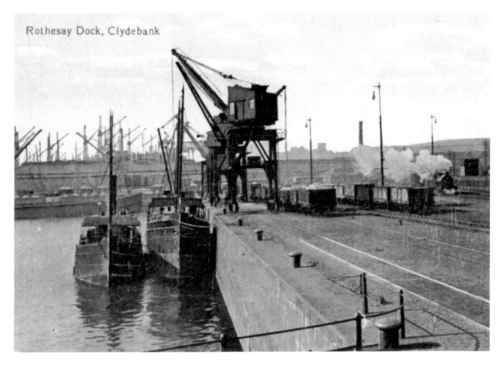

Rothesay Dock, Clydebank

Rothesay Dock in Clydebank was opened in 1907 and was used for cargo. *Balmoral* offered passenger sailings from here for a year or two around 1989.

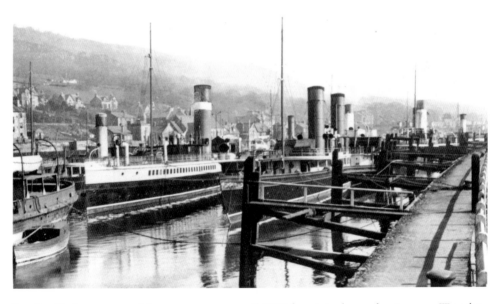

Bowling Harbour was used for many years up until 1952 for winter lay-up for steamers. *Waverley* and *Columba* are seen here with at least another five steamers, including *Fusilier* and *Iona* in the background in a post-1920 shot. There was a steamer pier at Bowling, known as Frisky Wharf, in use until 1937, and used from 1850 when a railway was built from Balloch to Bowling until the building of the railway from Bowling to Glasgow Queen Street in 1858 as part of a through route from Glasgow to Loch Lomond.

Bowling Basin, at the entrance to the Forth & Clyde Canal, was visited by *The Second Snark* on an enthusiast charter in 1995.

2
Dunbartonshire Piers

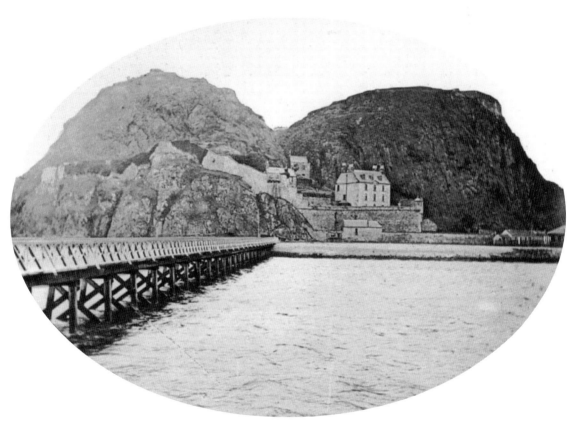

Dumbarton Castle Pier, seen here in an image from an old lantern slide, was built in 1875 and was damaged in 1900 in a storm and abandoned in 1908. The remains of the pier survived until the 1960s

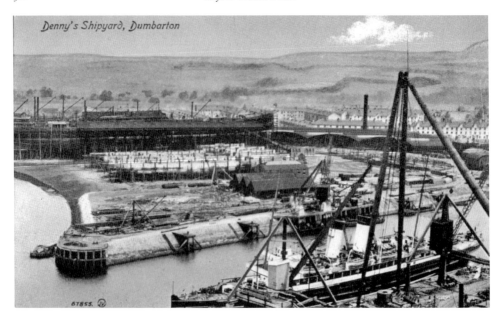

The Old Quay at Dumbarton, up the River Leven, was used in the early days of steam navigation and for one season in 1889. I have no image of it, but the well-known shipyard of Dennys of Dumbarton is shown in this postcard view, showing the South Eastern & Chatham Railway turbine steamer *Riviera* or *Engandine* at the fitting-out berth in 1911.

Craigendoran Pier was opened on 15 May 1882 for the services of the North British Steam Packet Co. and continued in use by the London & North Eastern Railway and British Railways until 1972 as the north bank railhead. Two finger piers were provided and a bay platform for boat trains, one of which can be seen in the background here in this view of *Marmion* of 1904.

Craigendoran on 5 July 1919, with, from left, *Dandie Dinmont*, *Kenilworth* and *Lucy Ashton*. The fanboards can be read on the original photograph and *Dandie Dinmont* is sailing for Kilcreggan, Kirn, Dunoon, Innellan and Rothesay and *Lucy Ashton* for the Gareloch.

The LNER fleet at Craigendoran *c*. 1930 with *Kenilworth* or *Talisman* to the right, *Lucy Ashton* behind her, and two more paddlers, one each side of the western finger.

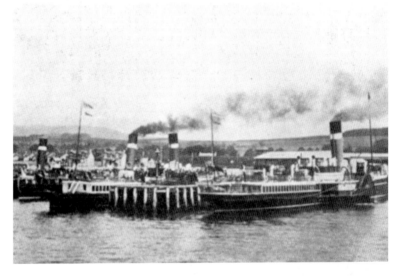

The first Helensburgh pier was built in 1816 for Henry Bell's *Comet*. It was lengthened in 1822, 1855 and 1877. This undated engraving shows an unidentified paddle steamer, possibly meant to represent one of the first two NB paddle steamers, *Meg Merrilies* and *Dandie Dinmont*, which operated from there to Ardrishaig in 1866. A smaller paddle steamer heads off towards the Gareloch in the background.

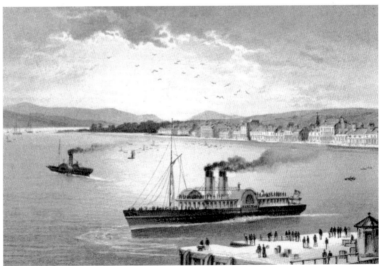

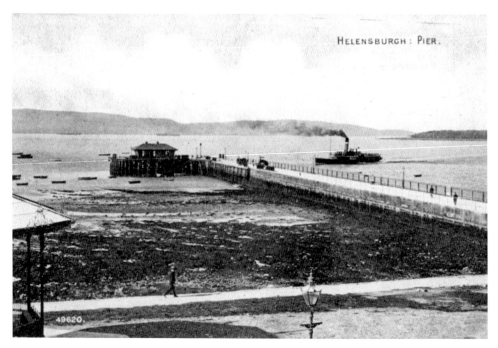

A new pier head was built in 1891. Helensburgh was used by *Lucy Ashton* on her Gareloch service and on sailings to Greenock. She is seen here approaching the pier in an Edwardian postcard. Helensburgh Pier was closed in 1952.

The area to the east of the pier was infilled and has been used by a funfair and, in recent years, for car parking. In 1979, *Waverley* recommenced regular calls and the pier is seen here in 1982 from her decks.

3
Inverclyde Piers

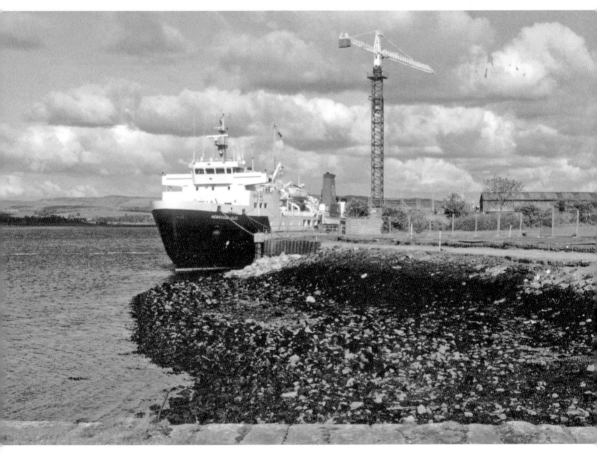

Port Glasgow had a Steamboat Quay, used until the 1890s, and a jetty at Newark Castle, used by Clyde Marine's *The Second Snark* on excursions in the 1980s and 1990s. Caledonian MacBrayne's *Hebridean Isles* is seen here in autumn 1998 undergoing repairs at Ferguson Bros shipyard's fitting-out berth.

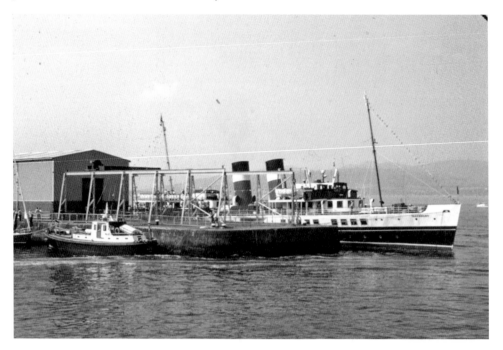

In 1999, during the Tall Ships Race, Greenock Custom House Quay was not available and
Waverley berthed at Victoria Quay at the entrance to Victoria Harbour. In early March 1947,
Waverley had her engines fitted here.

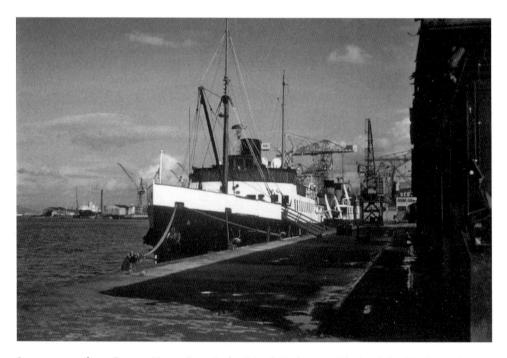

Just upstream from Custom House Quay is the Bristol Berth, overnight berth for MacBrayne's
Tarbert and Ardrishaig steamer until withdrawal in 1969. Here, *Lochnevis* and *Lochfyne* are
berthed.

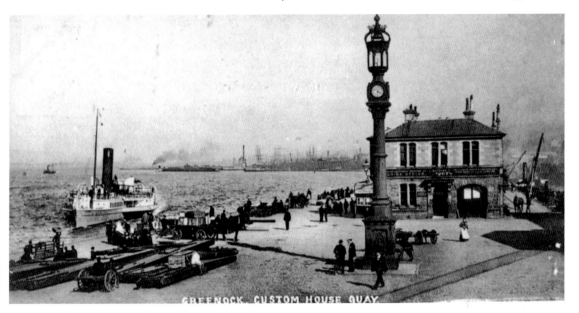

Custom House Quay was used by the Glasgow & South Western Railway until June 1915, and their *Glen Rosa* is seen here approaching the pier. Since 1975, it has been a regular calling point for *Waverley*.

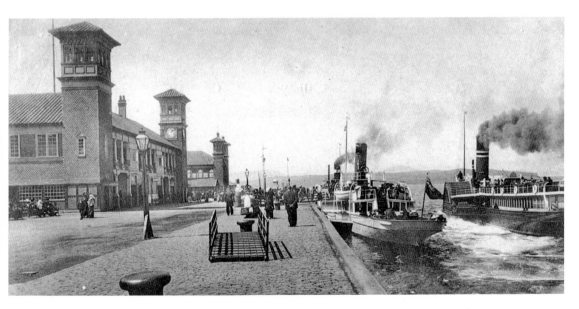

Greenock Princes Pier was built by the Glasgow & South Western Railway in 1894 at the terminus of their new line from Glasgow via Kilmacolm and had six Italianate red-brick towers. The line had been open since 1869 using a smaller pier, originally known as Albert Harbour. It is seen here with the GSWR *Marquis of Bute* and another unidentified NB steamer berthed and the Lochgoil Company's *Windsor Castle* departing. This places the image prior to 1900.

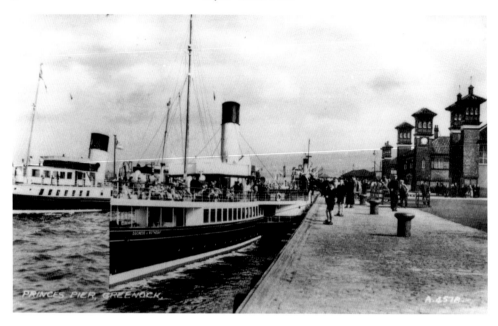

Princes Pier continued to be used after the railway amalgamation of 1923 and is seen here in the 1930s with *Duchess of Rothesay* at the pier and *Marchioness of Lorne* just pulling away from the pier. Steamer services ceased in 1952 apart from the tenders, normally a *Maid*-class vessel, to the Atlantic Liners berthed at the Tail of the Bank. Regular train services ceased in 1959, but the line continued to be used for Ocean Liner specials until 1966. For the next two years, until transatlantic liner services from the Clyde ceased, the tenders to the liners operated from Custom House Quay.

The pier buildings were demolished in the late sixties and the berth used for the occasional visiting cruise ship, like British India's educational cruise ship *Dunera*, seen here in 1968.

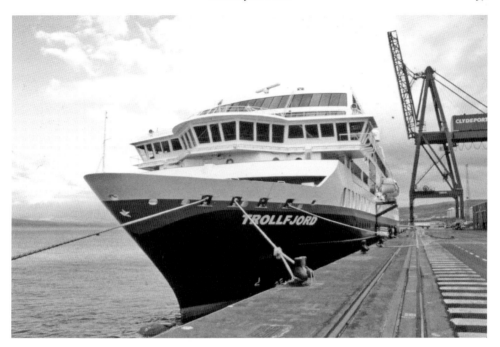

A new container terminal was opened in 1969. This is also used for visiting cruise ships, like Hurtigruten's *Trollfjord*, seen here in 2005.

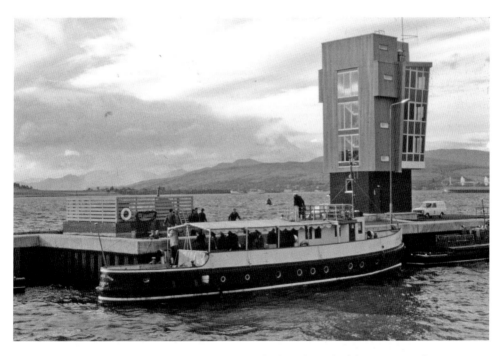

A Clyde Port Authority shipping control tower was built at the end of the pier around 1970, and the vessels of Clyde Marine, such as *The Second Snark*, seen here in 1971, were based there until around 1990. This is known as the Small Boat Harbour and is still in use for the cutters and workboats of the Clyde Port Authority.

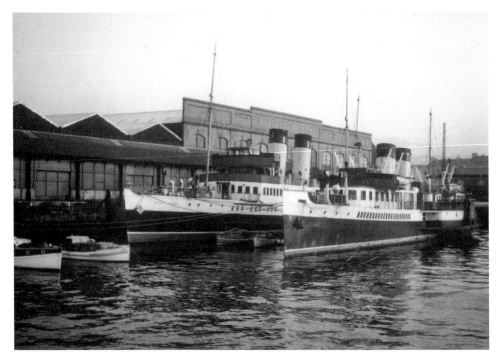

The Albert Harbour in Greenock was used for laid-up steamers until 1965, when the withdrawn *Duchess of Montrose* and *Jeanie Deans* are to be seen there.

Lay ups later moved to the East India Harbour, where the laid-up fleet of *Duchess of Hamilton*, *Maid of Ashton*, *Countess of Breadalbane* and *Loch Eynort* are berthed alongside each other, and the naval steam water carrier *Freshspring* is moored at the south quay in 1971.

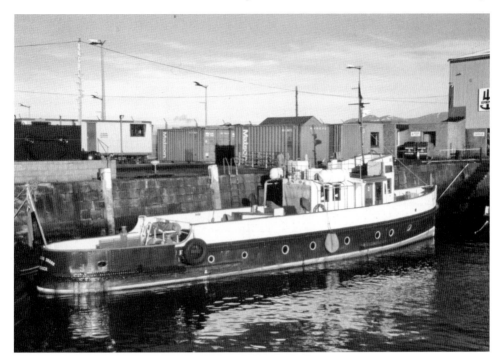

The Victoria Harbour is now used as a base for the vessels of Clyde Marine, and *The Second Snark* is seen here in spring 2005 in her winter condition without the awning and awning supports.

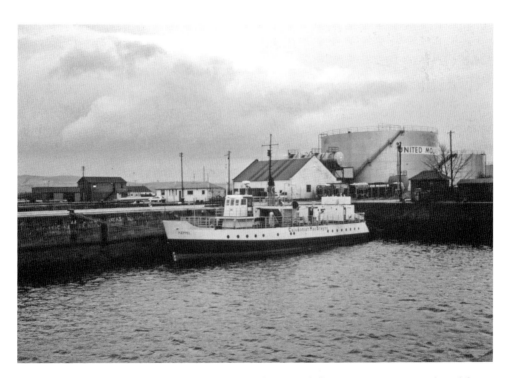

The James Watt Dock is used from time to time to lay up Caledonian MacBrayne vessels and for vessels overhauling at the Garvel Dry Dock. Here, we see *Keppel* there in 1988.

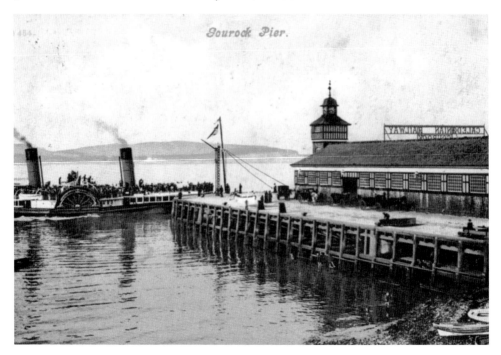

Gourock Pier was built in 1889 when the Caledonian Railway reached the town, and has been the headquarters for the Caledonian Steam Packet Co. and Caledonian MacBrayne right up to the present day, although the half-timbered pier buildings have long gone on the majority of the pier. Here, we can see MacBrayne's *Columba* calling on the return journey from Ardrishaig to Glasgow on a postcard posted in December 1905.

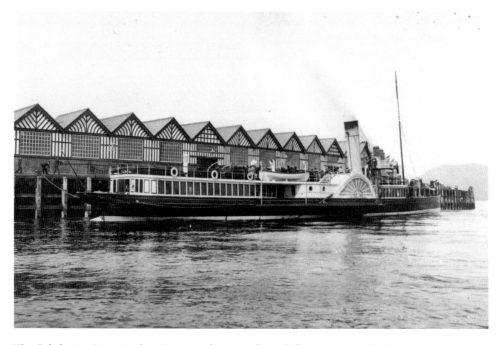

The Caledonian Steam Packet Co.'s *Marchioness of Breadalbane* at Gourock Pier prior to 1923.

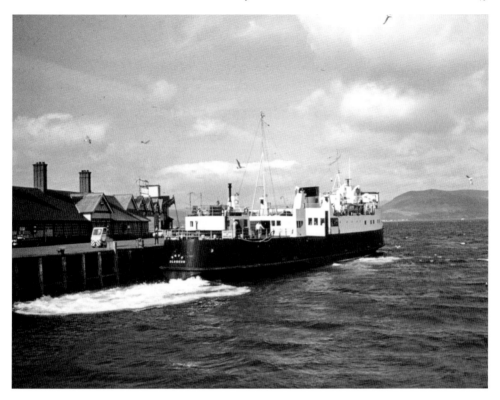

The side-loading car ferries continued to operate from Gourock Pier without any alteration to the structure. *Bute* is seen here leaving for Dunoon between 1970 and 1972.

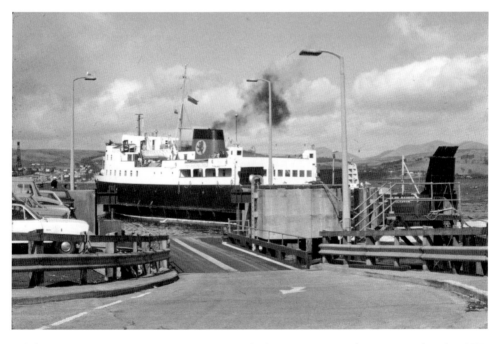

A linkspan was installed at Greenock in 1971 and *Glen Sannox* is seen here arriving there in 1977.

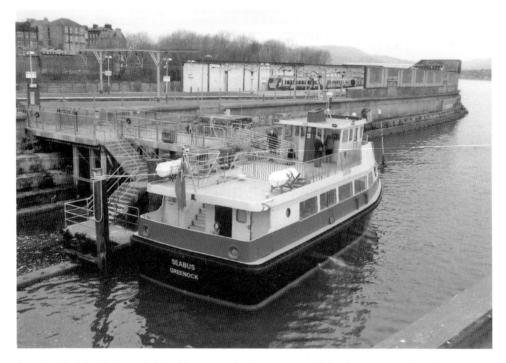

Just ahead of the linkspan is a small concrete landing stage, used by the passenger ferry for Kilcreggan and Helensburgh, where Clyde Marine's *Seabus* is seen in April 2010.

Opposite the linkspan is the head office of Caledonian MacBrayne, seen here from the Dunoon ferry *Jupiter* in April 2010.

How are the mighty fallen! The remains of the pier buildings at Gourock in April 2010.

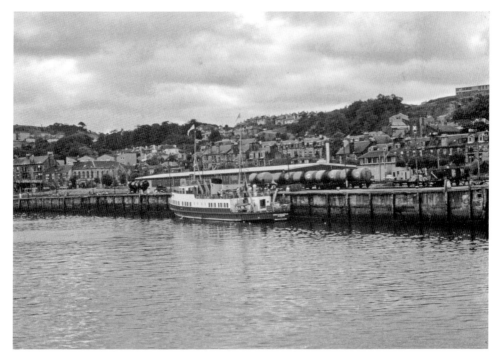

The area beyond the linkspan is known as 'the wires' and is used for ships out of service, whether for a few hours or a long period. *Maid of Skelmorlie* is seen there in 1969.

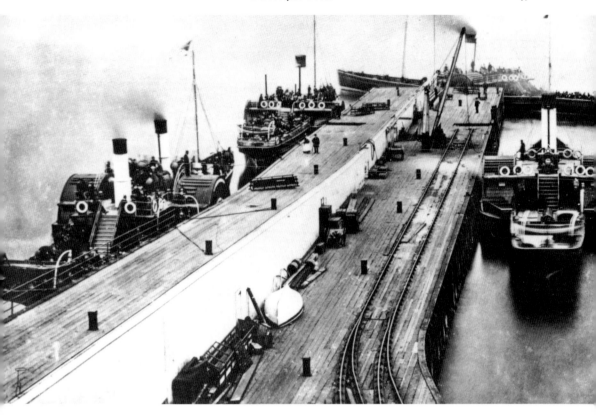

A pier was opened at Wemyss Bay in 1865, when the railway reached there. It is seen here *c.* 1875 with, from left, the steamers *Largs, Lancelot, Lady Gertrude* and *Argyle*.

Opposite above: Just east of Gourock Pier there used to be a small ship repair yard known as Adams Yard. *Countess of Kempock*, formerly *Countess of Breadalbane*, is seen here in spring 1979.

Opposite below: A terminal was established at McInroy's Point, between Gourock and the Cloch lighthouse in 1973 for Western Ferries car ferry service to Hunter's Quay, in which year, *Sound of Islay* is seen prior to the opening of the service.

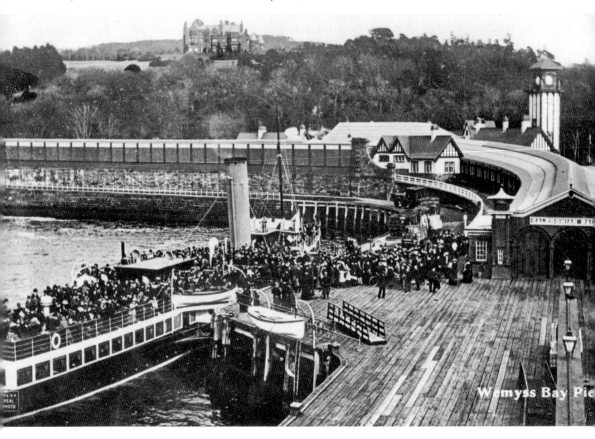

In 1903, a magnificent new station and pier was opened at Wemyss Bay, seen here with a heavily loaded *Duchess of Fife* embarking a large crowd for Rothesay.

Opposite above: The berths on the south side of the pier, where *Marchioness of Breadalbane* is berthed here and where the car ferries for Rothesay now berth, was traditionally used for steamers to Millport.

Opposite below: Cowal at Wemyss Bay on the Rothesay car ferry service, with a *Maid* beyond her, in the sixties. Note the railway siding used in earlier times to supply coal for the steamers.

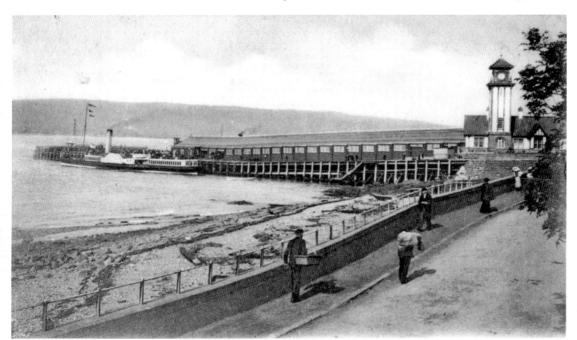

Wemyss Bay pier from the south in 1983, after the linkspan had been added, but before the pier had been shortened.

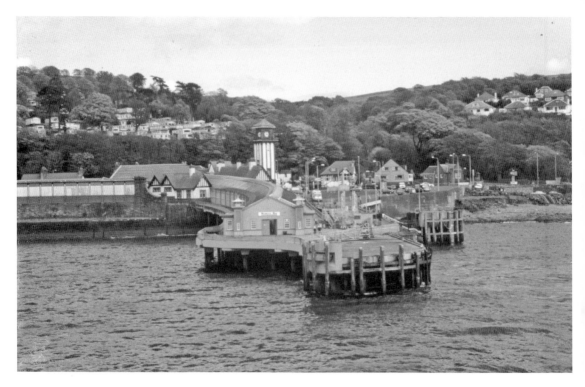

A similar view in 2004, showing how the linkspan has been added and the end of the pier shortened.

4
Piers of the Ayrshire Coast

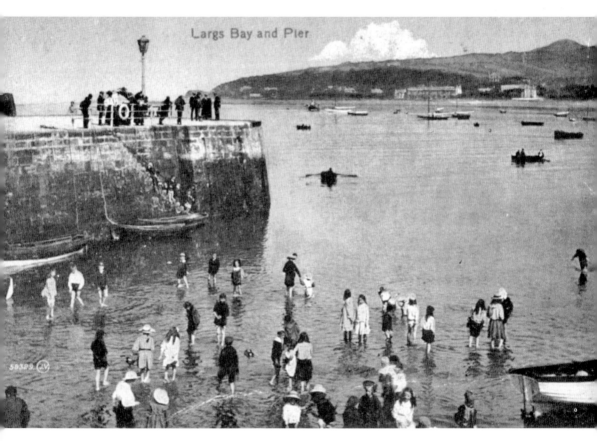

Largs Pier was originally built as far back as 1832 for steamers that brought passengers from Glasgow prior to the building of the railway. In this Edwardian postcard, bathers throng what is now the site of the Cumbrae ferry slipway.

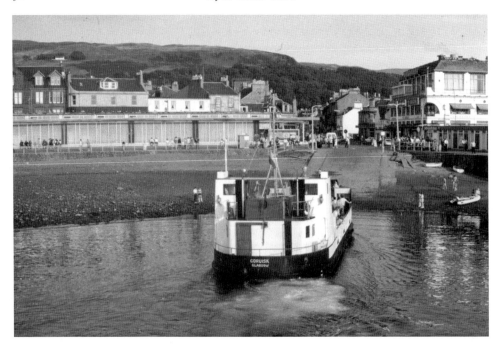

By the foot of Largs Pier, a slipway was built in 1971 for the car ferry service to Cumbrae Slip. Here, we can see *Coruisk* arriving in 1976, before the days of drive-through car ferries.

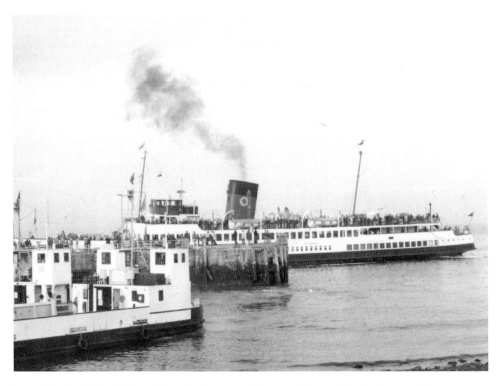

Largs Pier in 1976 with *Coruisk* at the slipway and *Queen Mary* arriving in her penultimate season, her first without the suffix '*II*' since 1934.

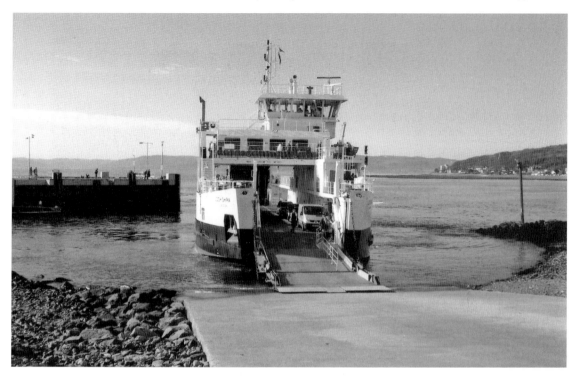

The slipway in April 2010, showing the ferry *Loch Shira* awaiting passengers for Cumbrae Slip.

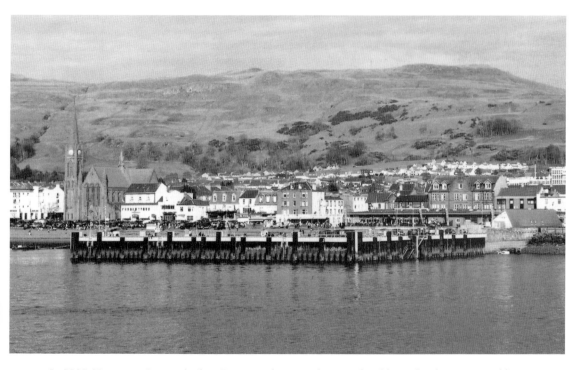

In 2008-09, a new pier was built at Largs, to the same shape as the old one, but longer, to enable *Loch Shira* to berth overnight sheltered inside the pier.

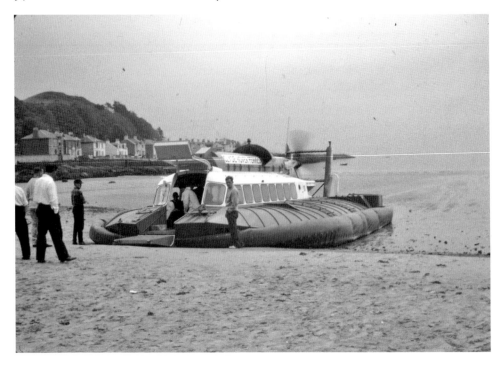

In 1965, Clyde Hover Ferries operated a SRN6 hovercraft from the beach at the north end of Largs.

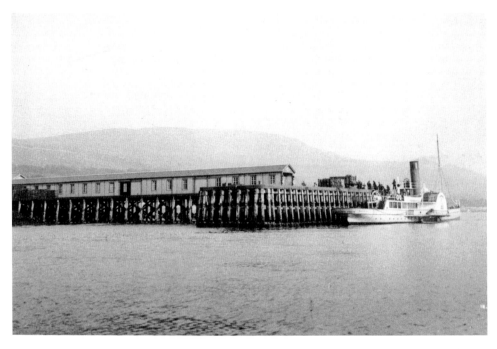

Fairlie Pier was opened in 1882 and was at the end of a short Glasgow & South Western Railway branch line from the line to Largs. *Marquis of Bute* is seen here berthed at the pier. It was used for services to Cumbrae and Arran and by the Campbeltown steamers.

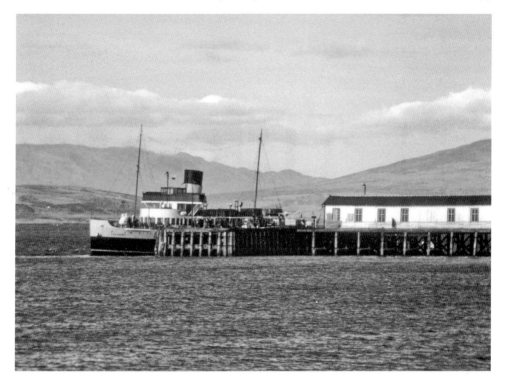

Caledonia at Fairlie Pier in 1964. The final call at the pier was made by the car ferry *Cowal* on 11 March 1972 and was destroyed by fire on the same evening.

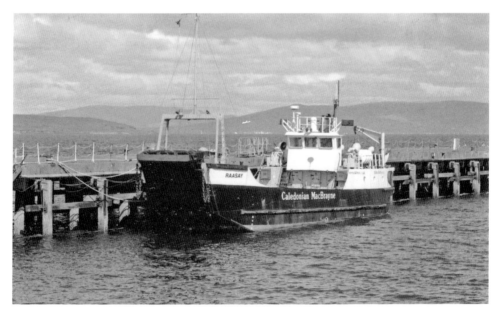

In recent years, the former Admiralty pier at Fairlie has been used by Caledonian MacBrayne for lay-up purposes, as in the photo here with Island-class ferry *Raasay*, and also by Hebridean Island Cruises as an embarkation point for their cruise ship *Hebridean Princess*, ex-*Columba*, and by *Waverley* in July 2009 whilst the new pier at Largs was awaiting completion.

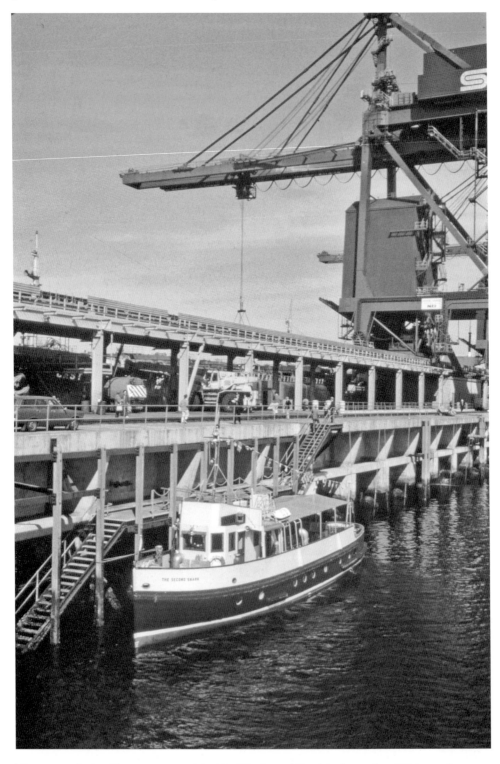

The ore terminal at Hunterston was visited by *The Second Snark* in September 1986 on a Queens Park Camera Club/Coastal Cruising Association charter. With the cessation of steelmaking in Scotland, the terminal now imports coal for Longannet Power Station.

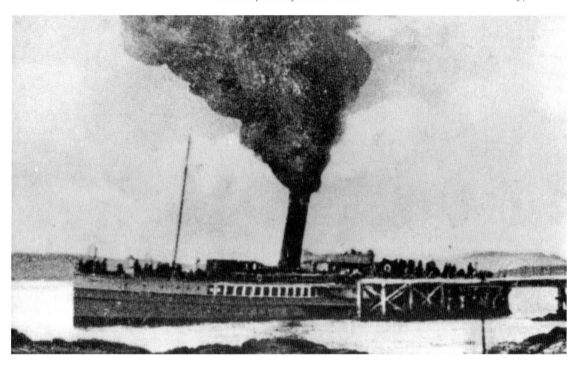

Portencross Pier, to the north of Seamill, was occasionally used for special sailings from 1912, when it was built, to 1914. The GSWR's Ayr excursion steamer *Juno* is seen here at the pier.

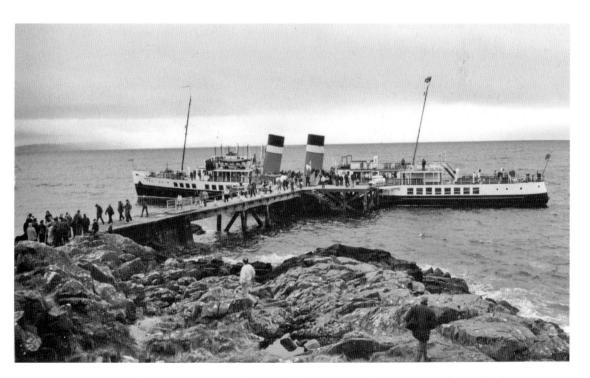

Portencross Pier has survived in private hands, and on Easter Sunday 1995, *Waverley* made what has so far been a unique call.

Ardrossan was served by two railways, the Glasgow & South Western, which had a branch to
Winton Pier, and the Caledonian, which served Montgomerie Pier. Both offered services to Arran,
but the through line via Lugton to the Caledonian terminal was closed for normal passenger
services in 1932, although boat trains operated until 1947 when a short link line was put in at
Stevenston to enable trains to reach Montgomerie Pier. This was latterly used for Irish and Isle of
Man sailings, and was rail connected until 1968, whilst Winton Pier, seen here around 1960, was
used for Arran sailings. The harbour tug *Seaway* can be seen in the background.

Opposite above: The Isle of Man Steam Packet turbine steamer *Manxman* embarking passengers
at Montgomerie Pier in 1968.

Opposite below: The advent of the car ferry changed matters, and Burns & Laird Lines' *Lion* ran
from a new linkspan, from a berth known colloquially as 'The Lion's Den'.

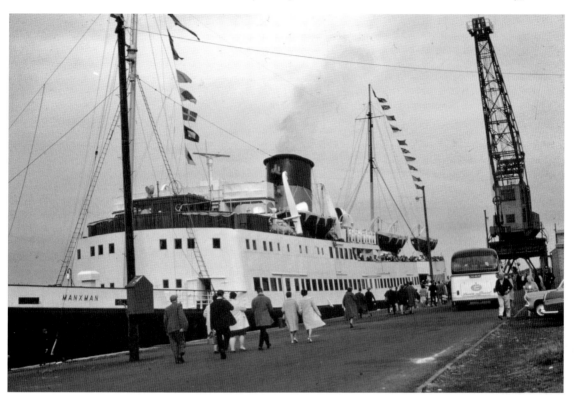

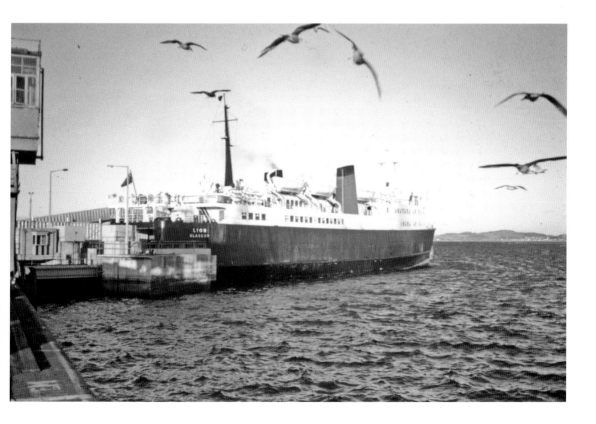

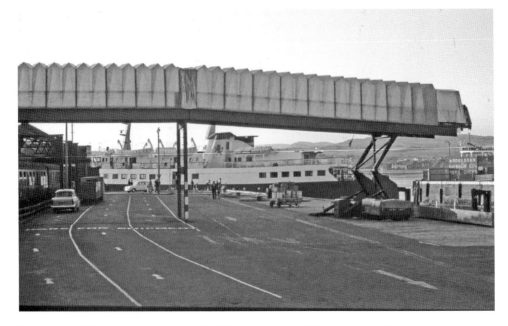

The advent of the car ferry *Caledonia* in 1970 saw a new end-loading ramp fitted and a new
overhead passenger walkway from the station to the ferry.

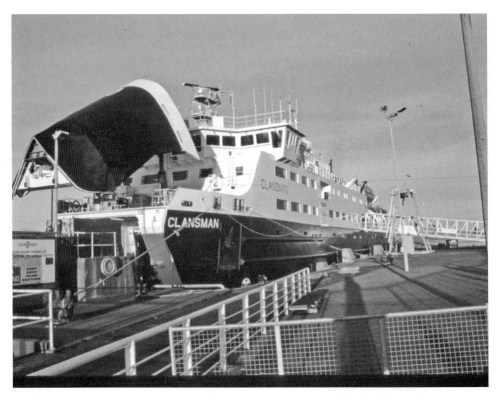

There is now a ramp in a U-shaped berth to the west of the old pier, where *Clansman*, relieving
when the regular ferry *Caledonian Isles* was on annual overhaul, is seen in January 2000.

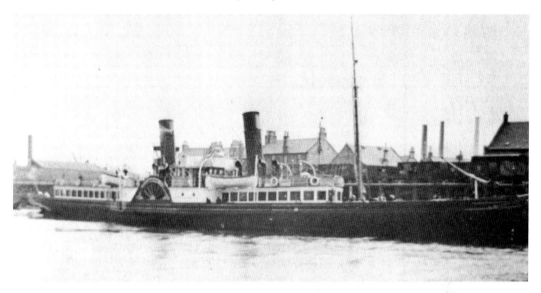

Irvine has seen only very occasional Clyde steamer sailings with some vessels like *Grenadier*, seen here, visiting for winter refits in the 1920s and a single visit by *Waverley* on 22 August 1978.

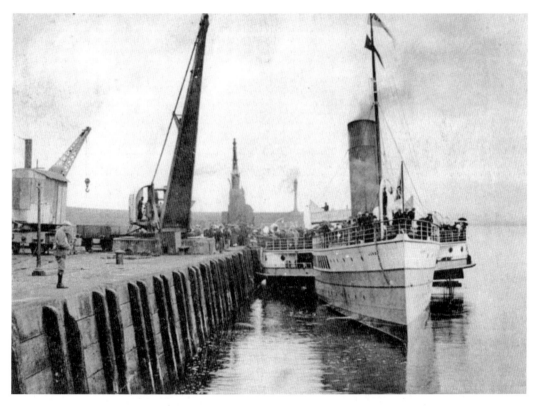

Troon was a port of call for the Ayr excursion steamers until the ending of regular sailings from the latter port in 1964. *Waverley* made calls here in certain years early in her preservation career but the recent building of the P&O ferry terminal has restricted access to the berth. *Juno* is seen here at Troon in the early 1900s.

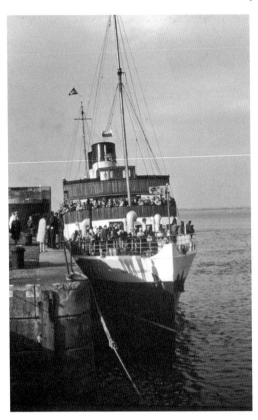

Left: Duchess of Hamilton at Troon on a Clyde River Steamer Club charter to Arrochar on 7 September 1968. The north breakwater at Troon was the site of the breaking up of *Duchess of Hamilton* in 1974. In the 1990s, a new linkspan was built on the outside of the seaward end of the northern breakwater for P&O Ferries' service to Larne, currently operated by the fast craft *Express*, augmented with a night-time freight service by *European Mariner*.

Below: The Isle of Man Steam Packet Co.'s *Mona's Queen* on an overhaul visit to the Ailsa yard at Troon in 1982.

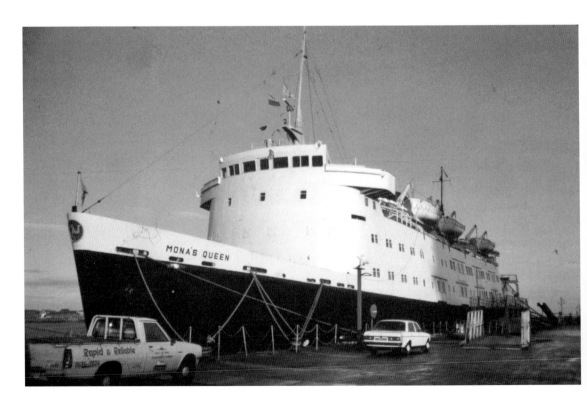

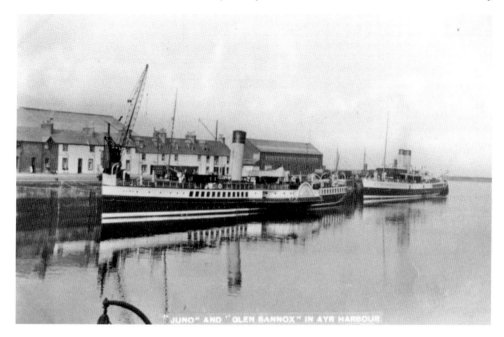

Ayr was a base for excursions by the GSWR from 1898 with the dedicated Ayr Excursion steamer *Juno*, seen here on a summer Sunday in 1925 with the turbine *Glen Sannox*. The new *Duchess of Hamilton* replaced her in 1932. Sailings resumed after the war in 1947 with *Marchioness of Graham* until 1953, and then *Caledonia* until 1964 and, from 1965 to 1970, with a weekly Friday cruise round Holy Isle by *Duchess of Hamilton*.

Waverley started offering mid-week trips in 1975 and has continued to do so ever since. She is seen here at her berth at Compass Pier.

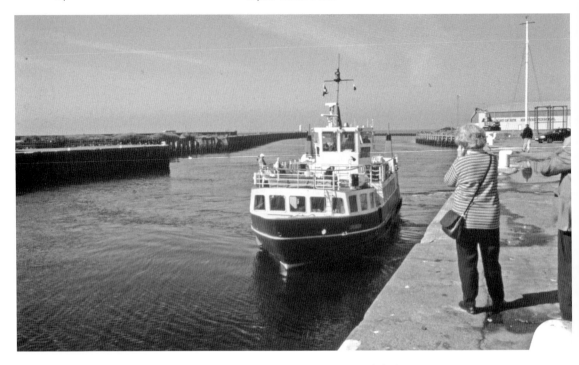

Clyde Marine's *Cruiser* arrives at Ayr for a Clyde River Steamer Club charter in 2002.

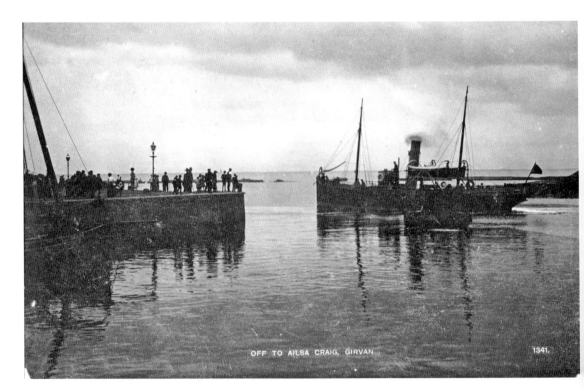

A. & S. Girvan offered a regular service from Girvan to Ailsa Craig to land with *Ailsa* of 1906. Such trips are now operated by a fishing boat.

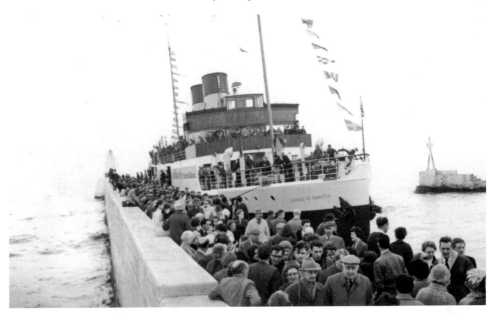

Girvan saw regular calls from 1891 to 1939 by the Ayr excursion steamer and by occasional trips from the upper firth. The first postwar call was on 29 April 1967 with a Clyde River Steamer Club charter from Gourock, Largs and Ayr by *Duchess of Hamilton*, carrying a large crowd, as can be seen here.

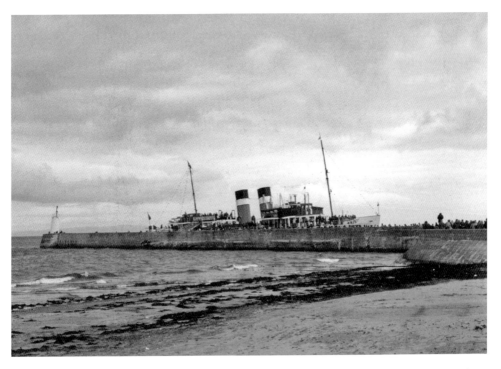

Waverley has called regularly at Girvan since her first year in preservation in 1975, most recently on her Monday Glasgow to Ailsa Craig trips, although calls have been limited to times of high tide in recent years because of a lack of dredging.

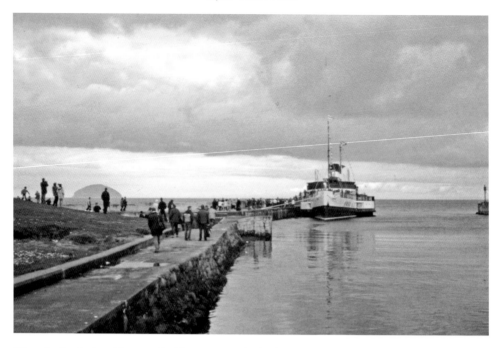

Waverley berthed at Girvan with Ailsa Craig in the background. She is dressed overall for a Clyde River Steamer Club charter.

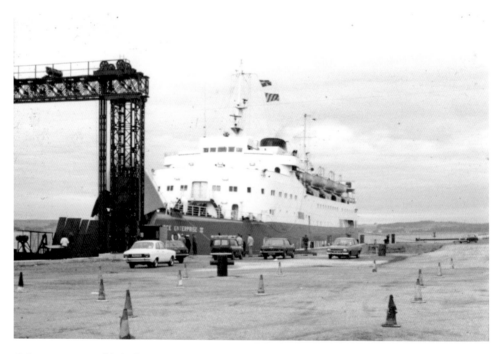

Cairnryan was established as a military port in the Second World War and a ferry service to Larne was established by the Atlantic Steam Navigation Co. in 1973. Their parent company Townsend Thoresen took over the service in 1974, when *Free Enterprise III*, seen here, was used. The service continues today under the P&O Irish Sea flag.

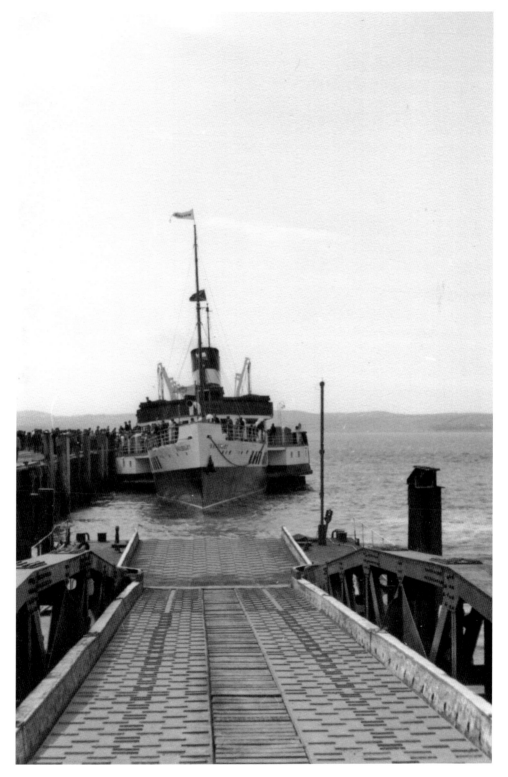

Waverley on the only call she has ever made at Cairnryan, showing the ferry ramp in the foreground, in 1977.

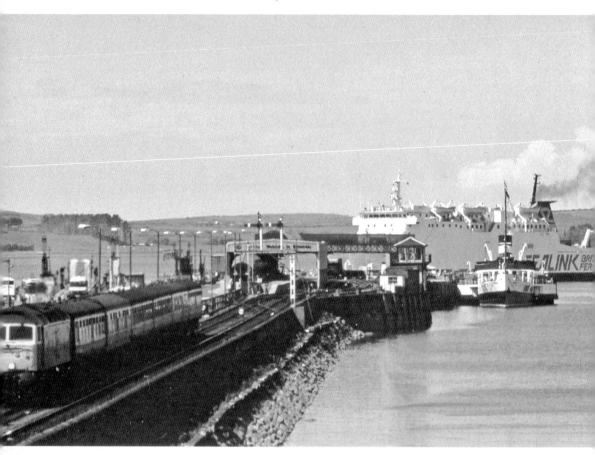

Clyde steamer calls at Stranraer have been very rare, even in the heady days pre-1914. *Waverley* has made a handful of calls and is seen here with *Darnia* departing for Larne in Sealink British Ferries livery, which places the photo between 1984 and 1991.

5
Piers of the Clyde Sea Lochs (Gareloch, Lochs Long and Goil and Holy Loch)

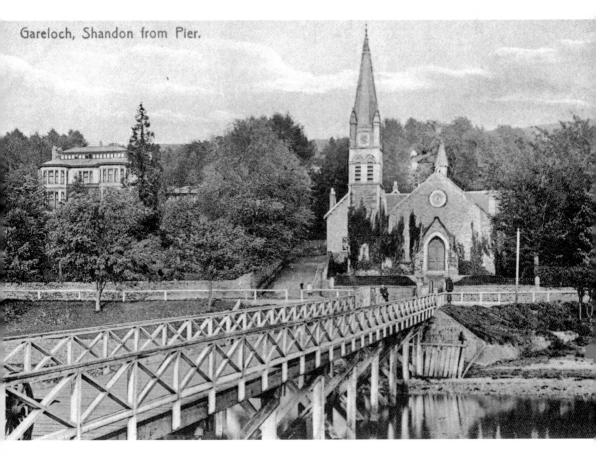

Gareloch, Shandon from Pier.

The Gareloch saw services mainly by the NB. There were two piers on the east side of the Loch, Rhu, then spelt Row, and Shandon, as seen in this old postcard. This served Shandon Hydropathic, originally the home of the shipbuilder and engine builder Robert Napier, and after his death a hotel. From 1878 to 1886, there was a pier at Balornock, slightly farther north. Shandon was closed to steamer traffic in 1919 and the structure survived until 1969.

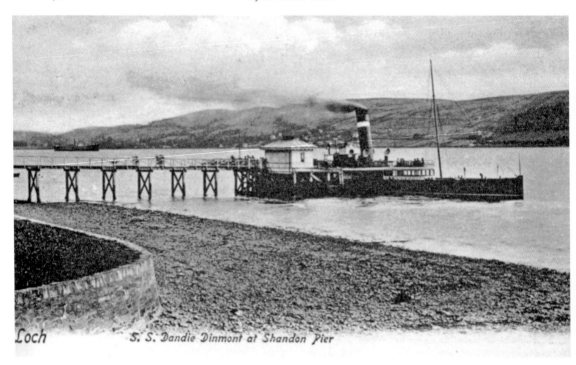

Loch S. S. Dandie Dinmont at Shandon Pier

Dandie Dinmont at Shandon between 1912 and 1914 in a postcard view, although by that time the Gareloch service was in the hands of *Lucy Ashton*, which served the loch until the service was withdrawn in 1942.

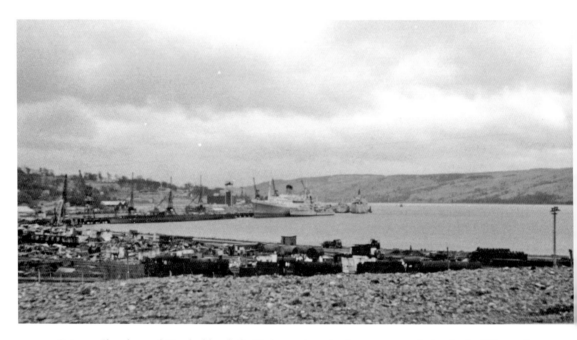

Between Shandon and Garelochhead, the Faslane submarine base now stands, but in the fifties and sixties, there was a shipbreaking yard at Faslane owned by Metal Industries Ltd. In this view, the Union Castle liner *Braemar Castle* can be seen with three small naval ships in 1966.

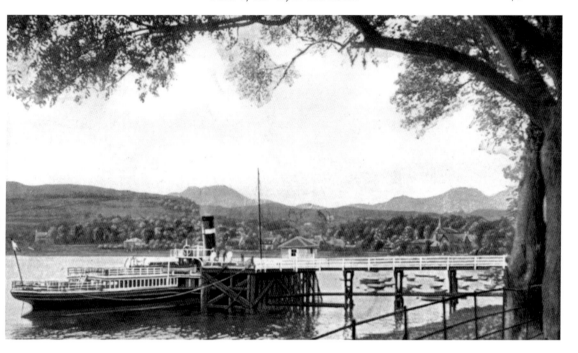

The pier at Lochgoilhead, seen here in a postcard view with *Lady Clare*, which served the loch from 1897 to 1903, was opened in 1845 and replaced by a new structure in 1879. It was closed on the outbreak of war in September 1939 and never reopened.

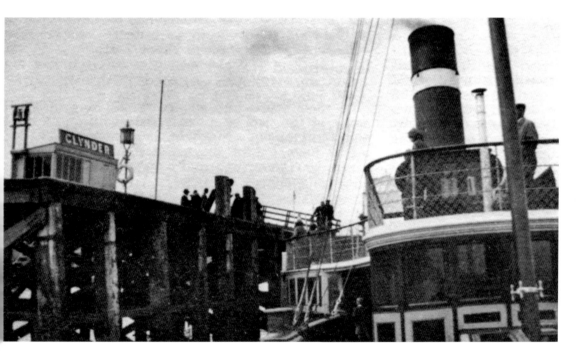

On the west side of the Gareloch, there was a pier at Mambeg, in use from the early 1870s until 1935, a ferry call at Rahane, in use until 1932, a pier at Baremman, in use from 1877 to 1942 and later renamed Clynder, seen here with *Lucy Ashton*.

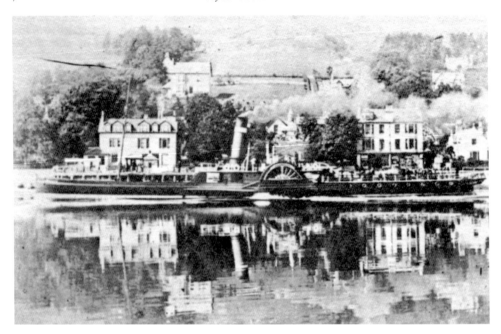

Only 500 yards south was Clynder pier, opened in 1866 and closed in 1892, after which Baremman Pier was renamed Clynder. *Gareloch* is seen here at the old pier. By summer 1942, that was the only remaining pier in the Gareloch, and with increasing naval use of the loch, in September that year, sailings ceased.

Rosneath had a pier from 1845, with a new pier opened in 1892 and closed in March 1942. In recent years, a jetty at Rosneath has been used as a lay-up berth for some of the Caledonian MacBrayne fleet, such as *Coruisk*, seen here.

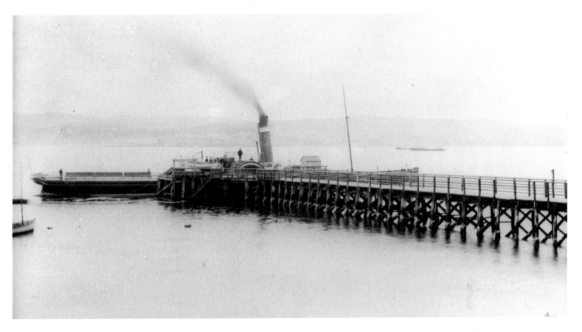

The original pier at Kilcreggan was in use from 1850 until replaced by a new pier in 1892. It is seen here with *Guy Mannering*, ex-*Sheila*, prior to the building of her aft saloon in 1891.

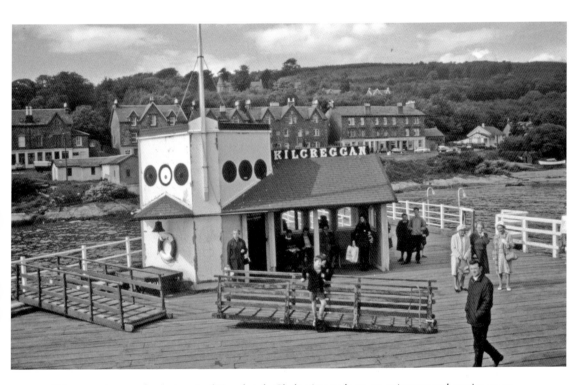

Kilcreggan is one of only two traditional-style Clyde piers to have an uninterrupted service up to the present day, with a regular service from Gourock by Clyde Marine's *Seabus* and regular calls in the summer months by *Waverley*. This is a view of the pier in 1971, showing the old-style wooden gangways with small boys playing with them.

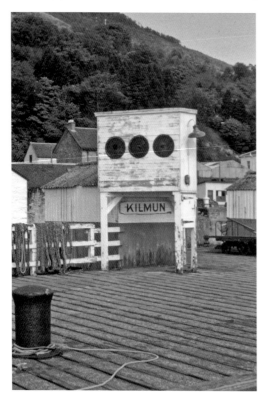

Left: Kilcreggan was the last Clyde pier with an old-style indicator board. These were invented during the great days of steamer racing in the nineteenth century. If two steamers were heading for the pier, the left or right black circle was changed to white to indicate the steamer the piermaster wished to berth first. If there were three steamers, the centre circle could also be used. The circles were changed by a simple system of pulleys inside the box.

Below: Kilcreggan saw a great increase in traffic in the 1970s and 1980s with the construction of the large Admiralty submarine base at Coulport, and regular calls were made by Caledonian MacBrayne ferries, such as *Arran*, seen here converted to stern loading between 1974 and 1979. Beyond Kilcreggan, at the seaward end of Loch Long, there was a pier at Cove, in use from 1852 to 1939.

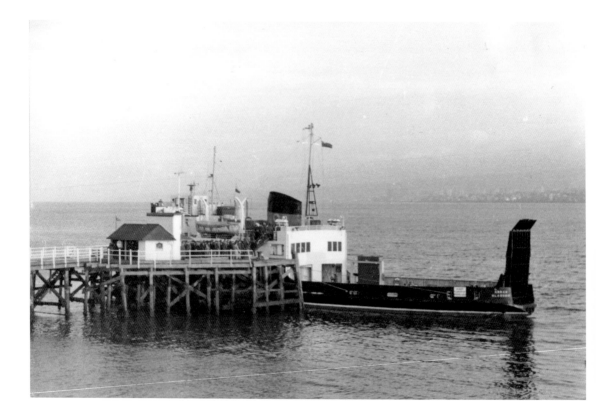

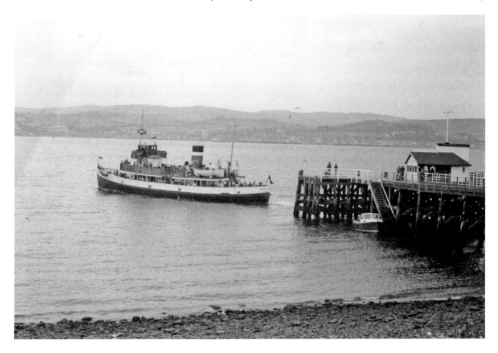

The motor vessel *Queen of Scots*, ex-*Bournemouth Queen*, departing Kilcreggan during the period in August 1977 when she was deputising for *Waverley* following the latter's grounding on the Gantocks.

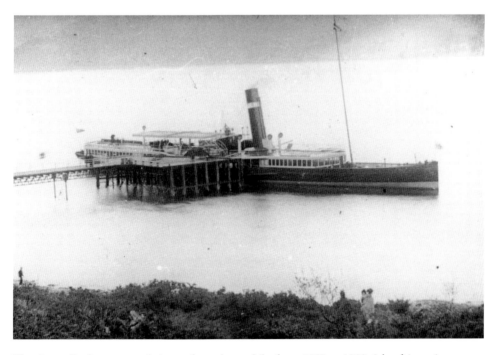

The pier at Coulport was only in use for a short while, from 1882 to 1900. *Isle of Arran* is seen here in what is the only known photograph of a steamer at the pier when she landed the Glasgow Orpheus Choir on an evening cruise for an open-air concert on the Braes of Coulport.

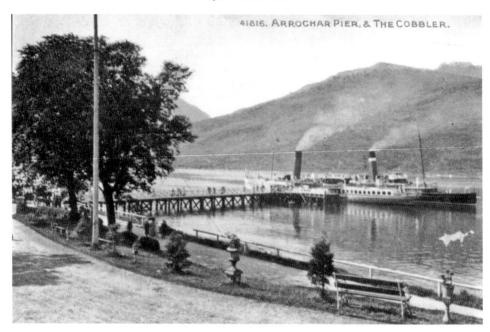

Arrochar Pier was built in 1850 and, from the 1890s to 1914, was the destination for steamers of all three railway companies, GSWR, CSP and NB. Here, the GSWR's *Mars*, on an excursion from Ayr, and the NBSP Co.'s *Marmion* can be seen at the pier in a postcard view, with the southern slopes of Ben Arthur (The Cobbler) in the background on the other side of the loch.

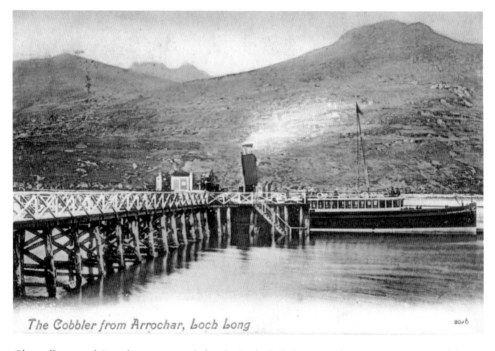

The Cobbler from Arrochar, Loch Long

Chancellor served Arrochar year-round, for the Loch Goil Company from 1885 to 1890 and for the GSWR from 1890 to 1900. She is seen here in a faked postcard, tinted with a Lochgoil hull and GSWR funnel.

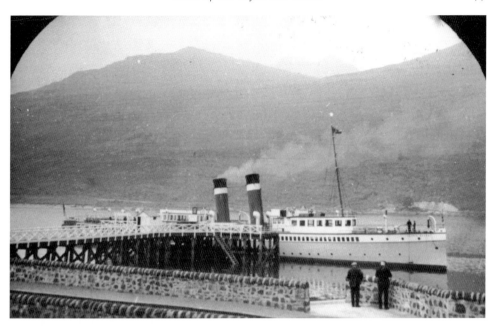

Jeanie Deans at Arrochar in her 1936-39 colour scheme with grey hull, probably in 1938 or 1939 when she was on the Lochgoilhead and Arrochar service.

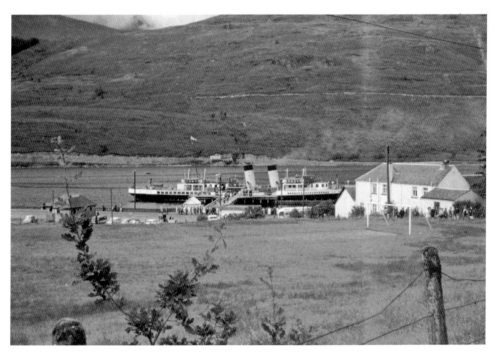

In the fifties and up to 1964, Arrochar was served three times a week in the summer, on a Tuesday and Thursday by *Jeanie Deans* or *Waverley*, and on a Saturday by a *Maid*. Passengers could walk or take a coach the couple of miles to Tarbet and get the Loch Lomond steamer *Maid of the Loch* to Balloch. This was known as the Three Lochs Tour, the third loch being Loch Goil. *Jeanie Deans* is seen here in 1964 from the road to Tarbet.

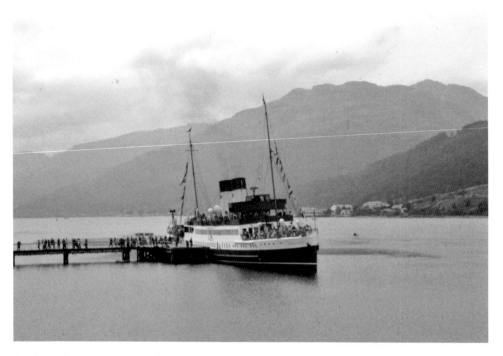

Duchess of Hamilton at Arrochar on 7 September 1968 on a Clyde River Steamer Club charter from Ayr, Troon, Largs and Gourock.

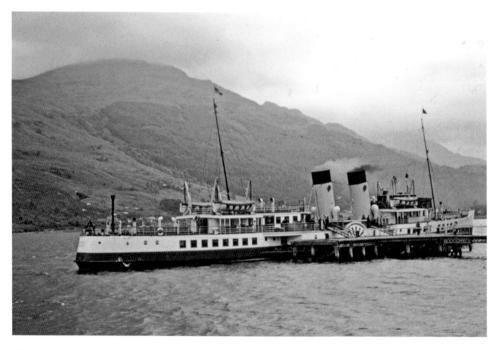

Waverley was the regular Arrochar steamer after the withdrawal of *Jeanie Deans* in 1964, and is seen here at Arrochar with a Monastral Blue hull and lions on the funnels between 1965 and 1969. Arrochar Pier was closed in 1972.

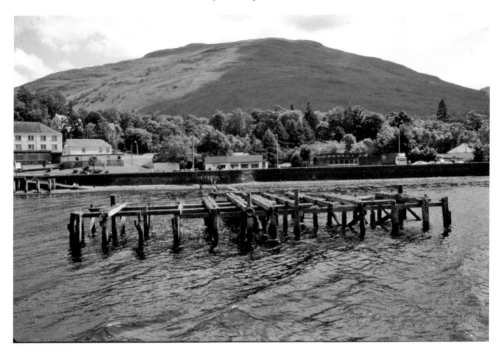

The remains of Arrochar Pier, seen from *Waverley* on a PSPS evening cruise in 2003. The Loch Lomond and Trossachs National Park Authority has plans to rebuild it for *Waverley* to call. With the hoped-for return to service of *Maid of the Loch*, this would enable the Three Lochs Tour to be reintroduced.

Across Loch Long from Arrochar was an Admiralty torpedo testing station at Succoth. After it came out of use, it was sold into private ownership and *Waverley* called on an occasion in 1996 on a cruise to celebrate the golden jubilee of her launch.

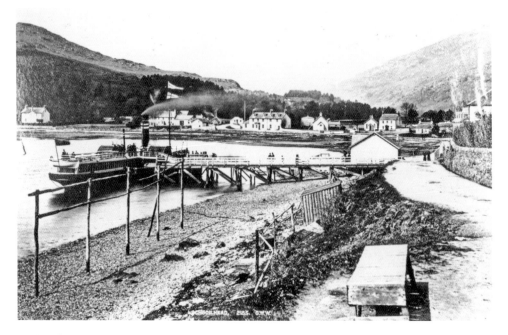

Lochgoilhead Pier was built in 1850. Until 1946, steamer was the only way to reach Lochgoilhead by public transport, and in the mid-nineteenth century, this was used as part of a route from Glasgow to Inveraray with coach and horses through Hell's Glen to St Catherine's and *Fairy* to Inveraray. The Loch Goil Company ran the service from Glasgow from 1825 until 1914, with two sailings daily up to 1900. Their *Windsor Castle* is seen at the pier in the 1890s.

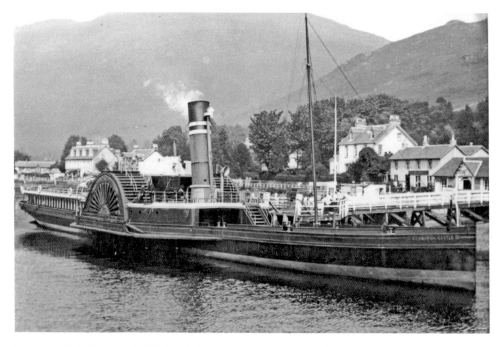

The Loch Goil Company's *Edinburgh Castle* at Lochgoilhead in the early 1900s. She operated on the route until 1913 and had the largest paddle boxes of any Clyde steamer.

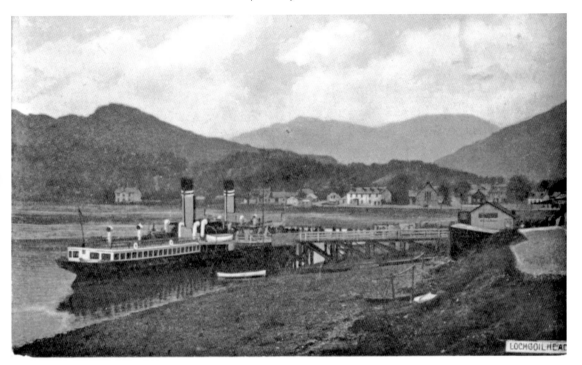

In 1910, the Loch Goil Company and the Inveraray Company merged, and in 1914, MacBrayne's took over the Lochgoilhead service, placing this postcard view of *Lord of the Isles* at Lochgoilhead between these dates.

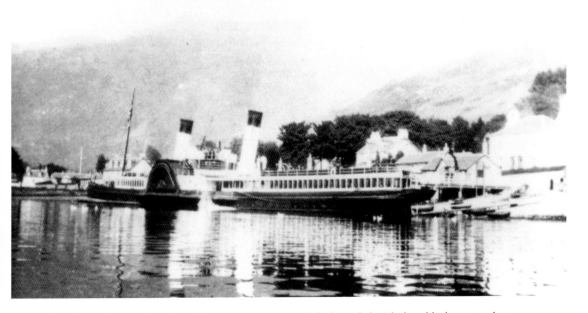

Ivanhoe at Lochgoilhead in 1912, the only year in which she sailed with deep black tops on her funnels.

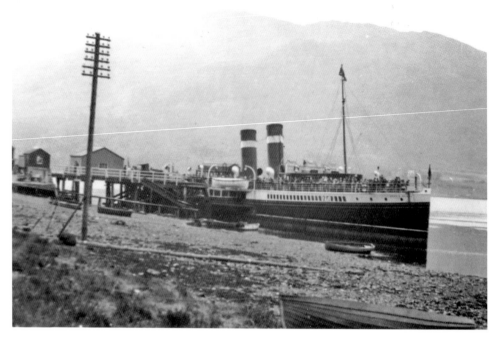

Jeanie Deans at Lochgoilhead between 1932 and 1935. At that time, she offered a Lochgoilhead and Arrochar cruise on Mondays. The year-round MacBrayne service to Lochgoilhead ceased in 1947, and the pier was used only by the summer excursion steamers following that year.

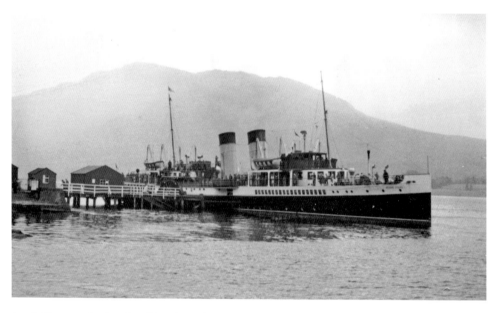

Jeanie Deans at Lochgoilhead in 1964. The pier was closed in July 1965 in mid-season, with the final call being made by *Maid of Skelmorlie*. A coach connection to Inveraray was marketed as a circular trip and named the Hell's Glen Tour, by steamer from Gourock to Inveraray, coach to Lochgoilhead and steamer back to Gourock.

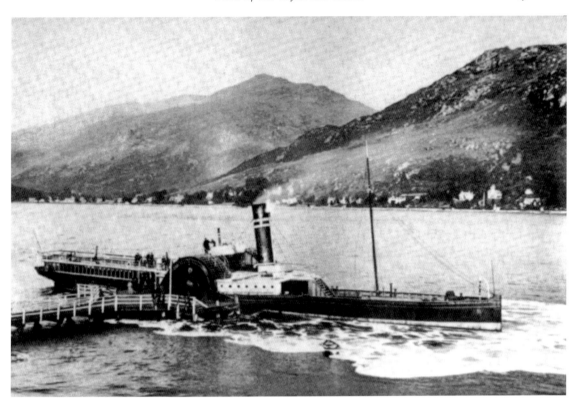

Above: Douglas Pier was on the west side of Loch Goil, near the head of the loch and was built probably in 1858-59 and closed in 1942. It did not serve a village, and traffic must have been sparse. *Edinburgh Castle* is seen there in this view.

Right: MacBrayne's *Iona* at Douglas Pier. *Iona* operated on the Lochgoilhead mail service from about 1920 until 1927. Douglas Pier was taken over by the Admiralty on closure for use in connection with submarine testing, and in October 1989, the car ferry *Pioneer* called with the Princess Royal on board. In 1997, *Waverley* called on a cruise to celebrate her fifty years in service.

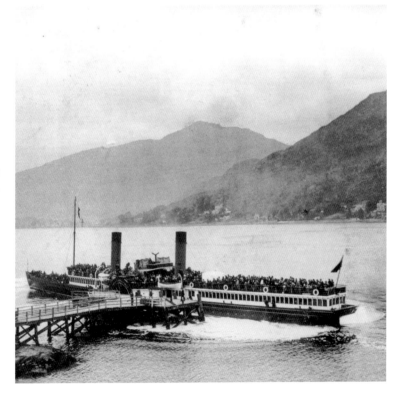

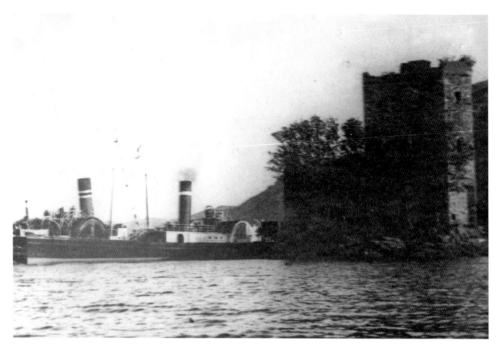

The village of Carrick Castle, near the foot of Loch Goil on the western shore, had a steamer pier from 1877 until 1955. Here, the Loch Goil steamer *Windsor Castle* and Williamson's *Benmore* can be seen at the pier below the castle in a view from 1896 or 1897.

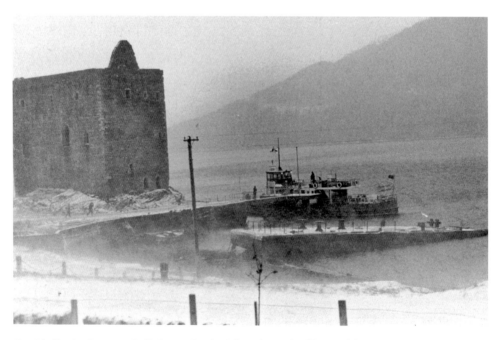

Carrick Castle pier was rebuilt for use by the Admiralty in the fifties and has occasionally been used by smaller vessels on charters, and by *Keppel* and *The Second Snark* in the eighties and nineties on cruising programmes. *Countess of Kempock* is seen here on a PSPS Christmas charter in a snowstorm on 30 December 1978. MV *Balmoral* has made several calls, the most recent being in 2005.

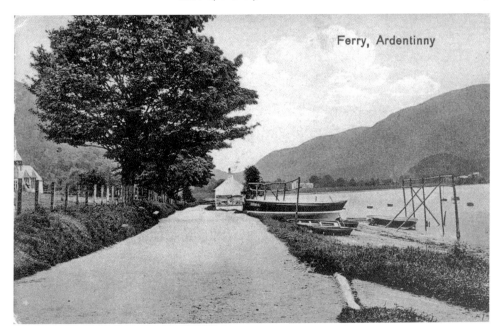

Ardentinny, on Loch Long, had a ferry call from the Loch Goil steamers until 1928, and also in 1936 for *Waverley*. The ferry, which also ran a service across the loch to Coulport, is seen here in a postcard view. Note the railway posters on the end wall of the house behind the ferry, which bears the number 313 R O.

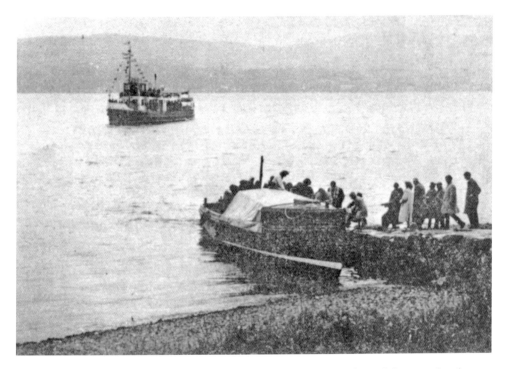

On 22 May 1965, on a Clyde River Steamer Club charter, *Countess of Breadalbane* made a ferry call at Ardentinny.

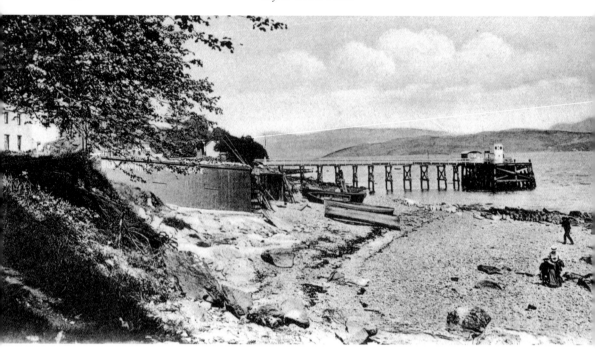

Blairmore Pier in the Edwardian era. Note the lady in all her finery on the beach with a small child. The pier was built in 1855 and was used by steamers on the Holy Loch service as well as by those on the Lochgoilhead and Arrochar run. The pier was closed in 1979 and was thence used for laying-up purposes, *Queen of Scots* lying there after withdrawal in 1980 until sold south a couple of years later, and Western Ferries vessels also berthing here when not in service. The condition of the pier subsequently deteriorated.

Opposite above: In 2004, the house by Blairmore Pier was purchased and the pier came included in the price. The new owner was anxious to repair the pier and Blairmore Pier Trust was established to repair and maintain it. It has since become a regular port of call for *Waverley*, seen there in 2006 with *Kenilworth*.

Opposite below: Strone, at the entrance to the Holy Loch, had a steamer pier in operation from 1847 to 1956. The stone throat of the pier has survived and has seen occasional use on enthusiast charters, as on this one by *Keppel* in 1992. Passenger disembarked and walked the couple of miles to Blairmore where they were picked up again.

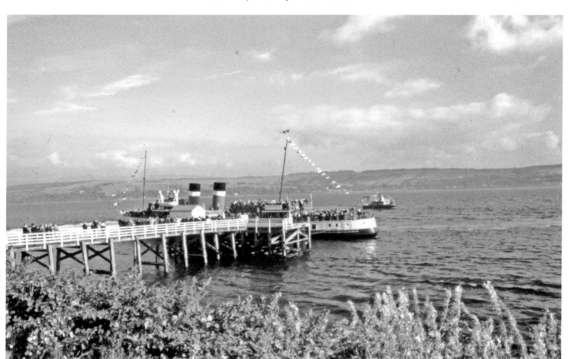

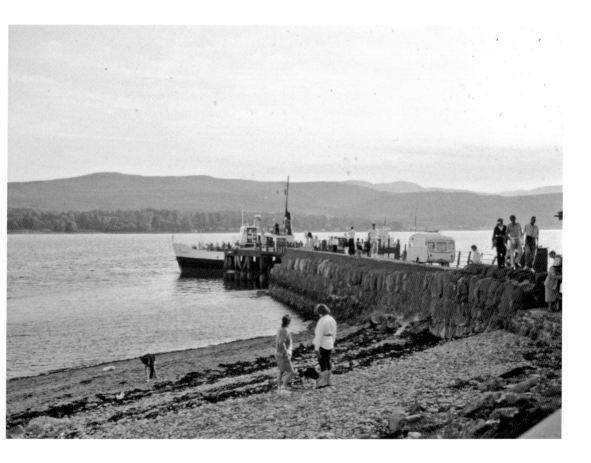

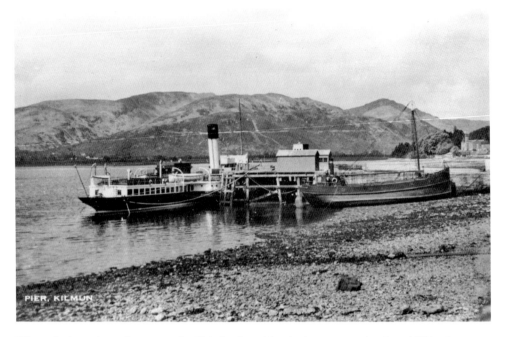

Kilmun is the main settlement on the Holy Loch and has had a steamer pier since 1827, when David Napier built the pier and ran a steam carriage from there to Loch Eck as part of a through route to Inveraray. All three railway companies offered a Holy Loch service, and the service was maintained, for most of the fifties and sixties by *Maid of Ashton*, until 1971. *Duchess of Fife* is seen here, in a postcard view from the 1930s.

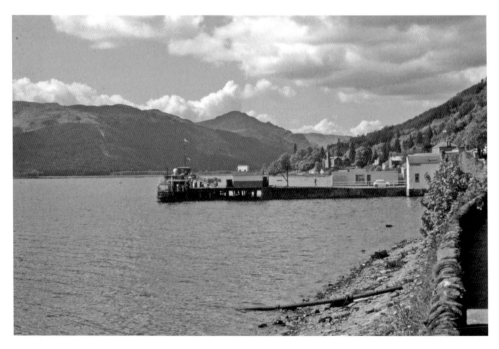

Countess of Breadalbane ran the Holy Loch service from 1967 to 1971. She is seen at Kilmun in her final week in service in May 1971.

Kilmun Pier has been used as a lay-up berth by Western Ferries. In this photo, their pioneer ferry *Sound of Islay* can be seen there.

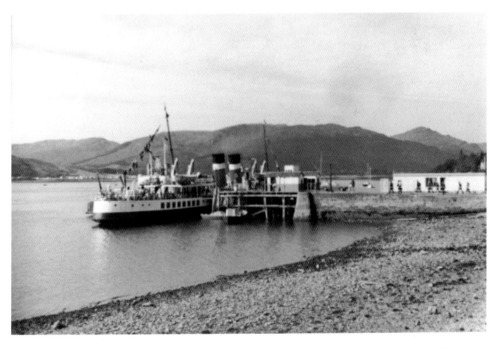

In September 1979, *Waverley* called at Kilmun on a PSPS charter. Western Ferries *Sound of Sanda* was laid up there at the time, and berthed outside *Waverley*.

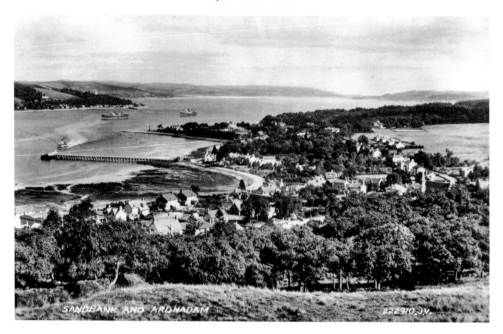

Ardnadam, on the south bank of the Holy Loch, had the longest pier in the upper firth. It is seen here in an early 1930s postcard with *Caledonia* approaching the pier and two cargo ships laid up at the entrance to the loch.

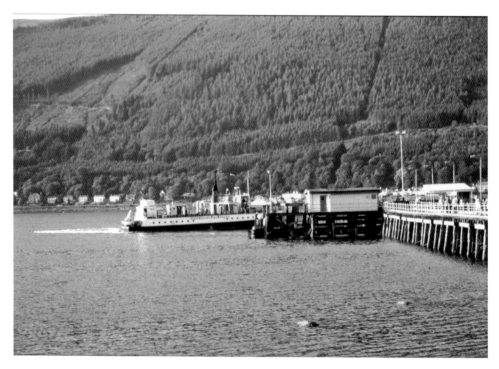

Ardnadam Pier survived after services there ceased in 1939 and was used for many years by the US Navy to serve the submarine base in the loch. Following their departure it returned to private ownership, and *Keppel* is seen here calling on an enthusiast charter in 1992.

6
Piers of Cowal

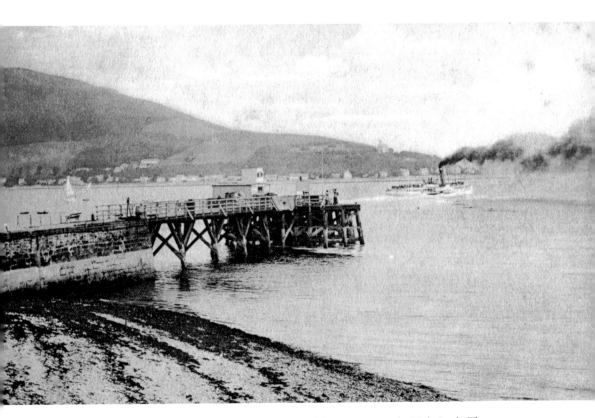

Hunter's Quay Pier is on the Cowal shore just south of the entrance to the Holy Loch. The original stone pier was built in 1828 and was replaced by a wooden pier in 1858, seen here in an Edwardian postcard view with one of the GSWR twins departing, either *Minerva* or *Glen Rosa*. It was served by the Holy Loch steamers and some of the Dunoon steamers.

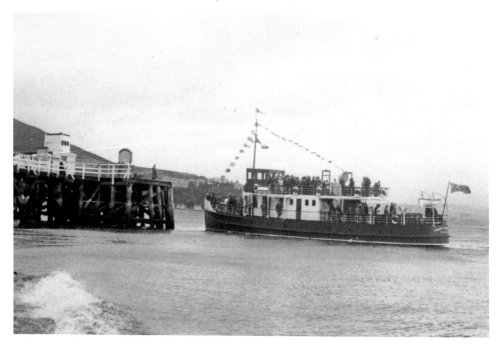

Hunter's Quay was closed in 1964. Here, on 20 May 1967, *Countess of Breadalbane* is approaching the pier on a Clyde River Steamer Club charter.

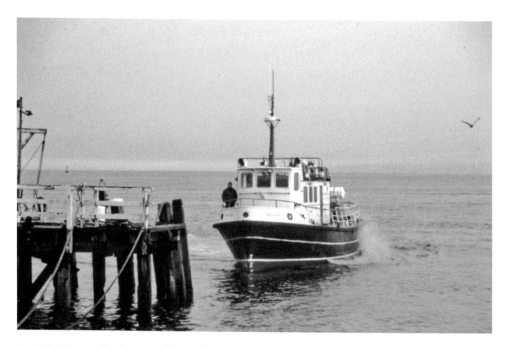

In 1971, Western Ferries opened a car ferry service to McInroy's Point from Hunter's Quay, which continues and thrives to this day, with a second ramp having been opened in recent years. The original pier survives, having been incorporated into the ferry terminal, and has seen only extremely occasional calls by passenger vessels, with Clyde Marine's *Rover* seen here approaching the pier in January 1999 on a Coastal Cruising Association charter.

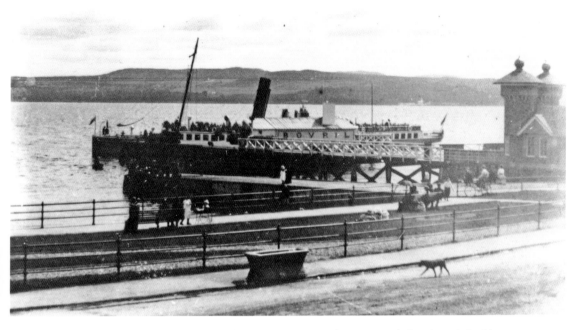

Kirn Pier, serving a northern suburb of Dunoon, was opened in 1845 and closed in 1963. *Glen Rosa* is seen there in a postcard view in GSWR days. Calls were made a few minutes before the call at Dunoon by many steamers, even the ABC car ferries in the fifties.

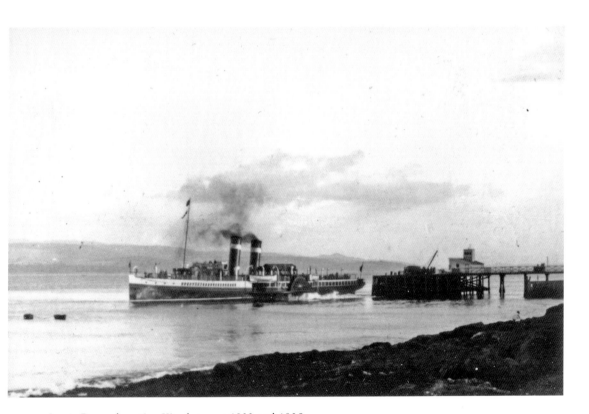

Jeanie Deans departing Kirn between 1932 and 1935.

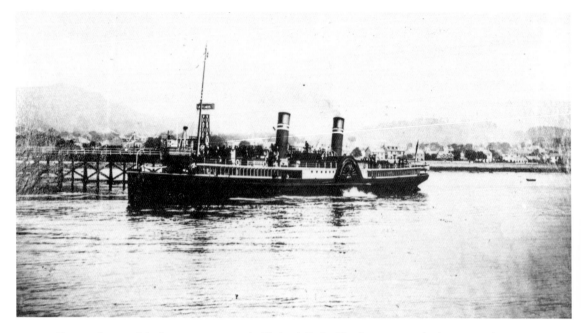

Dunoon is one of the largest resorts on the Firth of Clyde. The first pier was built in 1835, being replaced in 1867 and lengthened in 1881. This latter pier is seen here with the 1877 *Lord of the Isles*.

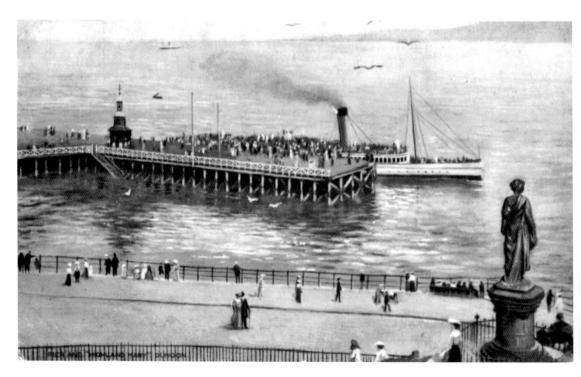

In 1897, the pier was extended southwards to form a double berth. This is a Tuck's Oilette postcard of the classic view of Dunoon Pier, with Highland Mary's statue, and one of the GSWR sisters, *Mercury* or *Neptune*, at the southern berth.

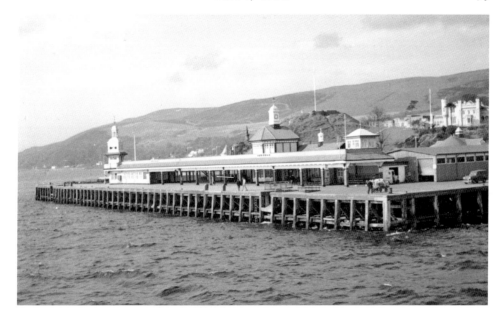

Dunoon Pier in the 1960s showing the full-length upper promenade, added in 1937, which gave marvellous views of arriving and departing steamers. This was removed around 1980 when the remainder of the pier buildings were refurbished. In recent years, the southern berth has fallen into disrepair and has been closed.

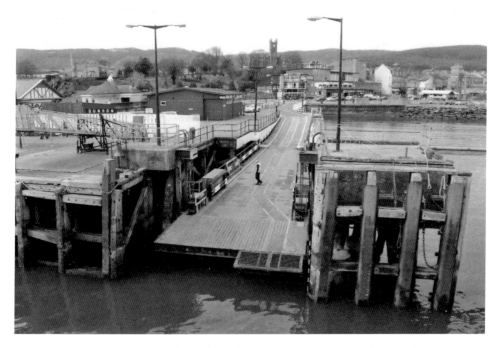

In 1972, a car ramp was erected along the north side of the pier. This was designed for ferries with a side ramp, *Jupiter*, *Juno* and *Saturn* having been the most frequently used over the years. It remains in use at the time of writing. The small extension at the bottom is used for berthing the small passenger catamaran *Ali Cat*.

A new breakwater-cum-pier was built in 2005 to the south of the existing pier with an end-loading linkspan inside it. This linkspan has never been used commercially, only for trial berthings, although the end of the pier has been used by *Waverley*, and the inside berth is now the favoured berth for this vessel.

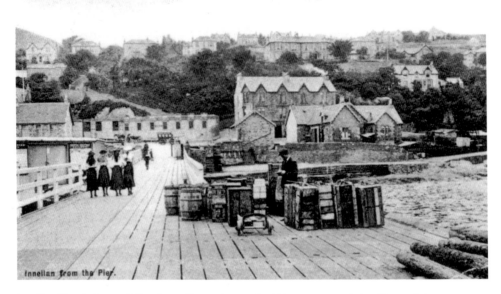

Innellan Pier, built in 1850, a few miles to the south of Dunoon, served the village of that name which grew up after the pier was opened. This is an Edwardian view of the pier, showing barrels and crates stowed on the pier, with a small hand trolley which would have been used to load them on the steamers.

1. Craigendoran in 1966, taken from the West Highland Railway, with *Caledonia*, *Waverley* and an unidentified *Maid* at the pier. By this time, *Caledonia*'s sailings from Ayr had ceased and she was based at Craigendoran.

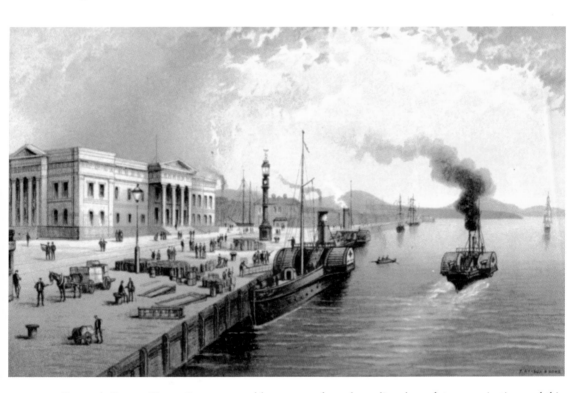

2. Greenock Custom House Quay was used by steamers from the earliest days of steam navigation, and this undated engraving shows two steamers at the pier and one passing in the river. None can be identified, and they may just be the product of the artist's imagination. This dates from after 1868 when the clock was erected.

Left: 3. A view of Gourock Pier from 1968 with *Countess of Breadalbane*, *Lochfyne* and *Duchess of Hamilton*.

Below: 4. Paddle Steamer *Caledonia* and car ferry *Arran* at Gourock on 1969, taken from a departing steamer.

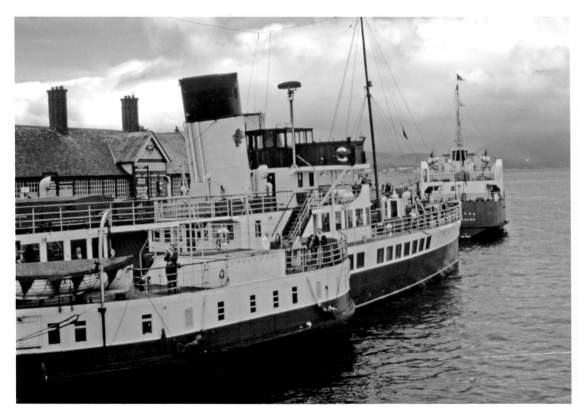

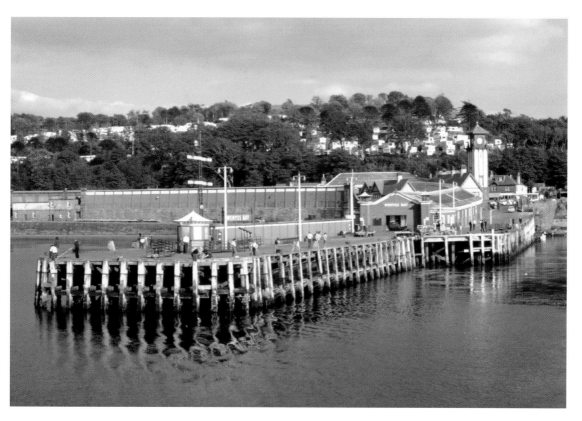

5. Wemyss Bay in 1972, before the pier was truncated. Note the semaphore signalling arms for the steamers. A fire in 1977 caused a large portion of the outer end of the pier to be removed.

6. *Waverley* berthed at Largs Pier, showing *Waverley* in post-rebuild condition and the pier in pre-rebuild condition.

The Slip, Largs Bay.

551/47

7. Small motor boats have for many years operated from a small jetty to the north of Largs Pier. In this Edwardian postcard view, a small steam launch can be seen.

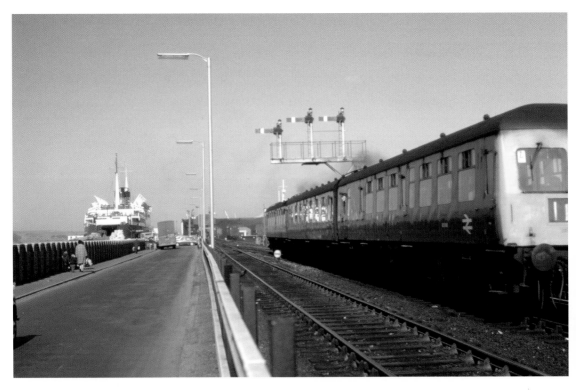

8. Stranraer had a long pier, with Stranraer Harbour station at the end of it. This 1969 view shows a train departing for Ayr and Glasgow and the steam turbine car ferry *Caledonian Princess* at the roll-on roll-off berth. Nowadays, the area to the left of the photo has been filled in to provide two new ro-ro berths.

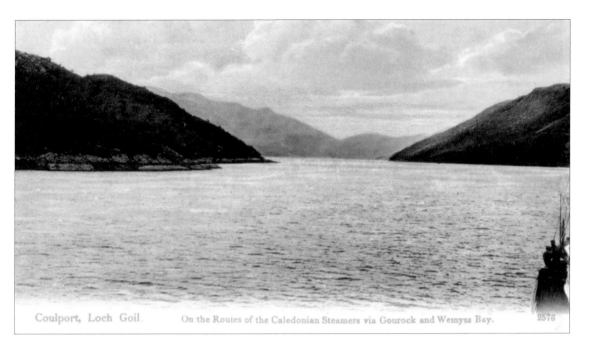

Coulport, Loch Goil. On the Routes of the Caledonian Steamers via Gourock and Wemyss Bay. 2576

9. A view up Loch Long from Coulport in a Caledonian Steam Packet Co. official postcard, with the fragment of a bow of a steamer to the right. Not much further up the loch, a ferry call was made at Portincaple, used by the NB's *Lady Rowena* from 1897 to 1903 as part of a circular tour, retuning from Whistlefield station by the West Highland Railway.

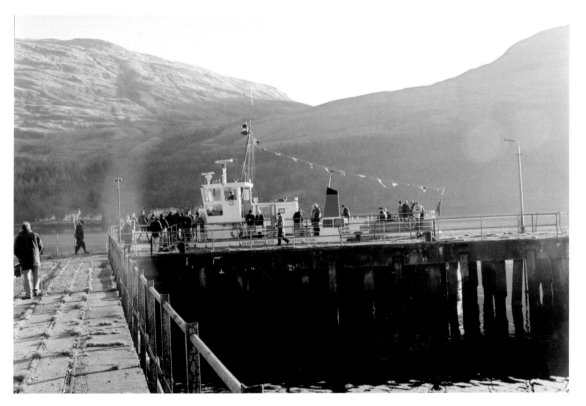

10. Clyde Marine's *Cruiser* at Succoth, showing the poor condition of the disused pier. Regular sailings could not be operated to here on health and safety grounds. This was to be the final occasion that permission was granted for a call by an enthusiast charter.

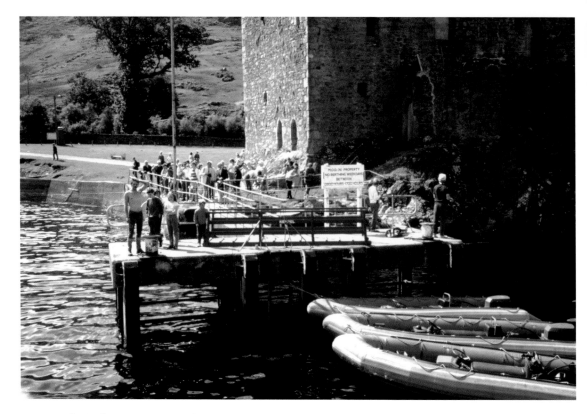

11. Carrick Castle jetty in 1986 with a *Keppel* gangway across the end.

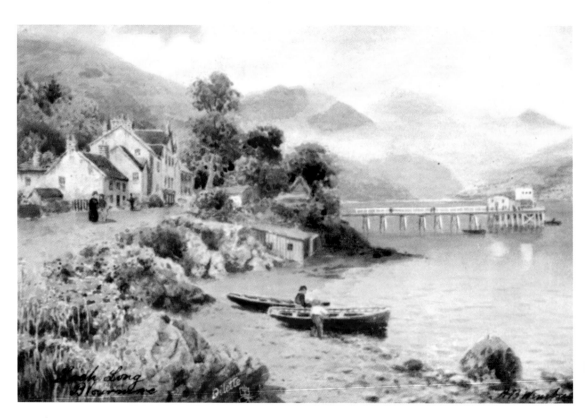

12. Blairmore Pier in Edwardian times on a Tuck's Oilette postcard.

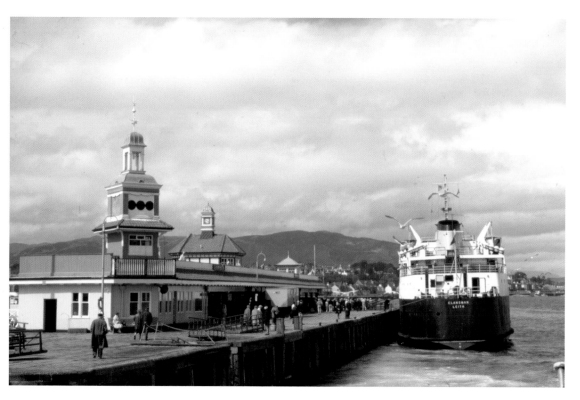

13. From the advent of the ABC car ferries in 1954, Dunoon Pier was used for loading cars, as seen here in 1970 with the chartered *Clansman* in CSP colours.

14. The year 1990 saw a unique visit by *Balmoral* to Ormidale, the only large ship call there since 1939.

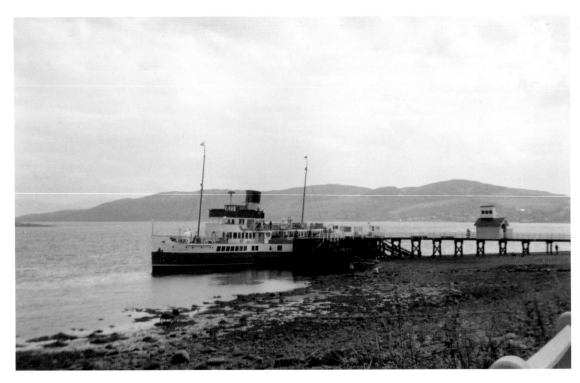

15. *Caledonia* in her Monastral Blue hull colours between 1965 and 1969, at Tighnabruaich Pier, from the eastern side, a less-often-photographed location.

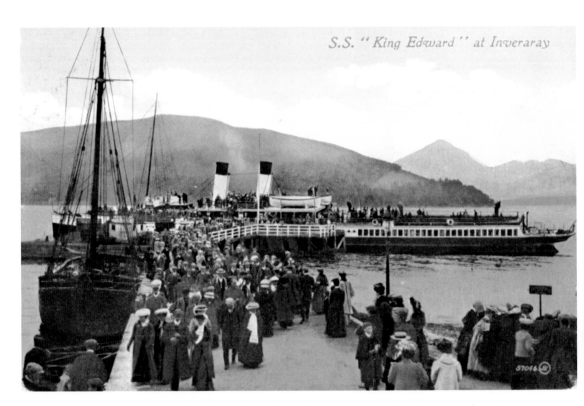

S.S. " King Edward " at Inveraray

16. In 1903, the turbine steamer *King Edward* started running to Inveraray, where she is seen here in a postcard view taken after 1906. Regular calls at the pier ceased in 1973 with the increase in oil prices meaning that the long day excursion were no longer viable.

17. *King George V* operated the Inveraray and Campbeltown services from September 1926 until sold to David MacBrayne after the 1935 season. On 19 May 1973, she returned to Inveraray on a Clyde River Steamer Club charter, as seen here.

18. On 5 September 1970, *Duchess of Hamilton*, in her final month in service, visited Ardrishaig on a Clyde River Steamer Club excursion from Ayr, Millport, Keppel Pier and Largs.

Left: 19. *Waverley* on one of her very occasional visits to Ardrishaig in spring 1996, on a sailing to celebrate the sixtieth anniversary of the entry into service of turbine steamer *Marchioness of Graham.*

Below: 20. *Waverley*, on the same occasion, seen from the Crinan Canal lock. Steamer calls at Ardrishaig have not taken place in recent years because the pier is used extensively commercially for loading timber into coasters.

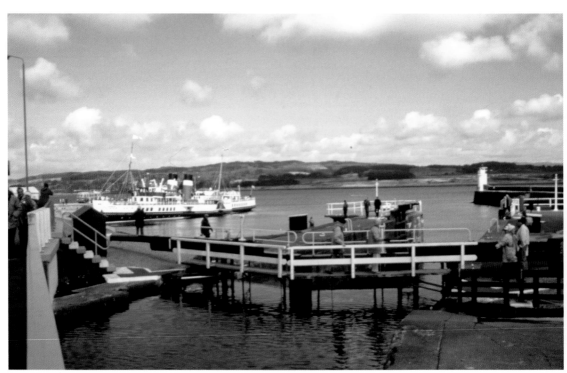

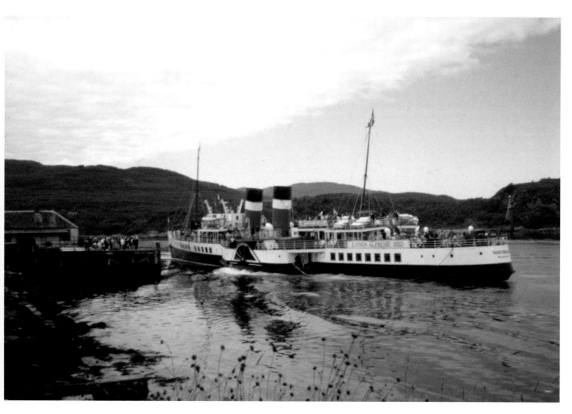

21. *Waverley* has offered a service from Ayr to Tarbert on Tuesdays in the summer season since 1975 and is seen here approaching the pier in the early 1980s.

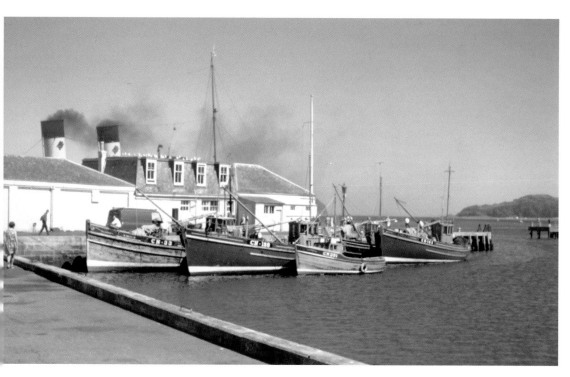

22. *Duchess of Hamilton*'s mast and funnels peeping above the pier building at Campbeltown in 1966, with a group of fishing boats at the nearer side of the pier.

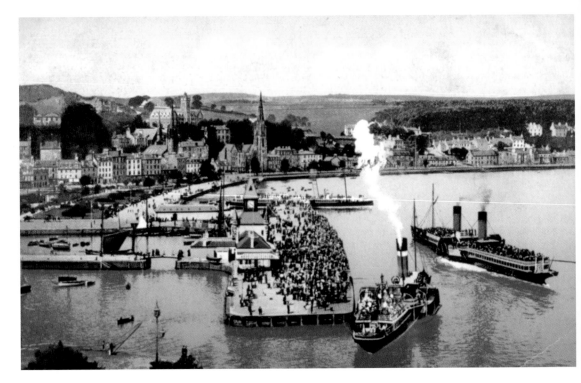

23. *Columba* arriving at Rothesay, while the NB steamer *Kenilworth* is departing and the CSP steamer *Marchioness of Breadalbane* is berthed across the west end of the pier and large crowds throng the front of the pier in this Edwardian postcard view.

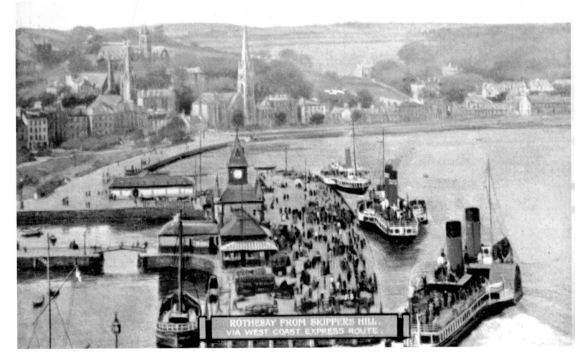

24. A London & North Western Railway official postcard, showing *Columba* and *Lord of the Isles* at Rothesay with the CSP paddler *Marchioness of Lorne* at the west end. The inscription at the bottom reads, 'Rothesay from Skippers Hill –Via West Coast Express route.'

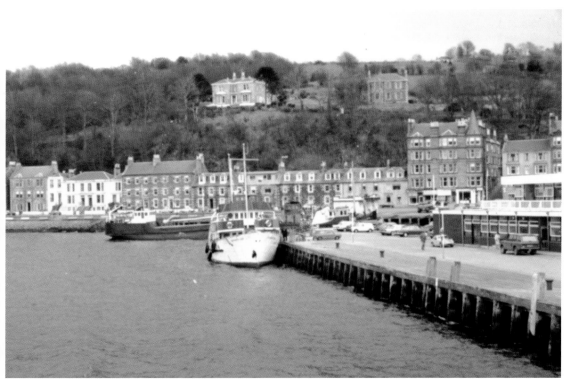

25. *Bournemouth Queen*, which was then operating a workmen's service to Ardyne, at Rothesay Pier in 1974, with a coaster and tug at the Albert Pier behind.

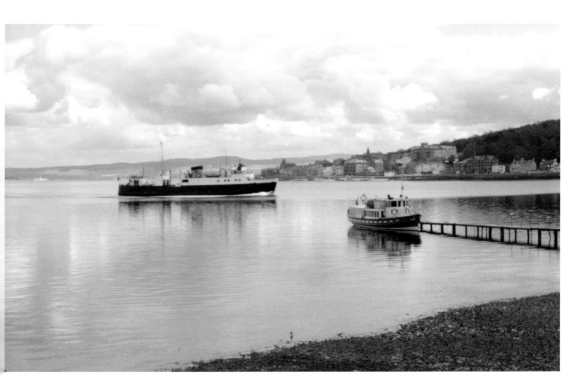

26. To the left (west) of Rothesay Pier was a small jetty known as McIver's Slip, used by the small excursion vessel *Gay Queen* from 1938 to 1983, which is seen there in 1975 with the car ferry *Cowal* passing in the background.

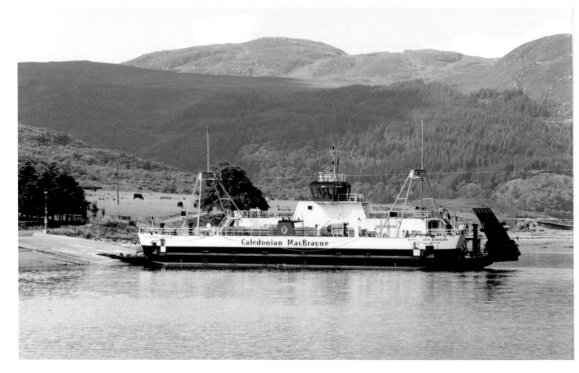

27. *Loch Dunvegan*, in use since 2000 on the Colintraive–Rhubodach service, seen at the Bute slipway at Rhubodach.

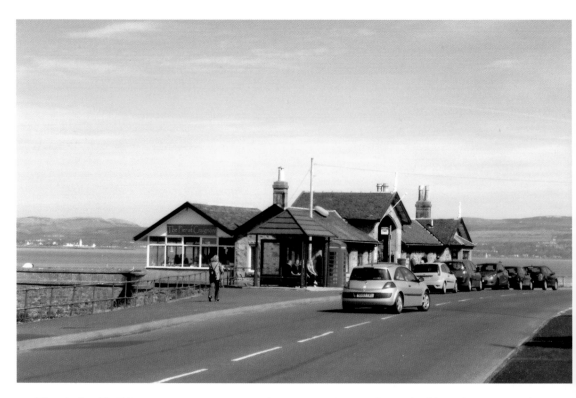

28. The pier head buildings at Craigmore remain and are now used as a café. South of here, the Marquis of Bute had a small private pier at Kerrycroy to serve his mansion at Mount Stuart, but this has only once seen a public call, on an enthusiast charter of *The Second Snark*.

29. Approaching Millport (Old) Pier on 5 September 1970 from *Duchess of Hamilton*. The pier was known as Millport (Old) to distinguish it from Keppel Pier.

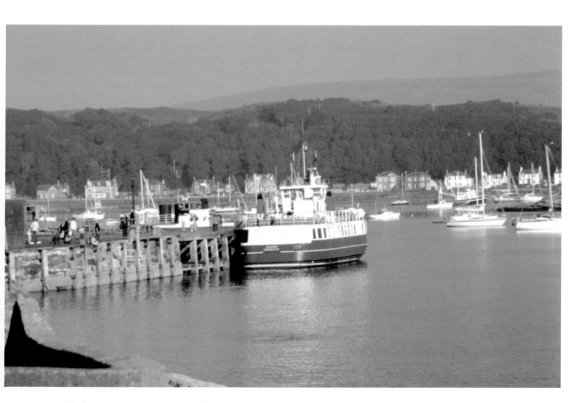

30. Clyde Marine's *Cruiser* at Millport in 2002.

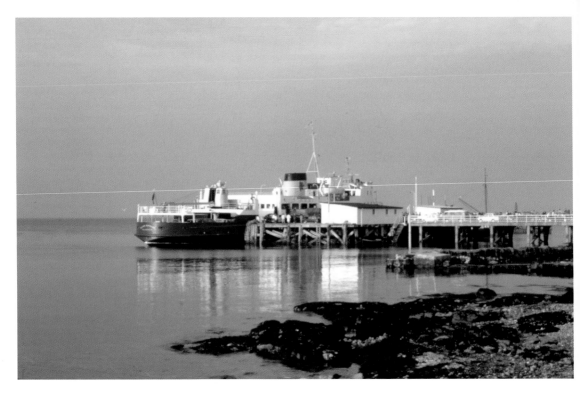

31. Brodick Pier in 1969 with the car ferry *Glen Sannox* in her penultimate year serving the island and prior to major rebuilding work for the ro-ro era and the introduction of MV *Caledonia*.

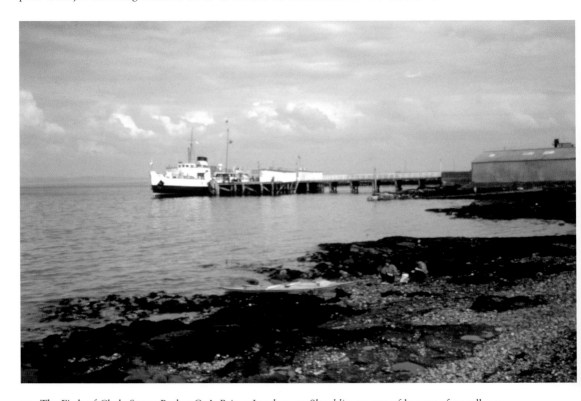

32. The Firth of Clyde Steam Packet Co.'s *Prince Ivanhoe*, ex-*Shanklin*, on one of her very few calls at Brodick in her short Clyde career in 1981. The pier and foreshore have changed out of all recognition since the 1980s, firstly for the introduction of MV *Isle of Arran* in 1984 and later for MV *Caledonian Isles* in 1993.

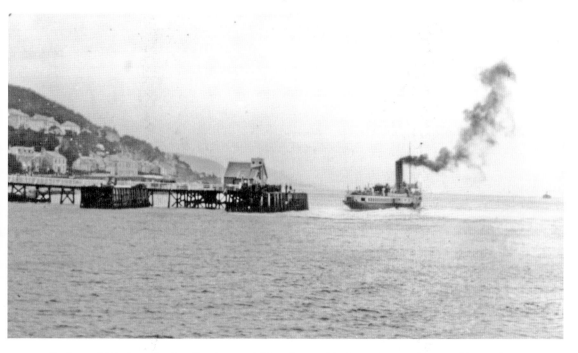

Duchess of Fife departing Innellan in post-1923 colours with *Queen Empress* approaching in the distance. Innellan was served by steamers from the upper firth for Rothesay and also by a service from Wemyss Bay.

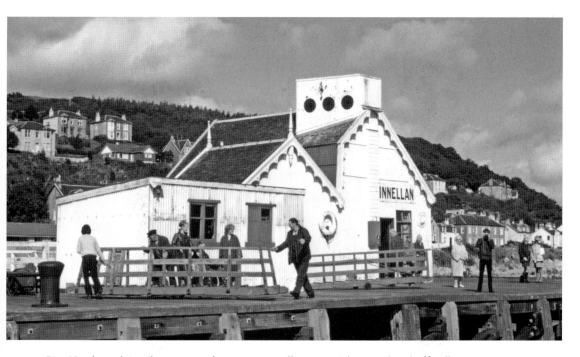

Pier Hands readying the gangway for a steamer call in 1970. The pier closed officially in 1972, with the final call being made by *Waverley*.

Innellan Pier opened again for a few months in 1974 for the use of workers at the oil rig construction yard at Ardyne. A few years later, in 1983, a PSPS evening charter of *The Second Snark* called, and by that time, a number of the pier timbers were missing, and the gates at the shore end were locked. Wood from the pier was used to rebuild Berry's Pier on Loch Striven in the nineties.

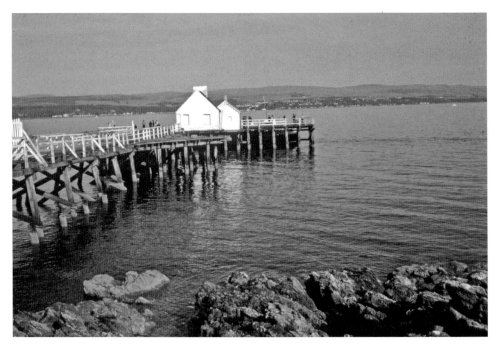

Innellan pier from the shore end with *The Second Snark* berthed on a PSPS evening charter on the same occasion. By this time, the pier was in poor condition with a number of planks missing and others loose.

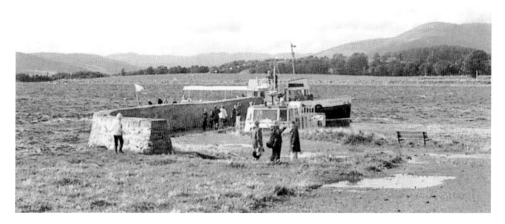

Toward Pier, south of Innellan, was in use from 1863 to 1922, and was on the Firth side of Toward Point. Round the corner was Toward Castle Pier, a small stone erection that never saw regular steamer calls. Donald Robertson recalled it being used in the 1930s by *Gay Queen* as part of the return journey from a Rothesay to Dunoon excursion for a football match. On 10 September 1994, it was used on a Clyde River Steamer Club charter of *The Second Snark*.

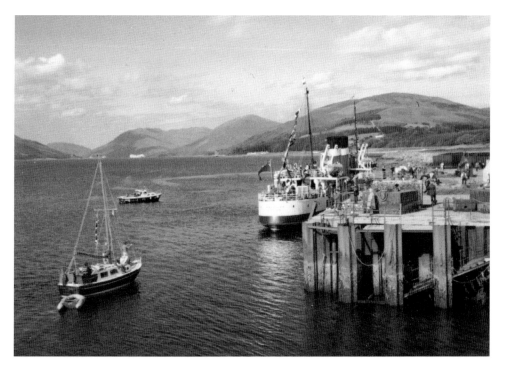

An oil rig construction was established at Ardyne opposite Rothesay in 1974 by Sir Robert McAlpine & Co., who purchased the motor vessel *Bournemouth Queen*, renamed *Queen of Scots*, in the following year, to offer a service for workers there from Rothesay. This service continued until June 1977. Various early CalMac car ferries took workers here from Wemyss Bay and Innellan in the mid-1970s. This shows *Waverley* in September 1979 on a PSPS charter.

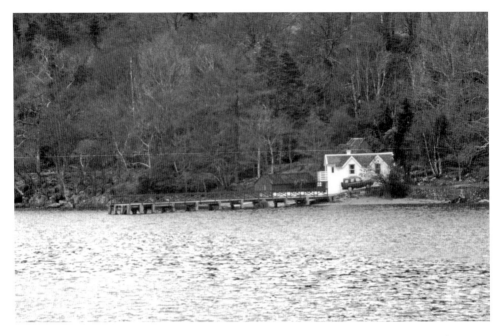

A small pier known as Berry's Pier existed on Loch Striven prior to 1914 in the grounds of
Glenstriven House. It was an occasional destination for excursions and evening cruises. In the late
1990s, the owner of the land purchased some old timbers from Innellan Pier and built a small pier
on the site of the old one.

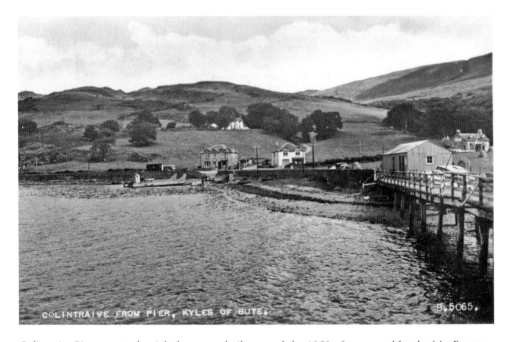

Colintraive Pier, seen to the right here, was built around the 1850s. It was used by the MacBrayne
streamers for Tarbert and Ardrishaig and was closed after the 1946 summer. In 1950, a car ferry
service to Rhubodach on Bute was introduced by the four-car ferry *Eilean Mor*, seen in the left
background.

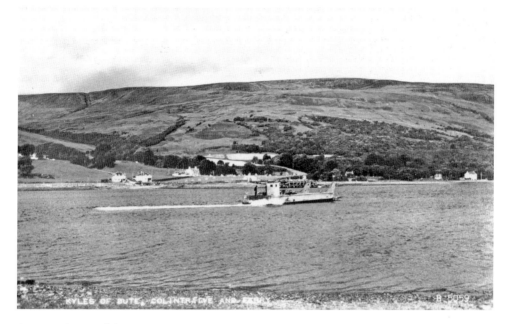

A postcard view of the Colintraive-Rhubodach ferry *Eilean Mor* in mid-crossing, taken between 1950 and 1954. Colintraive Pier is still standing in the background.

In 1970, the Caledonian Steam Packet Co. took over the crossing and introduced the former Kyle-Kyleakin ferries *Portree* and *Broadford*. This view shows Colintraive in 1987 with Caledonian MacBrayne's twelve-car *Loch Ranza*. Traffic has increased exponentially and the route is now operated by the thirty-six-car *Loch Dunvegan*.

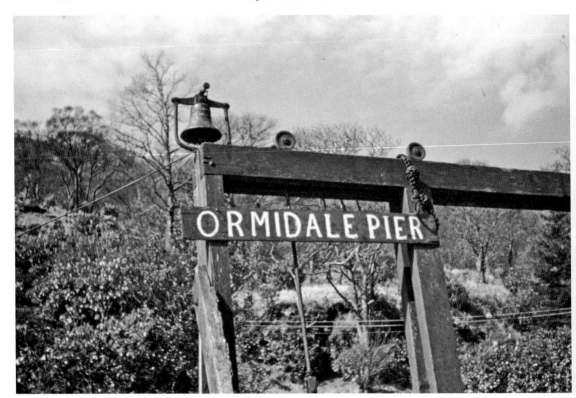

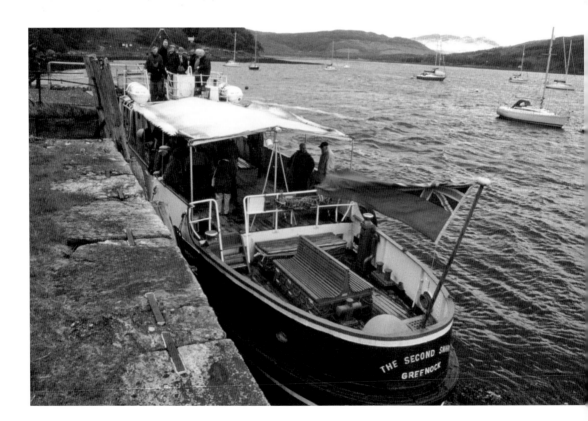

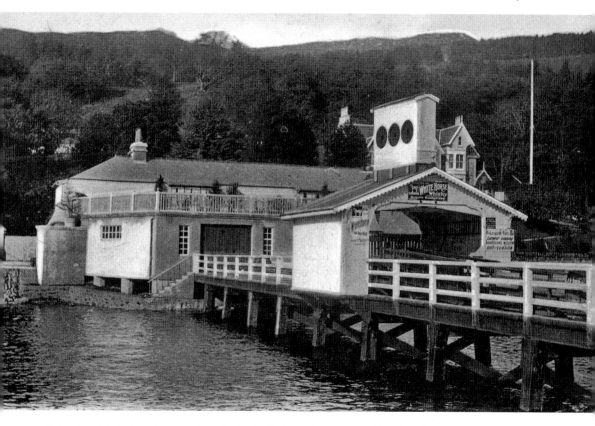

Tighnabruaich is the only surviving pier in the Kyles of Bute area and has long been a popular
destination for excursion sailings, still being served by *Waverley* each Tuesday and Saturday in July
and August. This Edwardian postcard is entitled 'Tea Gardens' rather than pier, the balcony over
the entrance having been used as a tea garden. The original pier had been built around 1857 and
rebuilt in 1885.

Opposite above: A pier was in use at Ormidale on Loch Riddon from 1856 until 1939. It is a very
remote location, with one house at the pier, and served the community in Glendaruel to the north.
In the 1970s, the pier sign and bell were still in situ.

Opposite below: Ormidale has seen occasional calls over the years by enthusiast charters, such as
this one by *The Second Snark* in 2003.

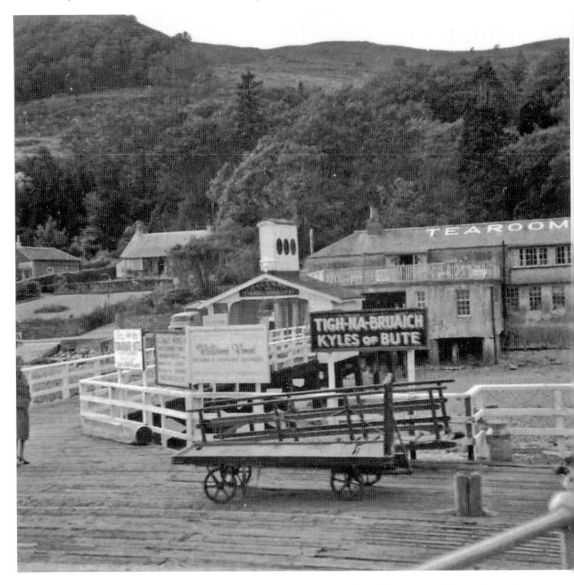

By the early 1960s, little had changed, the shelter over the middle of the pier, used for issuing pier due tickets, with the pier indicator above, was still there, and the area above the entrance was still used as a tearoom.

Opposite above: Queen Mary II at Tighnabruaich in 1973 from the road leading from the pier to the village, a location that has seen countless thousands of photographs taken of *Waverley* and other steamers over the years.

Opposite below: The Tighnabruaich Pier Association has taken over the task of fund-raising for necessary repairs and improvements to the pier in recent years, and the pier sign has been repainted in traditional style.

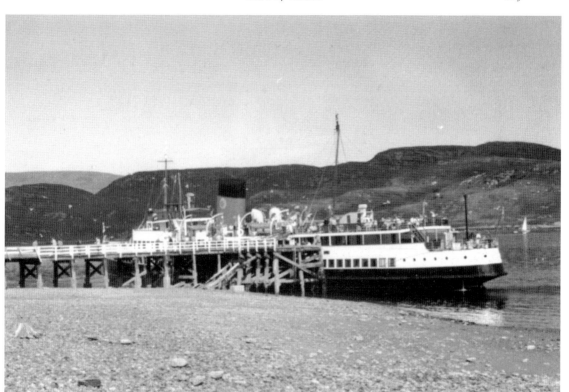

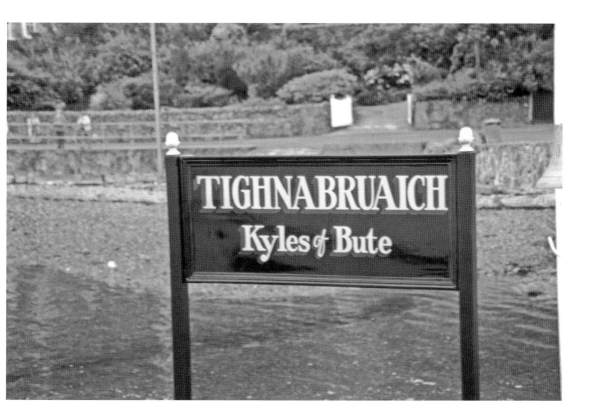

Auchenlochan, a mile or so south of Tighnabruaich, had an iron pier built in 1878 and closed in 1948. The excursion steamer *Victoria* is seen here at the pier with a couple of ladies posing for the photo in their finery in 1897 or 1898.

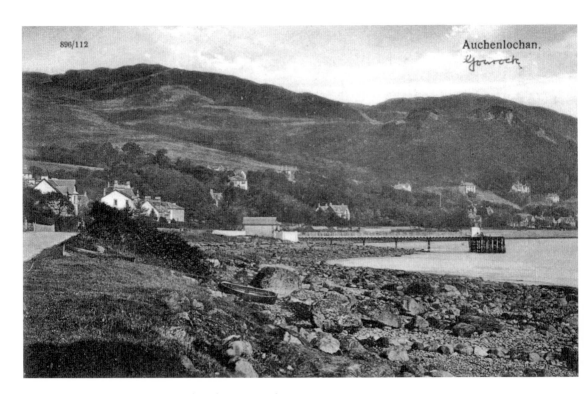

Auchenlochan Pier in an Edwardian postcard view.

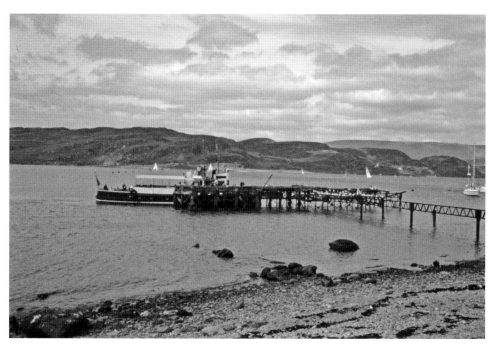

The skeleton of Auchenlochan pier survived until the 1990s, when *The Second Snark* is seen posing alongside. One foolhardy individual made his way ashore along that single girder. The vessel had deposited passengers at Kames Coal Pier and would collect them at Tighnabruaich.

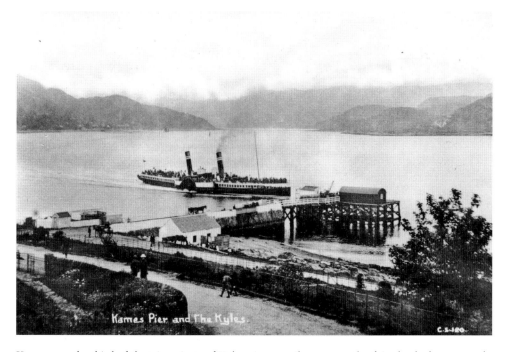

Kames was the third of the triumvirate of Kyles piers, a mile or so south of Auchenlochan, opened in 1856. It is seen here with the second *Lord of the Isles* approaching. The pier was in use until 1928.

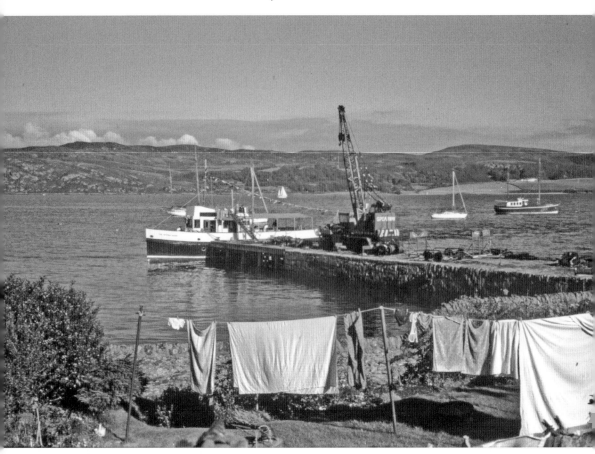

Kames also had a stone pier, known as the Coal Pier or Spearman's Wharf, and possibly originally built for the Kames Gunpowder works in 1839. *The Second Snark* is seen here in a charter in September 1984.

7
Piers of Loch Fyne and Kintyre

In the 1980s, an abortive oil rig platform yard was established at Portavadie. This never produced a single platform, and a slipway was established at Portavadie for a car ferry service across Loch Fyne to Tarbert in 1994. *Loch Linnhe* is seen here at Portavadie in 2003.

Further up Loch Fyne is Otter Ferry, where a pier was built in 1900 and used initially by the Inveraray steamer *Lord of the Isles*, but calls ceased after four years. MacBrayne's *Columba*, for one season in 1903, and then *Iona* until 1914 made trips there during their lay-over time at Ardrishaig. After 1914, the pier was only used for cargo steamers until closed in 1948, and still survives, although in poor condition. At Easter 1993, *Waverley* made a unique call, only possible because Captain Steve Michel repaired it sufficiently for passengers to get ashore, using planks he had purchased himself.

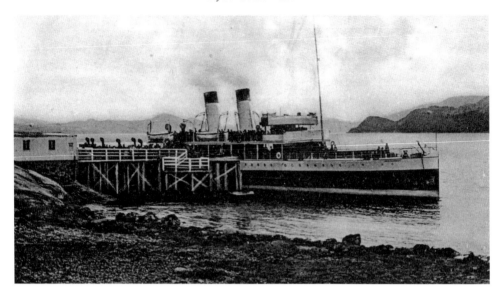

Strachur, further up the eastern shore of Loch Fyne, where the road from Dunoon joins the loch, had a pier that was opened when the first *Lord of the Isles* entered service in 1877. It was used for the Loch Eck Tour, which involved passengers sailing from Glasgow to Dunoon or Kilmun, and then taking a coach to the south end of Loch Eck, the little steamer *Fairy Queen* to the other end of the Loch, a coach to Strachur, and *Lord of the Isles* to Inveraray and back to Glasgow. When *Fairy Queen* was withdrawn after the 1926 season, a motor bus ran from Dunoon to Inveraray, and Strachur Pier was closed, reopening from 1929 to 1935. From 1920 to 1926, the Inveraray steamer was *Queen Alexandra*, seen here at the pier post-1920.

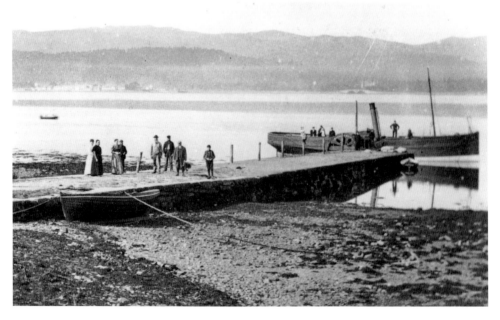

St Catherine's had a steam ferry service to Inveraray, connecting with a coach from Lochgoilhead, from 1865 until 1912 with two successive small paddle steamers named *Fairy*. This is the second *Fairy*, built in 1894, at St Catherine's.

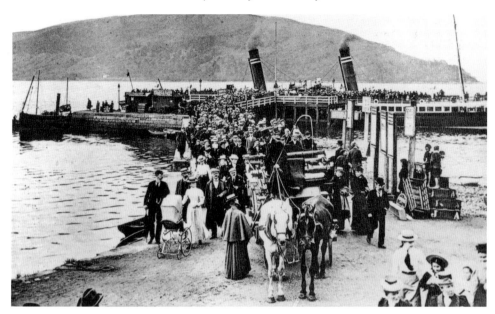

Inveraray had a stone jetty built in 1821 for the early steamers, and a T-shaped wooden pier added to the end for the introduction of service by the first *Lord of the Isles* in 1877. The second *Lord of the Isles* is seen here disembarking a large number of passengers in the early years of the twentieth century with *Fairy* at the left-hand corner of the old stone pier.

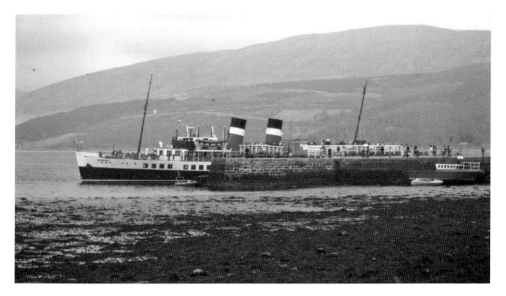

Waverley has made very occasional sailings to Inveraray in WSN ownership, and is seen there in May 1990. Down the west side of Loch Fyne, there was a pier at Crarae, in use from 1880 to 1933, with occasional calls continuing for another five years, and cargo steamer calls until about 1948. There were also piers, used by cargo steamers, at Furnace, north of Crarae, and Minard and Loch Gair south of there. On 25 September 1886, a number of passengers disembarked from *Lord of the Isles* at Crarae in order to see a spectacular blast at the nearby quarry. When she called on her return from Inveraray, many of those passengers had been poisoned and seven killed by poisonous gas from the blast.

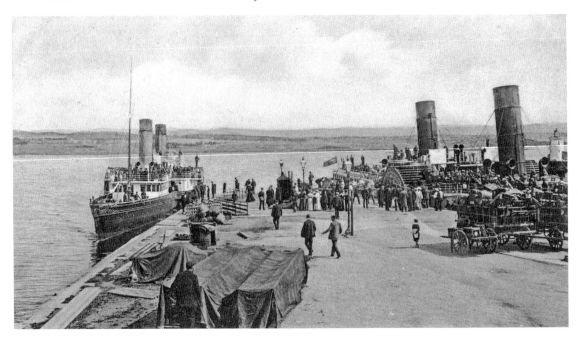

Ardrishaig is situated at the western end of the Crinan Canal and was the destination of the Clyde section of the Royal Route service from Glasgow by MacBrayne and, before them, Hutcheson and G. & J. Burns, from as early as 1817. In this postcard view, *Columba* is seen having recently arrived at the pier, and *Iona* is approaching the pier, probably on the supplementary service from Wemyss Bay between 1904 and 1914.

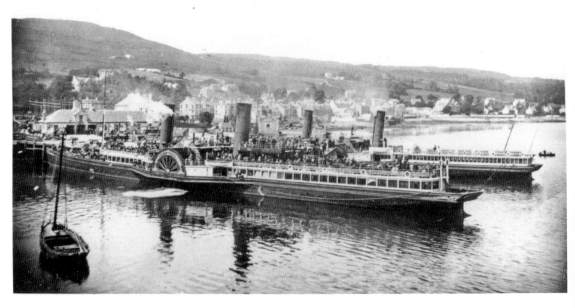

Columba and *Iona* berthed at Ardrishaig. The service further north on the Royal Route continued with the small *Linnet* on the Crinan Canal to Crinan and then the paddle steamer *Chevalier* to Oban and Fort William.

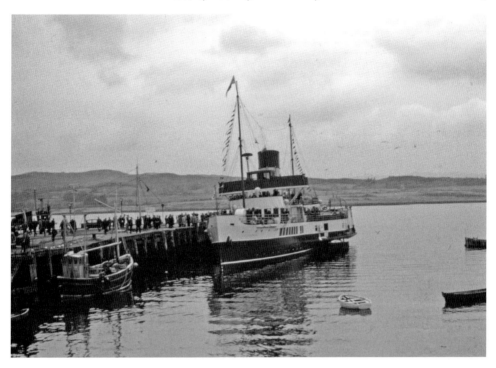

MacBrayne's mail service to Ardrishaig continued until 1969, from 1937 with *Saint Columba*, and from 1959 with *Lochfyne*. *Caledonia* is seen there on 4 May 1968 on a Clyde River Steamer Club charter from Gourock to Inveraray and a cruise to Dunderave Castle.

Duchess of Hamilton, on the same occasion, glimpsed between the classic MacBrayne buildings as returning passengers scurry back to the steamer.

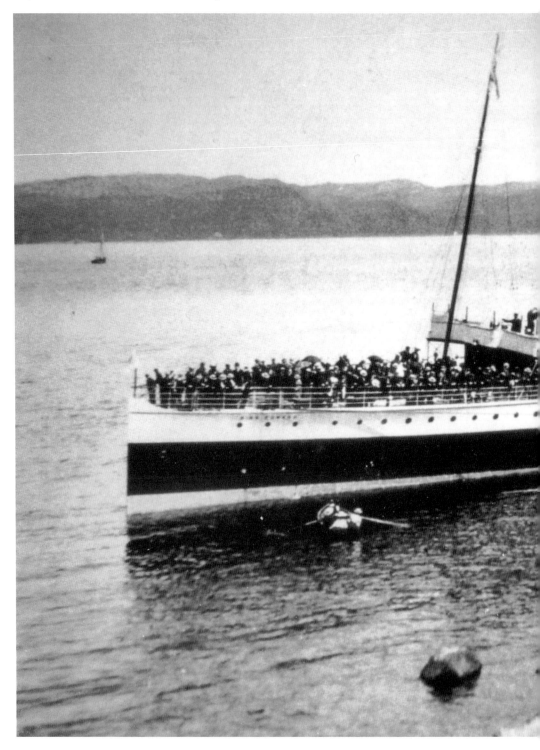

Tarbert Pier was built in 1879, the year after *Columba* entered service, replacing a smaller pier built in 1866, which was too small for *Columba*. Steamers had previously berthed in the inner harbour since 1815. The pioneer turbine *King Edward* is seen there in 1902, the only year she called there, when she operated on an Ardrishaig service in competition with *Columba*. This emphasises the primitive nature of the early pier.

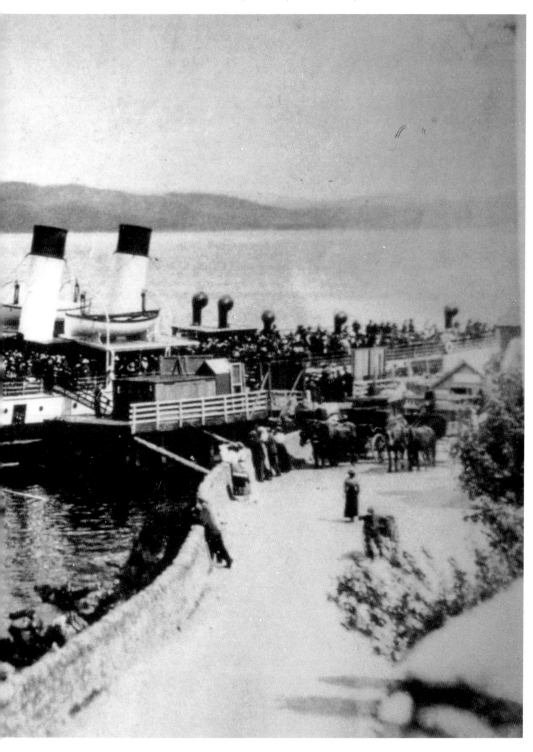

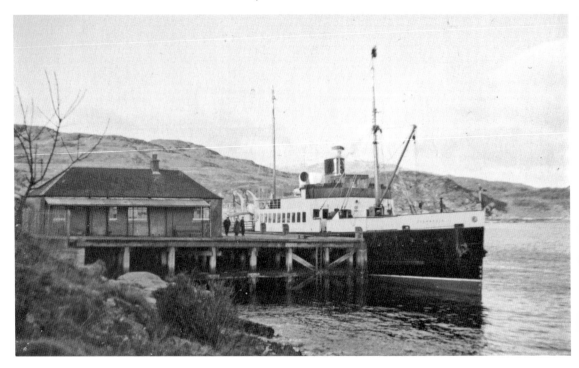

Lochnevis, seen here at Tarbert with a Christmas tree at the top of the mast, served the Tarbert and Ardrishaig service to relieve *Lochfyne* during overhaul periods, and during the spring when *Lochfyne* was operating out of Oban.

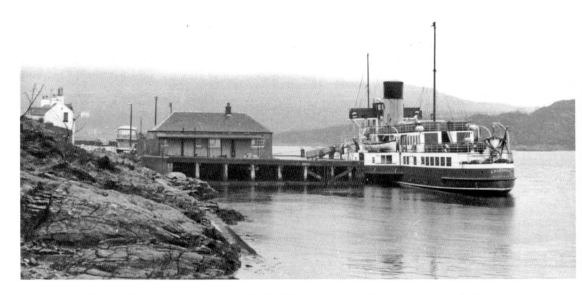

In April 1969, for a couple of weeks while *Lochfyne* was in use elsewhere, the Caledonian Steam Packet Co.'s paddle steamer *Caledonia* took over the Ardrishaig Mail Service, and is seen here at Tarbert during that period.

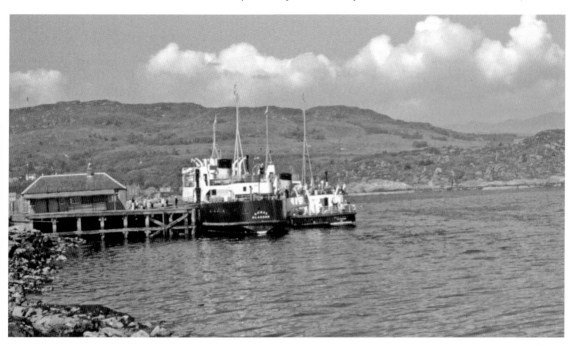

In 1970, on Fridays, *Maid of Argyll* had arrived at Tarbert from Gourock and the upper firth, and the car ferry *Cowal* ran a car ferry service from Fairlie and Brodick. Both are seen here berthed side by side at Tarbert. The *Maid* was covering the roster of *Waverley*, which had broken down.

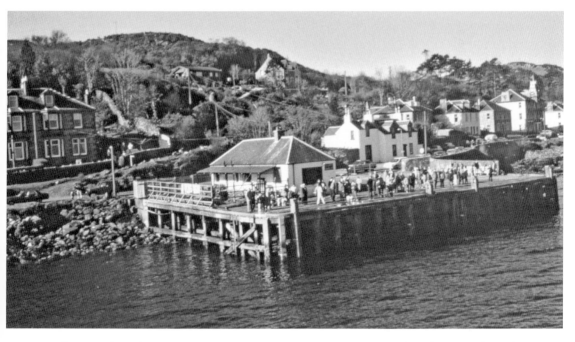

Tarbert Pier from the approaching *Waverley* in 1988. In recent years, calls have been more limited or with the aid of small boats due to a partially decayed structure. Hopes are high that much-needed funds can be secured to rebuild the pier in part.

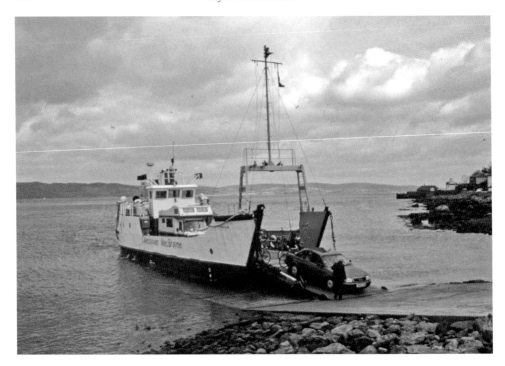

In 1994, a slipway was built at Tarbert, between the pier and the inner harbour, for the car ferry service across Loch Fyne to Portavadie. The Island-class car ferry *Rhum* is seen there in 1995.

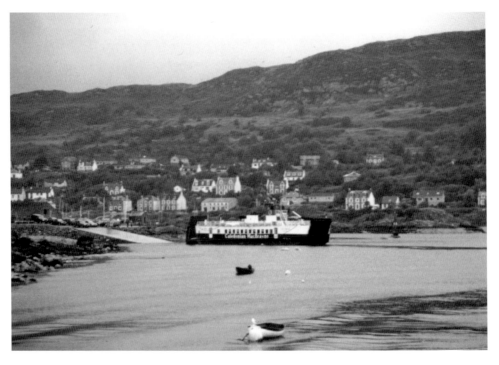

In 1998, the Loch-class car ferry *Loch Riddon* took over the Portavadie service and added a single daily crossing to Lochranza in the winter months. She is seen here arriving at the slipway.

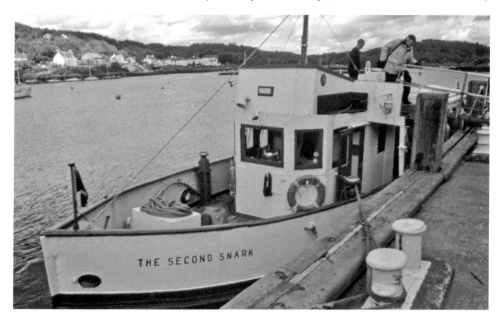

The Second Snark at the inner harbour in Tarbert on an enthusiast charter in 2003. Skipness, ten miles south of Tarbert, had an iron pier built from railway rails, in use from 1879 until after 1918, mainly used by cargo steamers, but the occasional destination for excursions. The CSP's *Galatea* and the GSWR's *Glen Sannox* are known to have called there on charters. Two miles south of Skipness is the ferry slipway at Claonaig, from where a summer service has operated to Lochranza since 1972, since 1992 by the seventeen-car *Loch Tarbert*.

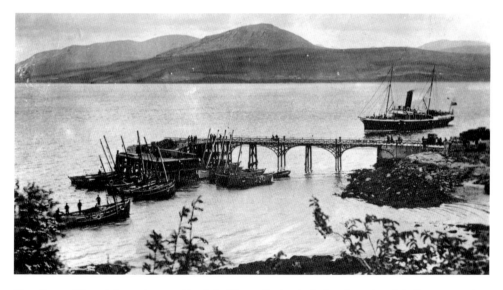

The village of Carradale, on the east side of the Kintyre Peninsula, had an iron pier of similar construction to Brodick, built in 1890 and replacing an earlier structure from 1858. This was used by the Campbeltown steamers, and the Campbeltown Company's *Davaar* is seen approaching the pier from that port in a postcard view from the early twentieth century. The pier was in use until the service ceased in 1940. *Waverley* has made a single call at Carradale during her years in preservation. At Saddell, halfway between Carradale and Campbeltown, the Campbeltown steamers made a ferry call until 1929.

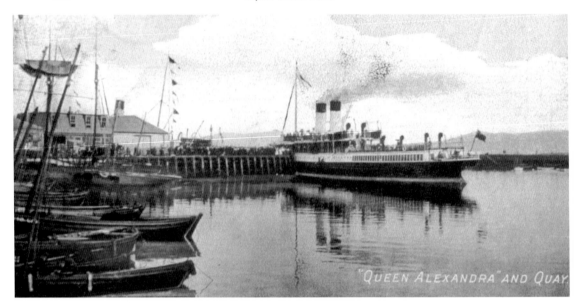

"QUEEN ALEXANDRA" AND QUAY

The market town and former fishing port of Campbeltown was first reached by steamer in 1815 and the Campbeltown and Glasgow Joint Stock Steam Packet Company was formed in 1826 to operate steamers between there and Glasgow, which it did until 1940. In 1901, Turbine Steamers established an excursion service from Greenock Princes Pier, Dunoon, Rothesay and Fairlie with the pioneer turbine *King Edward*, replaced in the following season by the first *Queen Alexandra*, seen here berthed across the end of the pier in this postcard view, posted in 1905. An Irish steamer, on an excursion from Belfast or Larne, can just be glimpsed behind the shed.

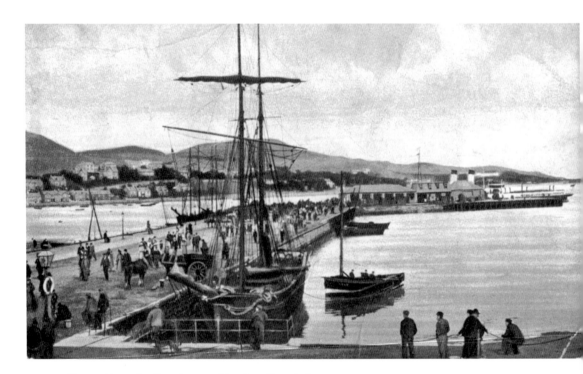

Queen Alexandra (I) at her usual berth at Campbeltown.

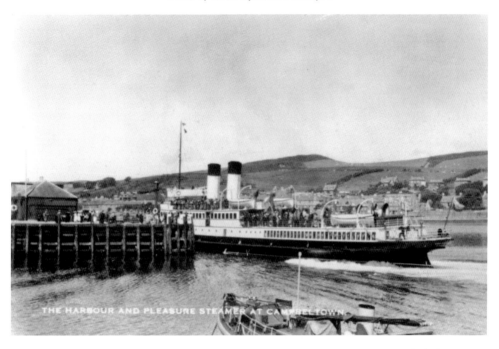

The second *Queen Alexandra* in her 1932-35 condition, with an enclosed promenade deck area forward, at Campbeltown, in a postcard purchased there in 1969.

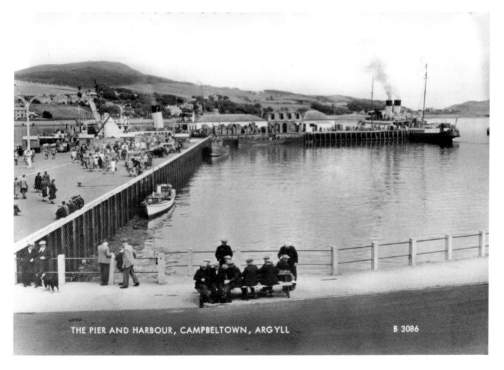

On occasion in the fifties and sixties, Campbeltown had two steamers arrive, *Duchess of Hamilton*, seen here, or *Duchess of Montrose* from the upper firth, and *Marchioness of Graham*, seen here behind the pier buildings, or *Caledonia* from Ayr.

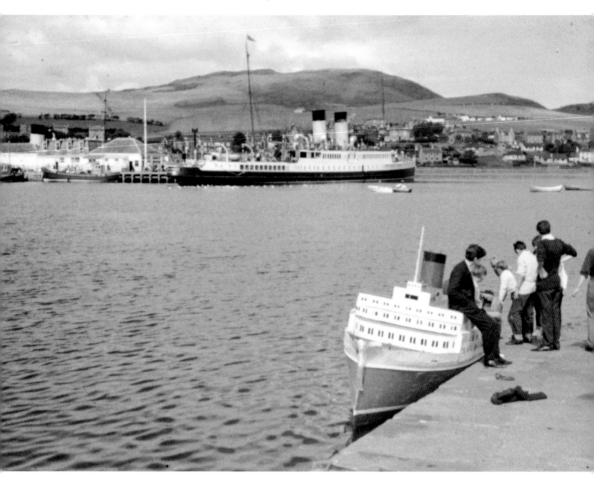

In the fifties and sixties, Campbeltown had a small replica of a Union Castle liner taking small groups on trips round the harbour from a slipway inside the harbour. This is seen here in 1964 with *Duchess of Montrose* across the end and *Caledonia* on the other side of the pier.

Opposite above: In 1970, Western Ferries introduced a service from Campbeltown to Red Bay in County Antrim with *Sound of Islay*, which lasted until 1973. She is seen here, with *Queen Mary II* at the other side of the pier.

Opposite below: Campbeltown had another jetty just outside the harbour, used by fishery protection vessels such as the steamer *Vigilant*, seen here.

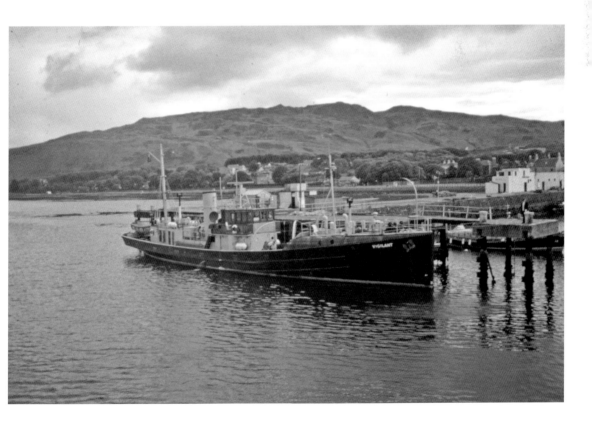

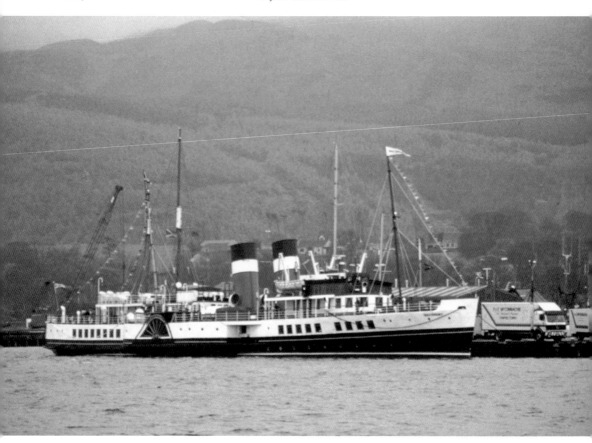

Waverley had a spell when Campbeltown was her regular destination from Ayr on Wednesdays, but now she rarely visits the port. Here, she is seen there in 1997 by which time the pier buildings had been removed.

8

Piers of Bute and the Cumbraes

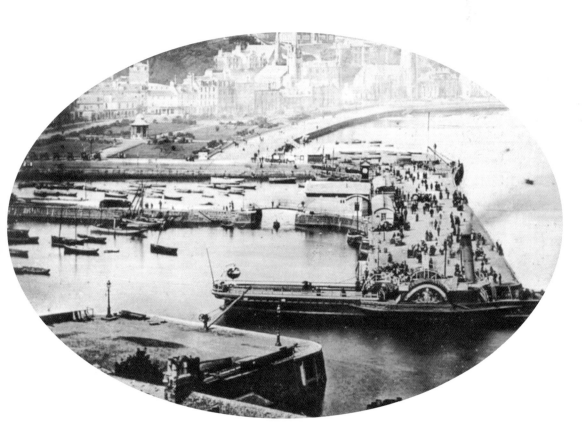

Rothesay's history goes back to Norman times, and it was made a Royal Burgh in 1400. Steamers have been calling here since 1814-15, and it developed as a holiday resort from the 1840s onwards. The harbour dates back to 1823-24 and in 1868 the width of the pier was increased, and the following year a concave extension at the west end was added, as seen in this reproduction from a lantern slide, dating to the 1870s. The steamer at the end of the pier is probably *Athole* of 1866.

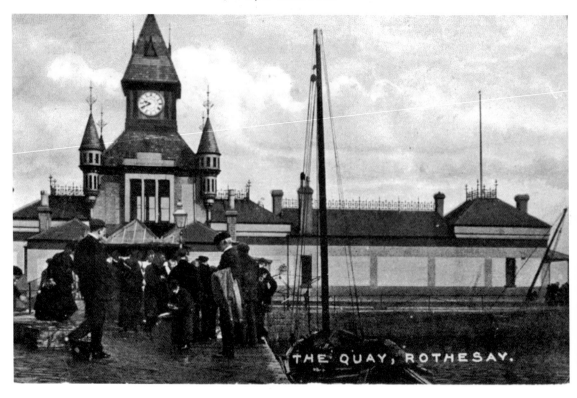

In 1885, new pier buildings with a large clock tower were built, as seen in this postcard.

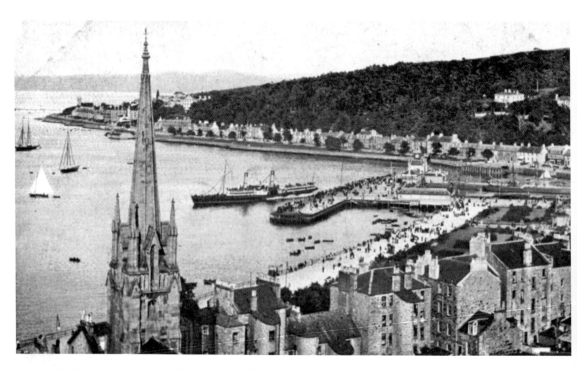

Rothesay from the west, from Chapel Hill, showing *Iona* departing for the Kyles and Loch Fyne.

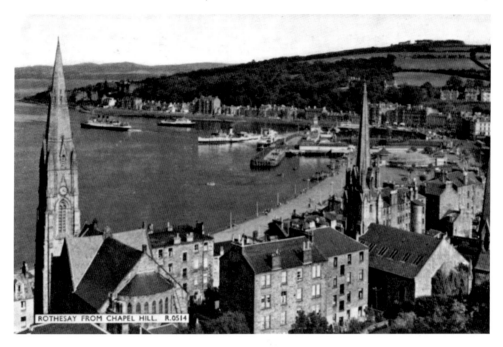

The same view in the 1950s with *Saint Columba* departing for Innellan, Dunoon and Gourock, a *Maid* arriving, *Talisman* leaving for the Kyles and an ABC car ferry berthed at the pier.

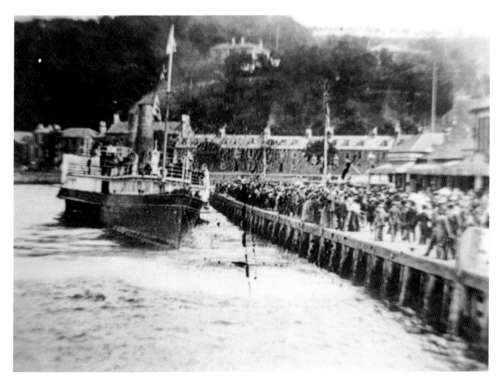

Lady of the Isles, originally the first *Lord of the Isles*, berthing at Rothesay in 1904. Note the large number of passengers on the pier.

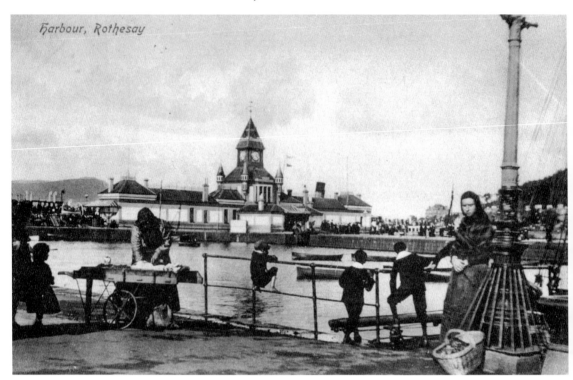

Harbour, Rothesay

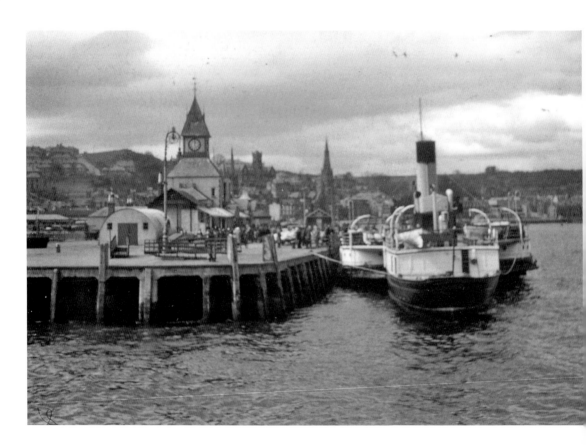

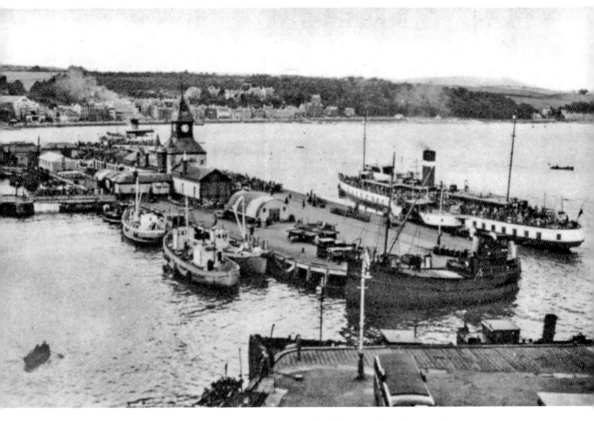

Rothesay in 1946 or 1947 with *Talisman* at the west end of the pier, *Caledonia* at the other end, some MFVs moored inside the pier, and a coaster at the Albert Pier.

Opposite above: An Edwardian postcard view of Rothesay Pier from the shore showing small boys playing on the railings and a couple of people selling what appears to be shellfish from baskets and a stall and the funnel of the GSWR's *Atalanta* peeping above the pier buildings.

Opposite below: An early colour photo of *Duchess of Fife* at Rothesay Pier.

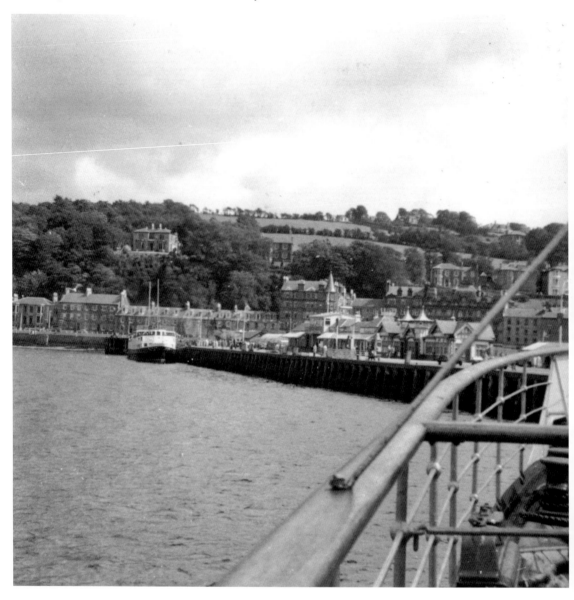

In 1962, the clock tower was destroyed by fire, but the old pier buildings remained until 1968, as seen here from an arriving steamer, with *Maid of Cumbrae* berthed at the far end of the pier.

Opposite above: The new pier buildings, seen to the left, were opened in 1968 by HRH the Queen Mother. Car ferry *Cowal* and *Maid of Cumbrae* are berthed at the pier in this shot.

Opposite below: The inside berth at the west end of the pier has long been known as the *Kylemore* berth, after the Williamson paddle steamer of that name which was based there in the interwar years, offering a morning departure to Glasgow. The berth is seen here in 1981 with a rather rusty *Countess of Kempock* berthed.

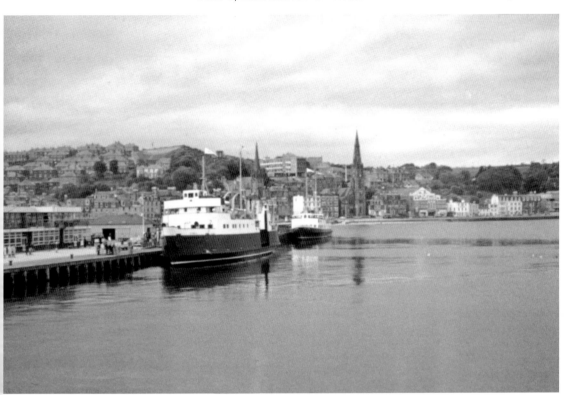

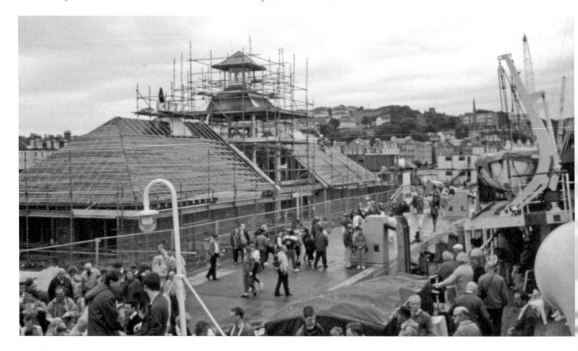

In 1992, new pier buildings were erected, more in keeping with the original than the utilitarian sixties block. This photo shows them under construction seen from *Waverley*.

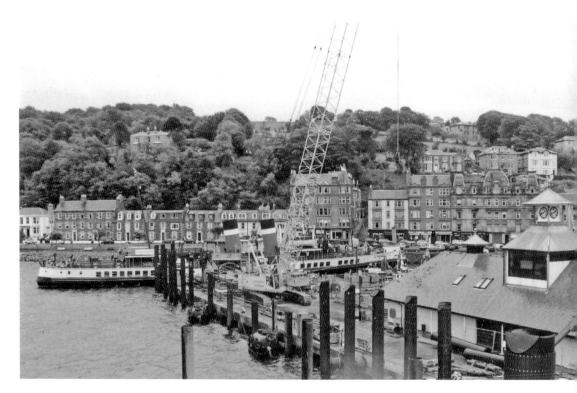

In 2007, work on the pier to include a new end-loading roll-on roll-off ramp meant that *Waverley* had to berth across the end of the pier. The new pier buildings can be seen in this shot.

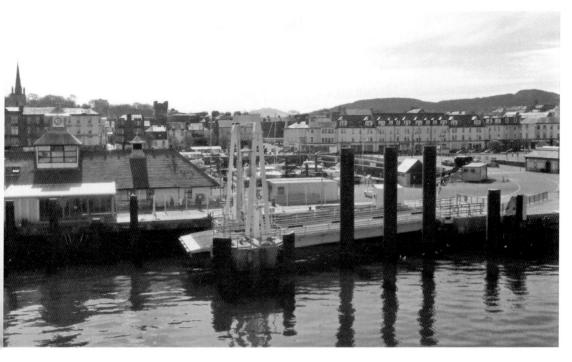

The new linkspan, which enables end-loading of the current ferries *Argyle* and *Bute*.

A new cumbersome passenger gangway has been installed, adjustable for different states of the tide, to enable passengers to disembark from these ferries.

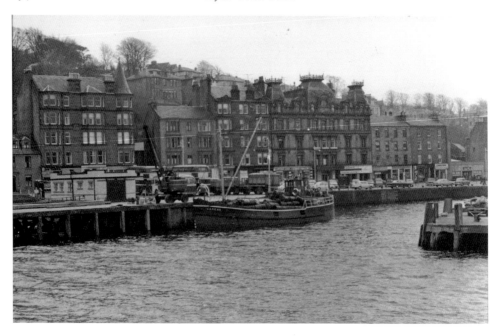

The Albert Pier at Rothesay was to the east of the main pier and the wooden pier was built in 1908-09 onto a stone jetty dating from the 1860s and was opened by PS *Duchess of Fife*. It was mainly used for cargo vessels and puffer, and is seen here in the 1960s with the puffer *Lascar* berthed with a cargo of barrels. The pier was demolished in the late noughties.

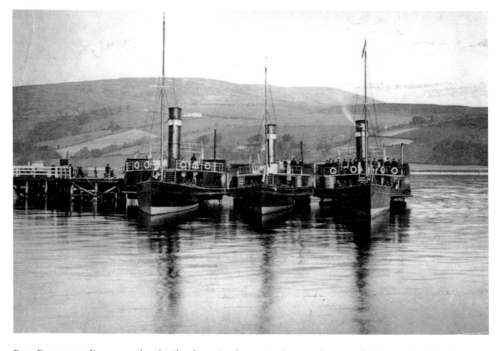

Port Bannatyne lies a couple of miles from Rothesay in the next bay north, Kames Bay. Its pier, built in 1857, was used as a headquarters for Captain Alexander Williamson's 'Turkish Fleet' of *Viceroy*, *Sultan* and *Sultana*, seen there around 1880.

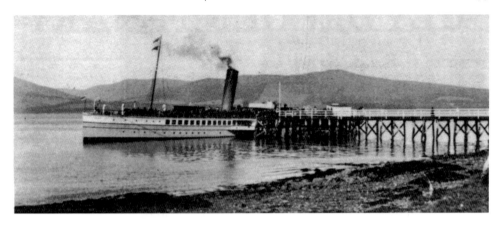

Prior to 1914, both the GSWR and CSP steamers used Port Bannatyne, and the GSWR's *Juno* is seen there in this photo.

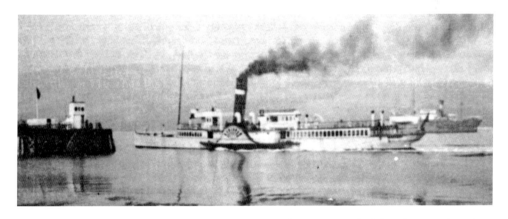

After 1914, the railway steamers ceased calling, and *Eagle III* and *Lord of the Isles* were the only callers. In 1933, the railway steamers started calling again with both LMS and LNER steamers calling. This is the LNER's *Kenilworth* approaching the pier on 17 August 1936. On outbreak of war in 1939, the pier closed and never reopened.

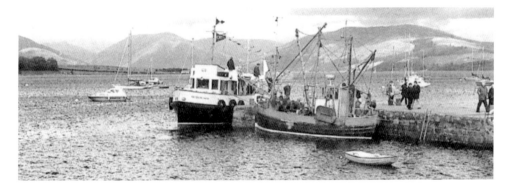

Port Bannatyne also had an old stone jetty, built originally in 1801, which was used by *The Second Snark* on 10 September 1994 on a Clyde River Steamer Club charter.

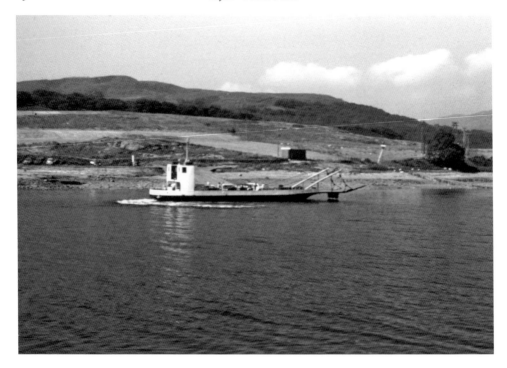

Rhubodach, at the Bute end of the ferry from Colintraive, has no settlement and is merely a slipway at the end of a road. The former Skye ferry *Portree* is seen there in the early seventies.

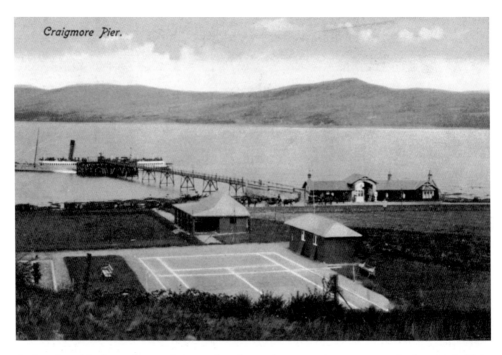

At the edge of Rothesay Bay, to the east of Rothesay, the pier at Craigmore was built in 1877. This colour postcard view shows the GSWR's *Mercury* or *Neptune* at the pier in the early years of the twentieth century.

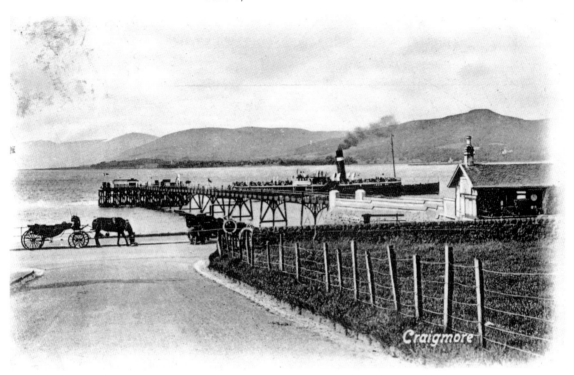

The NB's *Waverley* leaving Craigmore for the upper firth prior to 1914, the horse taking no interest in the scene.

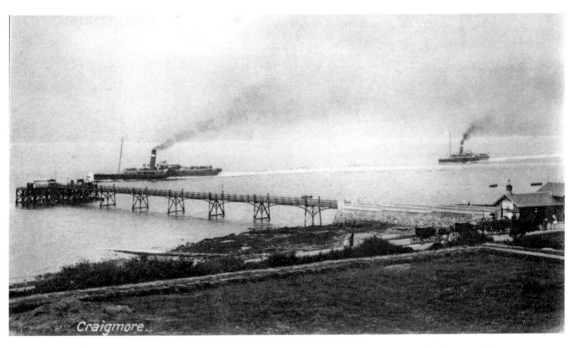

A couple of NB steamers arriving at Craigmore in the pre-1914 era. The pier closed in October 1939 after the outbreak of war and was demolished the following year.

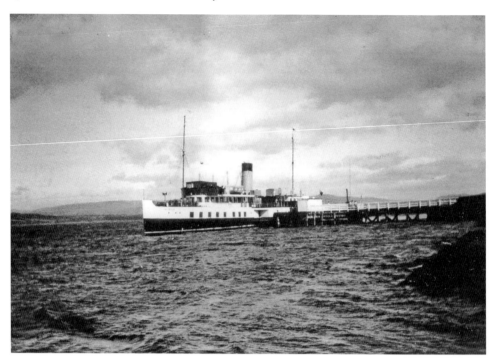

To the south of Bute, there was a pier at Kilchattan Bay, opened in 1880 and with the last call made by *Maid of Skelmorlie* in 1955. *Talisman* is seen here between 1948 and 1955.

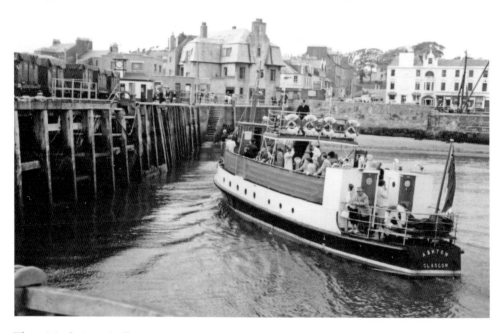

The original pier at Millport was opened in 1833 and extended in 1860. It remains to this day, and the small motor vessel *Ashton*, which maintained the service from Largs with her sister *Leven* during the fifties and early sixties, is seen approaching the pier.

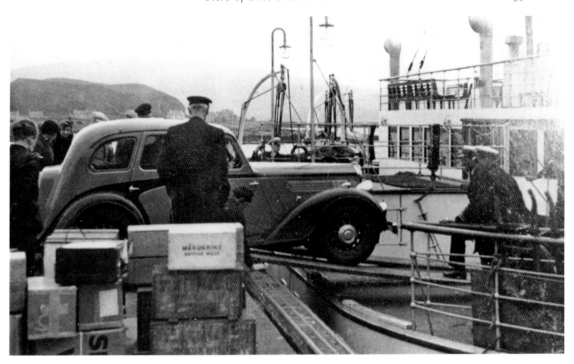

Prior to the advent of the car ferry, cars were moved on and off ships by planks, as in this view of *Mercury* unloading a car at Millport in the late thirties.

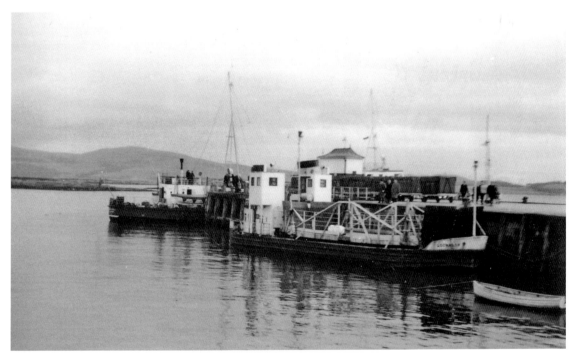

The Kyle-Kyleakin car ferry *Lochalsh* in a very rusty condition and probably on her way to overhaul, with a *Maid* across the end of Millport Pier in the Monastral Blue hull period (1965-69).

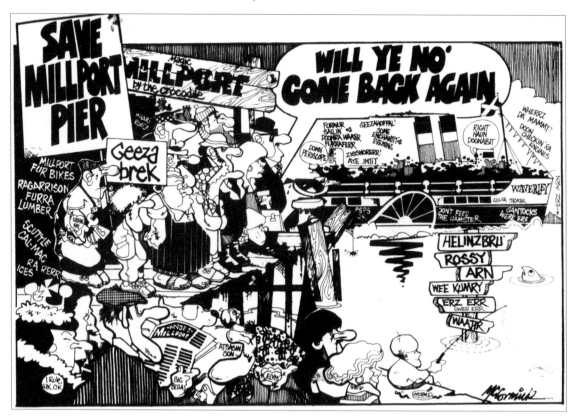

In the late 1980s, there was a real risk of Millport Pier being closed, and an action group was set up to campaign for its repair and retention. By then *Waverley* was the only steamer calling at the pier, and this cartoon postcard was issued to promote the group. In 1991, the pier was rebuilt and continues to be in use today.

Opposite above: A Tuck's Oilette postcard view of Millport (Keppel) Pier showing a CSP steamer arriving in pre-1923 colours. The pier was built in 1888.

Opposite below: The GSWR's *Vulcan*, later Williamson's *Kylemore*, at Millport Keppel Pier between 1904 and 1908.

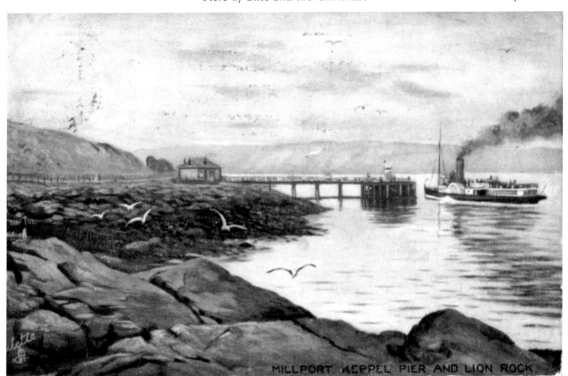

MILLPORT KEPPEL PIER AND LION ROCK

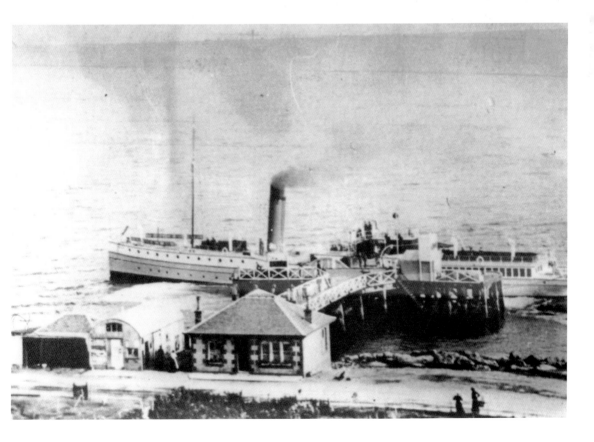

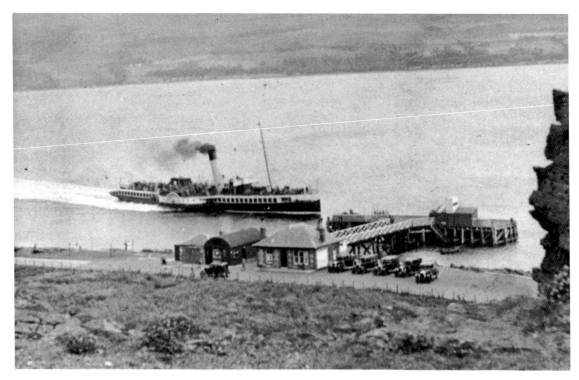

Duchess of Rothesay arriving at Keppel on 20 August 1936. Keppel was used for the longer distance excursions such as the sailings to Campbeltown and round Ailsa Craig.

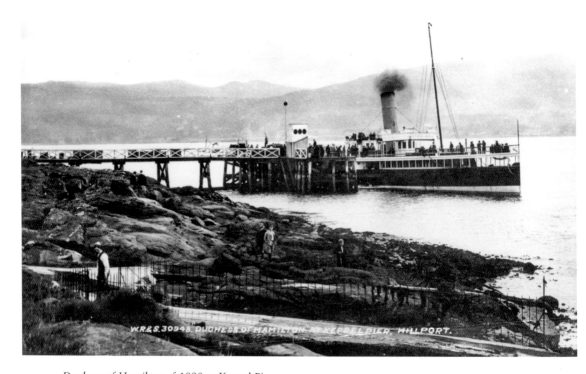

Duchess of Hamilton of 1890 at Keppel Pier.

Duchess of Hamilton of 1932 at the end of her career on 5 September 1970, returning from a Clyde River Steamer Club charter to Ardrishaig. Passengers for the upper firth changed here to *Queen Mary II*, having come down in the morning on *Waverley* to Innellan, while the *Duchess* had come from Ayr and was returning there after this call.

Queen Mary II at Keppel on the same occasion, on her way home from Campbeltown. The pier was closed in 1971 and was sold to the nearby Marine Research Station, which replaced it a few years later with a new steel pier slightly to the north after the old pier had become unrepairable. The final call was made in May 1973 by *Queen Mary II* on her fortieth-birthday charter to the Arran Coast.

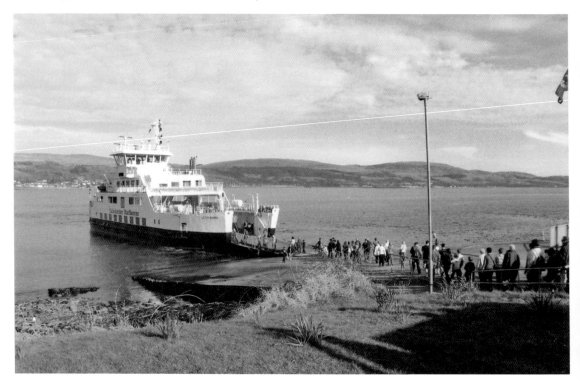

Above: North of Keppel at the old Tattie Pier, used by farmers at the north of the island, a new slipway, known as Cumbrae Slip, was built in 1972 for the new car ferry service from Largs, and *Loch Shira* is seen embarking foot passengers there in April 2010. In between there and Keppel Pier is the site of Balloch Pier, in use between 1872 and 1888 as an emergency pier when Millport could not be used due to inclement weather.

Left: Little Cumbrae has never had a steamer pier, but in 1980, *The Second Snark* made a call there at the lighthouse jetty on a Coastal Cruising Association/Queens Park Camera Club charter. There is also a small jetty on the other side of the island that serves the farm there, but this has never had a public passenger service.

9
Piers of Arran and Ailsa Craig

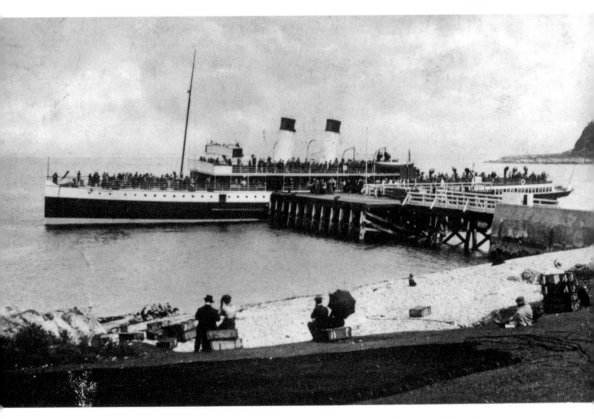

Lochranza, at the north of the Isle of Arran had a pier, built in 1888. This was used by the Campbeltown steamers, and the second *Queen Alexandra* is seen here in her first season, 1912, in a postcard view.

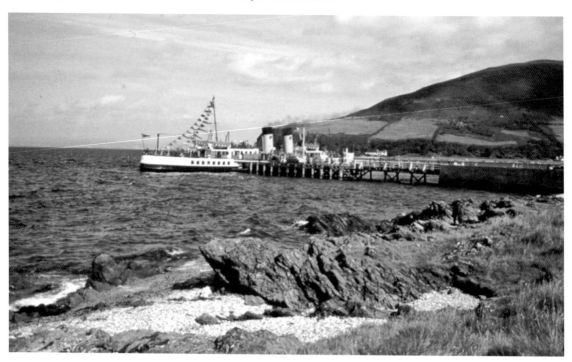

Waverley at Lochranza on 4 September 1971 on a Clyde River Steamer Club charter from Glasgow (Princes Dock) to Ailsa Craig.

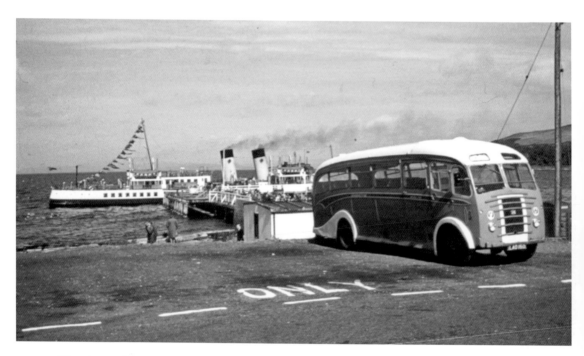

Waverley on the same occasion with a Bannatyne's bus at the pier head. The final timetabled call was made by *Queen Mary II* on 27 September 1971, and she closed the pier whilst on a charter in May 1972.

Lochranza Pier was replaced by a slipway for the new car ferry service to Claonaig. *Loch Tarbert* is seen arriving at the slipway with *The Second Snark*, on a charter, at the stone stump of the old pier.

Lochranza is one of the success stories of recent years. The pier was rebuilt and reopened on 29 June 2003, with a call by *Waverley*, seen here.

Loch Tarbert at the slipway in 2004, with the new pier in the background.

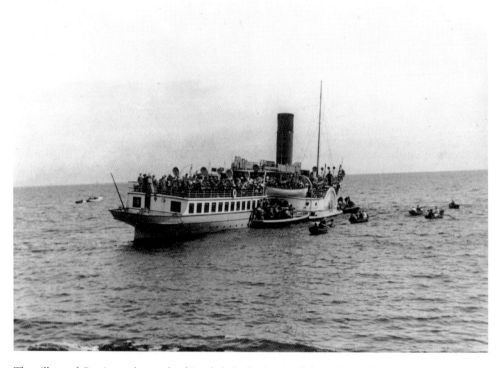

The village of Corrie, to the north of Brodick, had a ferry call from the mid-nineteenth century to the Second World War. The GSWR's *Jupiter* is seen here embarking passengers from the ferry around 1912.

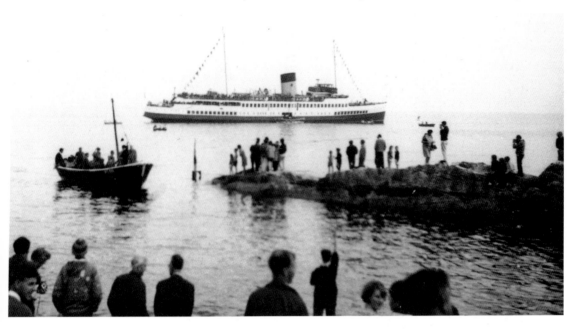

On 23 September 1967, *Queen Mary II* re-enacted the ferry call at Corrie while on a Clyde River Steamer Club charter. *Waverley* did the same in 1994 as part of 'Corrie Capers', a local festival in the village.

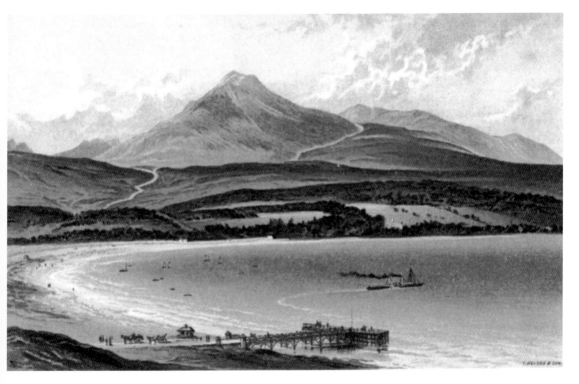

Brodick has always been the major pier on Arran, and the pier was opened in 1872. This is an engraving from the 1870s, showing an unidentified, and possibly imaginary, paddle steamer in the bay.

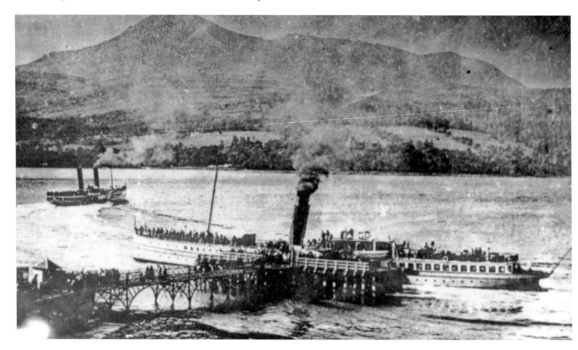

Brodick Pier in the early twentieth century, showing the GSWR *Jupiter* at the pier, on the Arran via the Kyles service from the upper firth, and the same company's *Glen Sannox* heading back to Ardrossan. This shows the original wrought-iron pier, with the pierhead rebuilt in wood.

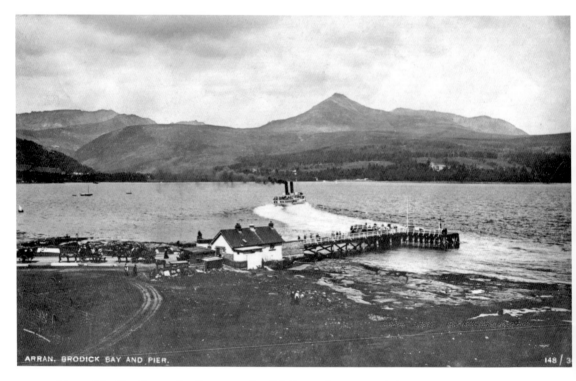

The paddle *Glen Sannox* heading across Brodick Bay on her way to Ardrossan.

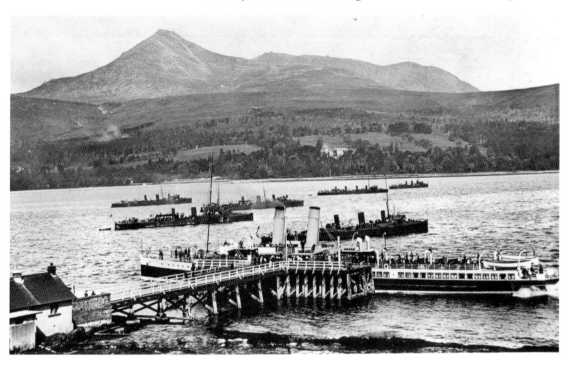

The CSP turbine *Duchess of Argyll* at Brodick Pier between 1910 and 1914, with a flotilla of torpedo boats anchored in the bay. By this time, the pier had been completely rebuilt in wood.

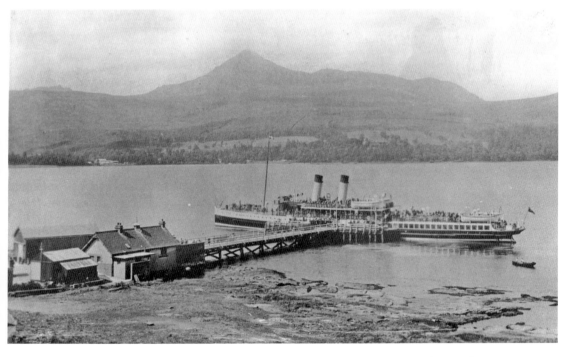

The turbine *Glen Sannox* at Brodick Pier in the late 1920s or 1930s in a postcard view. The pier was given a complete rebuild in 1946-47 and again for the advent of *Caledonian Isles* in 1993.

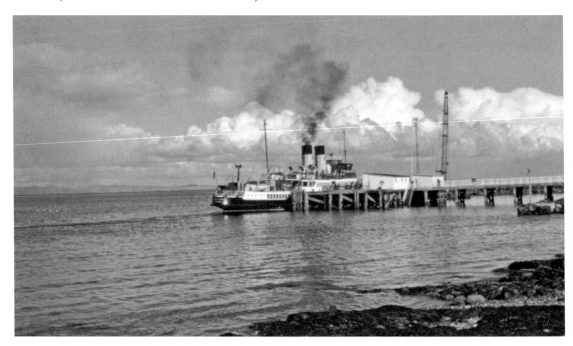

The turbine *Duchess of Hamilton* at Brodick in 1970, during the building of the roll-on roll-off ramp. The crane fitting the linkspan can be seen in the background.

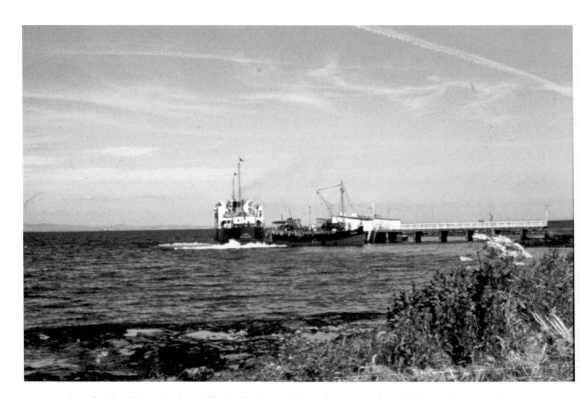

Cowal at Brodick with the puffer *Lady Isle* in 1970 on her return from Tarbert, about to sail for Fairlie.

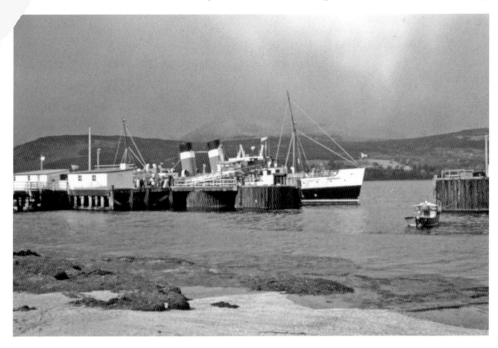

Waverley at Brodick Pier in 1990. Part of the area in the foreground here has now been reclaimed and is a marshalling area for cars.

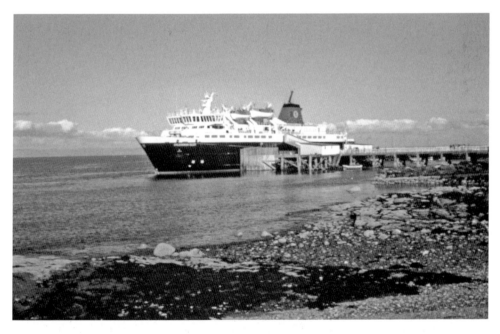

Caledonian Isles, the present incumbent on the Ardrossan route, at Brodick. Although the pier appears little changed from this angle, a new roadway to a stern ramp was added in 1970, and much of the area inside now reclaimed for a vehicle marshalling area. This shows phase one of the rebuilding of Brodick Pier. Later, a powered walkway gantry for foot passengers was fitted, and two concrete dolphins were built where the bow of *Caledonian Isles* is.

Lamlash Pier, seen here in a postcard view, was built in 1884 and closed in 1946, reopening again from 1953 to 1955.

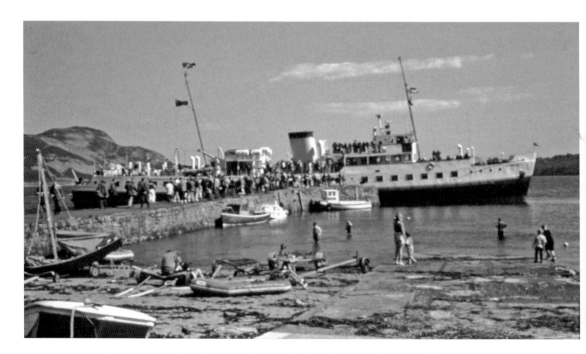

A stone jetty survives at Lamlash, and *Balmoral* called there in 1994 on a CRSC charter. This was the first call at the stone jetty. The final call at the pier was made in 1955 by *Duchess of Hamilton*

David

book in
your transform
your life !

[signature]

Saturday 8th May 2004
Kensington Town Hall, London, England
Deepak Chopra writes:
*"David and Linda's book will help you
transform your life."*

To Pat

SHIFT YOUR LIFE !

by
David L. Cunningham,
with Linda Lee Ratto, Ed.M.

**Loving and Forgiving Your Way
to Health and Wellness**

First Printing January 2004
Power! Press
Post Office Box 622
Tyrone, Georgia 30290 USA

SHIFT YOUR LIFE !
by David L. Cunningham,
with Linda Lee Ratto, Ed.M.

ISBN 0-974508-1-0

1. Health—Physical and Psychological; 2. Wellness—Mind, Body, Soul; 3. Counseling—How to repattern self; 4. Healing Energy and Disease Relief; I. Cunningham/Ratto; II. Title: *Shift* Your Life!

"FOR THOSE WHO BELIEVE,

NO EXPLANATION IS NEEDED.

FOR THOSE WHO DO NOT,

THERE IS NEVER ENOUGH."

www.SpiritualHealingCenter.com

England Contact: 44 191 536 2655

davidlcunningham2003@yahoo.co.uk

Ratto@mindspring.com

USA Contact: 770.486.0758

Table of Contents

<u>DEDICATION</u>

DLC:

I dedicate my life and God's gift of healing to my personal understanding of God, and respect for all mankind's journey.

To Rowland and Margaret, my parents, sadly not here to witness my life work now.

To my sister and brother-in-law, Margaret and Jim, for their love and support. To my nephew and niece, David and Lynsey, for being in my life, and to their spouses, Claire and Andrew. I love you all dearly.

LLR:

I dedicate my life to the rich development of others in their lifelong learning quest.

ACKNOWLEDGEMENTS

DLC:

I thank the thousands of people I have worked with for their faith and trust in me. In particular, I send special acknowledgement and honour to my lifelong mentor Don Galloway of the College of Psychic Studies, for leading me on my spiritual journey. Thank you,Sir, for guiding me in 1966 by saying, "Healing is going to be your destiny." I took this to heart, as you can well see.

I would like to thank, most sincerely, Linda Ratto, my dear friend who encouraged me to delve into my life to write this book with her, and for the thousands of hours of love, dedication and hard work in bringing this story and helpful book to you. Thank you Linda—what would I have done without your loyal friendship and love. Many, many blessings upon you.

LLR:

I humbly thank David Cunningham for allowing me the privilege of walking into his life and telling his story. My spiritual journey has been enriched and evolved with his loving presence in my life. In addition, I share heartfelt appreciation to David's sister, Margaret, her husband Jim and their children, Lynsey and young David, who have welcomed me into their family as a sister. I thank my family: David, Courtney, Eric, and Ryan for their years of love and unwavering patience during this book project, even with material that they found surprising and at times unbelievable. Thank you for accepting my work.

We encourage you to contact us with your comments and your own healing stories, if you so desire.

OVERVIEW

Author Note: The word 'God' used in this book is a name for my definition of The Universal, Loving, Creative Energy Force. With respect to the reader, the use of God does not conflict with any man or woman's religious and spiritual beliefs, it encompasses ALL.

~David L. Cunningham, January, 2004

A Healer's Life

*** A distraught mother comes to me through a series of acquaintances and numerous doctors. Her baby has leukemia. I quietly begin counseling, learning all about mum and infant Jennifer Marie. We spend a full hour together in a healing session. I hold the baby, find and release her eight energy centres. I meditate, touching her little head, asking for healing energy to flow again clockwise through her body giving the infant back her health.

Days later Jennifer's mum telephoned. "Our doctors said Jennifer Marie is in remission. Jennifer Marie's blood tests are normal!"

*** London-born Jack, age three, was brought to me by his parents. Jack was autistic and had not slept save dribs and drabs since birth. As with many autistic children, Jack did not speak. To cope, Jack's folks took shifts and I saw why. Jack virtually climbed the walls of my Hale Clinic office scurrying about like a bumblebee seeking nectar. We seatbelted Jack in his push-chair, while I explained the eight energy centres healing process. I moved my hands over all of Jack's chakras, opening his energies full steam. The family returned for another session three days later explaining, "Jack slept soundly

ever since your first session and spoke several words!" We hugged one another. On the second visit, Jack was calm—not the same toddler first presented to me. We did another healing and I sent them home. On Friday, October 22, 1999, I received word that Jack now attends normal public school.

*** I awaken in the middle of the night to a message: a close friend's face appears telling me, "Don't worry, David, I just passed into the Spirit world. It is fantastic!" The next day I telephone my friend's family and they tell of his funeral arrangements.

*** Chanel, a lady in her late fifties, with cerebral cancer manifesting a tumour in her left side of the brain (the area in the body that holds emotional issues) came to me on heavy medication with no more chemotherapy possibilities. After five sessions has reported that the pain has reduced and she is taking less pain medication (at her will) and feels the tumour has changed in size. Lab tests to confirm results are in process.

*** Pamela, with Irritable Bowel Syndrome (IBS), suffering for 20 years, healed after only two sessions.

*** Francine, with deep emotional pain after losing her son, already feeling the pain in her heart leaving.

*** Martin, with serve pain in his feet for many years has been healed after three sessions.

*** A woman named Hayley requested my services through a friend whose horse was gravely injured. Animals have similar energy centres as humans and we were successful in helping the horse become well. The *Hayley* turned out to be Ms. Hayley Mills, a beloved movie

heroine of my childhood. As many know, a person's health can be blocked, and Hayley is a perfect example. With her gracious best wishes, I share our experiences.

A Star's Healing Story

I often counsel in the comfort of a person's home. Hayley invited me to her Hampton house on the Thames just outside London. I was excited, having watched her grow-up in films such as *Pollyanna*. One of my first jobs as a young teen was in a local theatre. I knew every movie by heart, especially Hayley Mills'. She portrayed girls I would have loved meeting. It so happens that Hayley is exactly my age; we found much in common and made fast friends.

In 1995-96, *Dead Guilty* was the play in which Hayley portrayed a murderer. She chose the character because it was quite different. Hayley revels in acting challenges and did enjoy this play on some levels. However, the dramatic implications of murder and the live performance schedule upset her entire being. Hayley's deteriorated condition brought her to seek my aid.

We worked together for several healing sessions, helping her through the final month of the play. She saw great results, feeling lighter, brighter and began enjoying life and performing again. The Almighty's healing energy through my hands eased her back into the best of health. She expressed delight in her renewed strength and overall wellness in body and spirit.

After our healings, Hayley wrote an article highlighting her healing work with me, which was published in London's *The Daily Mail*, December 1996. She said, "My article is a gift of gratitude for what we have accomplished together." She is today refreshed and happy, in a lovely, healthy state of being. I appreciate deeply that Hayley chose to go public concerning her healing with me. It was

the first publicity of a larger scale that I experienced and she literally opened floodgates in my life as a full-time healer.

Hayley grew to trust my professionalism and asked me to house-sit for her after the London play; she was going on tour for *The King and I*. What an honour this was to have her home and her trust placed in my hands. I lived there sixteen months, with Hayley's permission to see people for healings. Hayley's gracious friendship fostered the health of close to one hundred people whom I counseled in her home. Hayley's house in fact took on the positive energies emitted in sessions. It was Hayley who mentioned the energy changes. She noticed how exquisite she felt whenever she walked through the door. Her home to this day is filled with positive vibrations, which enhance health.

Over time I met and worked with Hayley's parents, Sir John & Lady Mills. Hayley and I remain very good friends, keeping in touch by phone and meeting for healings when she is in need. I was welcomed into the family with many kindnesses, including an invitation to Sir John's ninetieth birthday celebration. It was a marvelous night of stars in London's Dorcester Hotel. I am blessed by this family. To those clients and myself, Hayley Mills is an angel.

NOTE: With her kind and express permission, Ms. Hayley Mills' article is shared in full in the Appendix.

Healing Work ~ Yours and Mine

The Almighty has created a miraculous human body, a humming, vibrating, pulsating system that maintains itself with an ease that is often surprising. All we need do is properly feed it, exercise it, fuel the mind and soul, and we are able to withstand much of what life throws our way. We can survive.

Existing with excellent health and for a very, very long time is another matter. We cannot optimally function if the inner energy, our life force, is not running. No pills, potions or lotions can free the ills from blocking negative energy. We must keep our healthy, flowing systems going. We accomplish this by freeing ourselves. Those who have learned the art of quiet stillness, meditation or prayer can significantly influence their daily energy stream. Releasing troubles to the Divine helps people cope with emotional pain and maintain wellness. Quieting the mind and body opens a channel to God's energy and our renewal.

Every living soul's energy flows naturally in a clockwise direction. Healthy energy surges from the Almighty above the head, down through the body's energy centres (called chakras) to earth where we are grounded. The mind, body and soul remain balanced if we seek the positive side of life and the good in each situation. Alas, most of us need reminding; even the highest loving soul has to work on staying positive and healthy in the human body. The best way to keep the energy centres surging is to become silent and peaceful. In so doing we hand over to the Divine our worries and negatives of the day and replenish ourselves.

Energy is slowed or even blocked when we judge and then feel hurt by a situation and therefore we are unable to deal in a healthy way with today's or yesterday's events. We place barriers and build walls to protect ourselves. By creating protection against pain, we cause blockage and

imbalance (dis-ease) in mind, body and soul. Rather than being safe from the emotional upheaval, we block the very energy that releases pain and keeps us well.

Within these pages is a story of my life and continual quest to heal and replenish myself and those who seek assistance. Spiritual energy healing involves unblocking the energy centres called chakras and counselling for understanding. This work shifts people. Releasing energy flow causes a person to relieve buried hurts and it is surprising what can be let go and forgiven when the healing process is begun.

Shift Your Life! is the story of my personal healing journey, but also yours, for healing is not just for a few but for all souls. Within these pages are useful tools for optimising our spiritual and physical wellness. Energy healing has been frequently misunderstood and it is my humble desire that you come away from this book filled with increased knowledge, awareness and greater compassion for the self. And, if you are so moved, I hope you'll connect with your loved ones to help them feel loved and well.

By changing a simple thing, such as a thought pattern, you can effect a healthy shift in your body this very moment. As Norman Vincent Peale said, "It is the power of positive thinking." The mind is but a tool to be used in creating your reality. Quiet reflection to nurture the self opens energy pathways so we are free to create experiences for our individual and collective highest good.

M. Scott Peck, MD, tells us in *The Road Less Traveled* that the purpose of his chapter on grace is to help readers understand the perfect timing and fit of grace's serendipity. The grace of just the right teacher at just the right time helps us realize that merely opening our awareness can create miracles. Grace and serendipity, what I call synchronicity, abound in this life if we only open our hearts and listen. So may this book—right now—fill your life with perfectly timed wellness!

Part One
Your Private Healing

Education and Counselling Session

Hands-On and Hands-Off Healing

Healing Your Self

Healing Stories

Education and Counselling Session

I am like you.

I hurt and then feel better.

I heal myself and assist others in healing every day, as you can.

Thank you for inviting me into your space. Come join me in a time set aside to help you feel wonderful! You are inspired to open the cover of our book. Allow this work to serve you to the highest degree.

Feel our love.

Know love is real.

Peek into a Client's Session

Welcome. I am David Cunningham and I ask you if there is anything physical or emotional going on that you would like to share with me.

"David, I am here today because I want to improve my life and be happier."

This is one of the most frequently vocalized goals in healing sessions with clients. I ask that you peek into this private session formatted with you in mind. Consider this your very own time with me and that you have the goal stated above—you want to be happier and improve your life.

This time today is divided into conversation, hands-on healing and healing yourself suggestions. Communication is a key to growth. I hope you will listen to these words with your soul as I share my learnings with you. I will explain how I use the energy I have within to help your body, mind and spirit feel better. Finally, I will outline a way for you to continue to heal yourself whenever you wish.

Healing is a God-gift and a universal one. We can and do repair one another and the self when we choose. Healing takes many forms, such as counselling, listening,

teaching, forgiveness, using intuition, and the sixth sense. Three forms of healing that I utilize are: conversation, teaching and hands-on touch. The job of my type of healing is to transmit God's higher vibration healing energy field into the person with whom I am working. This God-force rejuvenates and increases wellness of the mind, body and soul by clearing physical and emotional problems.

Some of the reasons we become unwell are when we are not at peace, not at harmony or we are not loving ourselves sufficiently enough to let go of hurts. Perhaps we are not forgiving others and loving them for themselves. All this negativity, unhappiness and dis–easement will filter through from our soul and either be let go or strike our physical body for release in some manner. That's the core spark of illness. Emotional and physical dis–eases begin this way, manifesting from unloving instances that are kept inside deep within the body structure. Often we are unaware of this building-up of dis-harmonious feelings because most of us have *not* been taught to release and love again under any and all circumstances. When we do not realize this supply of pent-up negativity, we can get ourselves into an unhappy place where we are crying, inside or out, *Why me? Poor me?* This is setting ourselves up for a victim situation.

To become well is to take charge; it is to look at who we are in everyday moments. Each part of the anatomy is linked to what is going on in the spiritual unrest arena, which is also connected to negative, unhealthy thought patterning. In order to move forward in life, we have to sit quietly and reflect on our life to understand from where our dis–easement may be coming. If it is unconstructive thoughts or negative replaying of damaging thoughts about self or others, we must change to effect health shifts.

Look Into Your Past

Everything, in my fifty-odd years, seems to be traced to our time as children. If we are born into an environment of unlove or we receive experiences of what love is not, such as hearing often: *You are not worthy* and *You are not good enough*, we begin to develop inner feelings of unworthiness. Replaying these learned thoughts breaks down our love for self, affects our self-esteem and skews self-evaluation. The more we are unable to sort this all out, the more unwell the physical/emotional body becomes.

To release all of this disharmony and unhappiness from our souls is to work on understanding life. My interpretation, from all information I receive, is that the experiences we agreed to have in this lifetime centre around what love is and what love is not. This is the crux of life-on-earth at this moment in time. Because we have been given an abundance of experiences around these issues for complete and full understanding, we choose— sometimes subconsciously, sometimes consciously— exactly what we need to learn: unconditional love.

Between life experiences (between reincarnations), my understanding is that we sit down with our guardian angels and draw-up a blueprint of the life to come. We choose the timing, the place, our parents, the conditions, perhaps even our departure date—the whole package deal. The heart and core of this planning is to experience what is love. For all of humankind to evolve, we need to know how to love in spite of it all, because of it all, besides it all. This is loving without any set condition and when we choose to experience what love is not, life gives us an inherently golden opportunity to use our love for everyone at any time we may have felt harmed in some way, shape or form.

Scores of folks are not taught why we are on the earth plane and thus get terribly confused when violence

and other unloving incidents occur. Whenever we have an unloving experience, we have the chance to rise above the non-love with love and forgiveness, unconditionally. The 'bad scenario' is only a perception of unloving, for we can turn any situation into a loving one.

Remember Our Free Will

Know this: God creates us with total free will and that nothing—absolutely nothing—may happen without our permission, either on a conscious or subconscious level. Most often, because we are human, these manifestations and life movements are on a sub- or unconscious level. It would be quite confusing for each soul to instantaneously realize over and over, *Wow, THAT's what is going. I just chose this. I've chosen that and I can't play someone else.* We would not be able to live this way, for we would be constantly asking ourselves questions instead of living. The blueprint or reason why we are on earth shields us from co-creation realization until we come to a moment of self-consciousness, when we seek answers on purpose. Then we find out that **we create our own life stories**; our lives are not conducted by a big, punishing hand of some gigantic being. In this new awareness, we no longer place blame. For example, the word 'sin' simply has a renewed meaning: *missing the mark.* Rather than self-condemnation, our free will choices are viewed as marvellous learning opportunities. What a compassionate, liberating and constructive way to look at life.

Where is the Love Teaching?

Unfortunately, this unconditional love information is not taught, truly modelled nor available in most of our schools, churches, media, and other group communities. We were not actually taught to love above all, to step-up and claim our total independence and freedom. These

institutions, from a power standpoint, teach fear and submission, rather than love; they do not teach free will and that the Almighty is total love and is always there for us. There is no judgement, no punishment upon us, but rather pure experience and the open choice to love.

Frequently, people become unwell because they have been taught that they have committed a sin—even upon birth. This is when my healing can help individuals reclaim their free will. Alas, people find it difficult to realize that we **do** have total freewill to create and manifest every single experience in this daily life and that we come to earth on a spiritual journey attached to a physical body. I believe we are here to remember who we are and from whence we have come. We are God, in His image, and therefore perfect! We are love and we, together, are the Infinite. It takes an abundance of experience to remember who we are. In the Divine's gift of free will, we are given the chance to experience every aspect of love time and again until we realize—'re-member'—ourselves back into God.

The Most Common Question
"Then why do I become unwell? Can't I choose to simply love and have only loving moments and perfect health?"

We can choose love and perfect health any time.

In dis–ease, we are not loving ourselves enough. It all begins with the self. This is the first mis-step. We are in misunderstanding when we are taught that holding on to feelings of imperfection and sinfulness are the **real us**. The soul gets weighed down and heavy with guilty feelings and continually feeling wrong. The physical system becomes slowed into a lower vibration existence when always feeling unworthy. The body stops flowing and gets blocked with these slowing thoughts, ceasing its original, harmonious surging of bright, light energy flow from birth. Unwellness is the product of negative build-

up. All this dis–easement manifests into dis–ease of the mind/body/spirit.

The Second Most Common Question

"How do I become well? "

Look at who you are. Ask the Creator for assistance, for the right readings, the best teachers, angels, guardians, masters to help you move forward and arise from disharmony. And, when you allow yourself to lift your vibration and show love in all situations—choose love over all that you perceive to be evil or hurtful—then loving forgiveness becomes your healer and life is transformed. (Remember, 'evil' is simply LIVE in reverse!) In addition, doing all the positive things for your body that you know will promote health and aspiring to a higher level of loving existence, is to find peace and wellness once again— mind, body and soul.

Examine Your Negativity

To release yesterday and begin anew, sit down and write a list of situations and people that you perceive have harmed you. Next, write from-the-heart letters to each person and every situation, expressing feelings that come from pen to paper spontaneously. Address each letter specifically; say and write: *Dear so-and-so or Dear It or Dear Self, this is how you have affected my life.* Write in guiltless honesty; use any strong language you need to express. Use just key words, phrases or whole sentences and pages of paragraphs—whatever comes to you. If you like, you can forgive, but you don't have to straight away.

Forgiveness sometimes takes many letters. Please understand: ***All is well and good in the process of self-realization and self-love.*** Upon completion of each letter, sign it to own its contents, fold it and tear it into three pieces, then set it safely on fire. As you watch the flames and smoke curl into the universe, say, "Please,

Lord, remove this pain from my soul and deliver this letter with love." Watch the fire take your hurt away.

To accomplish a new direction in your life, do this letter-writing and releasing on a daily basis until you feel a major shift in your soul and are at peace. Continue this cleansing activity as your days ebb and flow, getting yourself into the habit of understanding and releasing, watching and feeling your feelings and then letting them go for health and personal harmony. Life will clear for you.

We are love and we are God who makes perfection in us. The new space that is empty from let-go anger and pain is filled to the brim with the love of who we are. The more honest releasing, the more freedom we realize. The more pain and unhappiness is let go, the more freedom we allow into our souls. When we raise ourselves up to loving forgiveness of self and others we heal.

Love.

Forgiveness.

Release.

These are the greatest healers.

The Missing Link

In all due respect, the medical profession does not seem to recognize that we have souls. If our medical practitioners would spend more time seeking and discovering the why of patients' illnesses and the reasons for clients' unhappiness, then they would be our partners, equipped in helping us clear our own natural healing pathway. Loving care never steers us wrong, especially when we surround ourselves with people who do just that—care.

Life can be and is simple and complete.

Write and author the pain out of your soul any time. Always.

The writing will not be graded; it is only for you.

Try it now.

What do we really take with us?

We are here to have a spiritual experience in a physical body. Life on earth is a series of pure love/unlove experiences, and we get to choose! We can choose love. We can choose abundance and joy! We can have wealth and castles and items surrounding us. We are meant to enjoy, but what we take from this life is love through the interaction of our fellow man. We carry in our souls: gentleness toward others, love for self and respect for all without judgement.

Every time you need a reality check to see where you are on your love pathway, look at what surrounds you. If you are actually 'calling in' experiences in which you have golden opportunities to choose love, and do choose love, you will feel love around you. If you are hurt and pained, you can choose to hate the person and seek revenge, or love in spite of the act that caused the perceived agony. If you look around and see misery, find out where you've been unloving. This is watching your soul evolve and grow. When you notice that, in fact, you are pulling toward you happy, loving situations, then that is what you are projecting into your life. We are experimental, experiential human souls and most often we see a balance of love/unlove in our days. Pay close attention, for the painful, angry moments are rich with positive, evolutionary love potential for our forward growth to a higher self.

Try to project love today. No longer stay attached to the person with whom you have experienced negativity of any sort. Watch, forgive, release, and love, for of these the greatest healer in its simplest and strongest form IS LOVE.

Roughly, 6.2 billion people live on earth just now. If you asked each of the 6.2 billion what they truly wanted, they would say:

> **I want to be loved no matter what.**
> **That is the journey of human kind.**
> **Love me. Do not judge me.**
> **Let me be.**
> **Love me on my pathway.**

For all 6.2 billion, you know, I know and everyone truly knows that all of our pathways lead to this common place.

Love is home.

We seek to be home.

Love is God and home in all its perfection, as are we.

> Please take time to quietly ponder what you have just read and nurture yourself.

> You might re-read this section

Hands-On and Hands-Off Healing

The second half of our healing session is a hands-on time. Let me explain about the energy points of the body that are the focus of healing hands work.

Barry Neil Kaufman, author of *Happiness is a Choice*, tells of the regeneration of tissue in children. In his 'Nothing is Impossible' chapter, he explains that young ones have the ability to re-grow finger tips and heal wounds overnight. This is well documented the world over. Teens and adults, who become trained to believe people cannot re-grow limbs, nor heal rapidly, do not. Mr. Kaufman questions scientists' claims that older cells cannot perform, nor have the reorganization potential of cells that new baby and child cells do. If humans, of any age, can re-grow cells in the skin and liver, why can't we change our limited beliefs and the neuropathways that support them into healing the entire body, the complete self? In this new millennium, we are continually finding evidence that we can intentionally shift our inner chemistry. This is the subject of many medical studies. Mr. Kaufman coined a fresh and exciting word: ***bodymind***. He asks: "If happiness were a seed, what bodymind would grow from it?"

That old black magic, white magic, light magic—what is this thing called healing? I have pondered this subject for decades. It is a lifelong quest to fully understand. I pray that you will find the material shared here enlightening and that you walk away yearning for more. After fifty years, the last dozen spent as a full-time professional healer, I am still an eager student.

Our Energy Centres Called Chakras

To follow are sketches of the classic seven energy centres, called chakras, plus an awakening centre. I have added the Thymus Energy Centre as the eighth chakra. In meditation I learned that the ordinarily dormant thymus gland is evolving in the human body. I often see the thymus

unblocked in health-regained patients. The Thymus Centre is linked to deep emotions and the fluid abilities of a person to achieve. Being motivated to do so can be blocked in the thymus. Blockages are frequently due to missing experiences of love or past hurts.

The diagrams on the following pages depict the framework of the highly refined wellness energy system of Ayurveda. The Ayurveda medical philosophy, founded in India, was documented in Sanskrit as scientifically well developed since 1500 BC, far earlier than Ancient Greek or Chinese methods. It is written that the Divine's **Life Force** comes from above the body, as light radiating to the earth, and flows into each of the interdependent but distinct chakra energy centres in each person. The energy swirls and spirals clockwise through the chakra points, finally flowing out through the Base Chakra. The healthy body feels light, bright and has a full, harmonious sense of the partnership between the mind, body and soul/spirit.

What is this thing called chakra?
It is a field of light-energy-vibration connecting mind, body and soul with the God-Force. If this energy becomes blocked, moves counter-clockwise or stops flowing through one of the chakra points, it causes imbalance and the person can become ill.

We have twelve chakras in all. Four flow above the Crown (top of the head chakra) attaching the soul with the body from the Source (God). The remaining eight energy centres run in a straight line streaming through the body, from the soft spot of the baby's head (Crown Chakra) down the centre to the base of the spine just below the navel (Base Chakra). This light from the Almighty keeps us going. It is Divine Energy that flows into the body spinning in a clockwise direction through each of the eight wheels of light that finally grounds the body and soul on earth. Thus, we are connected from spirit to ground and anchored in present life.

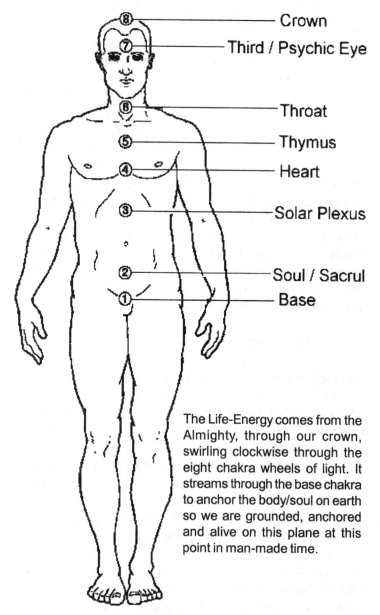

Crown
Third / Psychic Eye
Throat
Thymus
Heart
Solar Plexus
Soul / Sacrul
Base

The Life-Energy comes from the Almighty, through our crown, swirling clockwise through the eight chakra wheels of light. It streams through the base chakra to anchor the body/soul on earth so we are grounded, anchored and alive on this plane at this point in man-made time.

© 1999 T. Christian Keane
1999 Yale Graduate
Former student of Linda Lee Ratto

Crown Chakra: top centre of the head; where life force energy enters the body
physical connection: full skeleton, all muscles, skin, pituitary
mental/emotional: sense of selflessness, spirit, trust, faith

Third Eye Chakra: centreed on the forehead; connected to our psychic senses
physical connection: nervous system, brain, sinus, ear, nose, throat
mental/emotional: intelligence, awareness, imagination, intuitiveness

Throat Chakra: base of the neck; thinking and speaking
physical connection: mouth(teeth, gums), neck, voice, thyroid
mental/emotional: expressing oneself, criticism

Thymus Chakra: situated just below the throat; has been dormant in mankind; past life patterns
mental/emotional: deep past life emotion

Heart Chakra: chest centre, below sternum
physical connection: heart, circulation, lungs
mental/emotional: love, compassion, anger, grief

Solar Plexus Chakra: below breastbone, centre 'hole'; linear thinking
physical connection: stomach, liver, pancreas, small bowel, adrenal glands
mental/emotional: 'who-we-are', charm, charisma, confidence of self

Soul/Sacral Chakra: below the navel; all memories/feelings buried here
physical connection: hips, lower back, large intestine, bladder
mental/emotional: human relationships, power centre

Base Chakra: between anus & reproductive organs; where life force leaves body
physical connection: immune system, excretion, sexuality
mental/emotional: vitality, survival instincts, potency

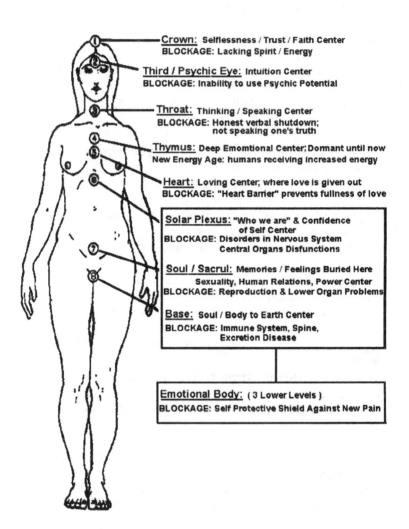

Crown: Selflessness / Trust / Faith Center
BLOCKAGE: Lacking Spirit / Energy

Third / Psychic Eye: Intuition Center
BLOCKAGE: Inability to use Psychic Potential

Throat: Thinking / Speaking Center
BLOCKAGE: Honest verbal shutdown;
not speaking one's truth

Thymus: Deep Emomtional Center; Dormant until now
New Energy Age: humans receiving increased energy

Heart: Loving Center; where love is given out
BLOCKAGE: "Heart Barrier" prevents fullness of love

Solar Plexus: "Who we are" & Confidence
of Self Center
BLOCKAGE: Disorders in Nervous System
Central Organs Disfunctions

Soul / Sacrul: Memories / Feelings Buried Here
Sexuality, Human Relations, Power Center
BLOCKAGE: Reproduction & Lower Organ Problems

Base: Soul / Body to Earth Center
BLOCKAGE: Immune System, Spine,
Excretion Disease

Emotional Body: (3 Lower Levels)
BLOCKAGE: Self Protective Shield Against New Pain

Your Private Session—Assessing Any Blocks

"Do I get undressed? What do you do to me physically?"

No, clients stay clothed and lay down on a padded table, much like a masseuse's. I say, "Relax and close your eyes if you wish."

To diagnose an energy blockage, I use a quartz crystal pendulum (any weight on a cord serves the same purpose). I hold the pendulum above each chakra, beginning at the base straight to the crown. I hold the pendulum steady and observe. The pendulum will swing the same way that your chakra point energy is moving (or not moving). If the energy is spinning in a healthy, clockwise direction, the pendulum will do so. If the chakra's energy is off balance, the pendulum will swing counter-clockwise. However, if the pendulum does not move above a chakra, then that chakra's energy has ceased its flow.

More Chakra Details

Emotional Body = the first three chakras:
#1 = Base
#2 = Soul + Sacral
#3 = Solar Plexus

If the first three chakras are *all* blocked, the emotional body is being shielded by an invisible barrier to the energy life force. Protection of the emotional body is often traced to personal events as far back as childhood. Anything that has not been dealt with, such as unlovings or pent-up anger, for example, can cause impediments to proper energy flow and health-filled living. This can build a defense screen against more pain, which only blocks the life force further. It can be a vicious dis-ease cycle and often an unhealthy pattern, which can be traced back for generations in a family.

As I move on to the centre of your body, I hold the pendulum above the heart. If the Heart Chakra is blocked, even in the person who is outwardly loving and caring, a 'heart barrier' can prevent the fullness of love from blossoming. Love is always there, truly waiting to be shown. God is Love in us.

The Thymus has been blocked and dormant in almost everyone. I have seen signs of it coming unblocked as a new age of increased energy unfolds. Watch this chakra space in the future! For Thymus blocks can be released when healing takes place as this energy centre spins healthily.

Throat Chakra blockage shields the self from voicing true feelings and thoughts. There is often lack of communication in a person's life due to buried unlovings. A throat block manifests as an inability to tell the whole truth, vocalize who we are, what we are thinking, and/or how we honestly feel. Truth will eventually and always does come out, sometimes in turbulence and often as dis-ease. We must speak truth to self and to one another for our life energies to flow freely.

A Third Eye Chakra block prevents the person from using his or her psychic ability and potential. Listening to our gut reactions and intuitive feelings is a first step in using this centre. Paying attention to messages in dreams is another use of the Third Eye.

Crown Chakra blockage materializes as lack of energy. If the first avenue of free flow life energies—God's faucet of energy so to speak—is slowed or stopped, the entire body is affected. *I have to get out of bed, I have to get going,* are typical thoughts that can be replayed in a person's head, if the lovelight is not allowed to enter the body and spin properly. Interruption of flow forces the person to work by sheer willpower rather than with the ease filled grace of Light.

Complete eight-chakra obstruction frequently appears as sluggish daily living. Every day seems to be an effort of massive will. Nothing is easy because of the hindrance the person has created against the healthy energy stream. Every task is a struggle: *I have to do this, I have to do that.* It is as if the person has stepped into a huge bubble of protective defense. It is okay living, but it is not a full life using the free-flowing grace of God's energy to the highest potential.

The Laying of Hands

If you've read any history, or some of the Bible, the physical laying of hands has been mentioned throughout time. Modern science touts the use of touch as an impressive healing and nurturing modality, even today. Clients have noticed, and I have seen, the energy flow from my hands. Sometimes it is a pulsing heat that is being transmitted. Others have commented on a glow, or my eyes even changing colour as I touch the point of pain. It is unique, which is why I work full-time for wellness. It is a healing gift to share, just as your gifts are meant to be shared with those around you, too.

After the pendulum assessment, I slowly move my hands above your body to redirect and unblock your energy flow and if you have a physical ailment, I will gently place my hands on the area in need. I begin at the base chakra and hold my hands above each of the eight energy centres in order: base, soul/sacral, solar plexus, heart, thymus, throat, third psychic eye, and crown, assuring that I give extra time and attention to any blocked areas as the pendulum indicated. If a client has mentioned a problem area, I will gently place my hands on, or very close, to help relieve the dis-ease. I end with the crown, where I place my hands to allow refreshing, replenishing energy to flow from the Creator through my fingers and into the individual for increased flow and lighter well being.

The lightness refers to the heavy, weighty effect of troubles, which have been lifted during the session by way of relaxation and release.

I help the patient sit up and sometimes I have to awaken clients, for they go off into a dream state. Clients mention a light feeling, light-headedness or even dizzying sensation. We wait quietly until he or she is ready to stand and then sit for a final chat. A conclusionary discussion involves comments on what blockages I observed. Usually the client shares what was seen, heard, or noticed during the pendulum/hands-on time.

Results & Residuals

"When can I see results?"

Often, clients see improved health and well-being results instantly, continuing for a few hours or days after a session. Some individuals need more than one session to get help in dealing with issues that rise to their consciousness. People may have buried hurts from as far back as childhood, or even other lifetimes, which may need sorting out.

After-session emotional and physical cleansing releases take enormously differing avenues because people are so unique. From acne and boils, to crying outbursts and low feelings, to giggles and giddiness, the entire emotional spectrum can be experienced after a healing session and for the next few days. The full healing process is dependent on how the person assimilates the shifts and changes into everyday existence. The direct effects of healing cleansings go away, followed by a superior sense of well being which seems to be permanent in the majority of people.

Healing Your Self
Daily Visualization
(Follow-up to Reading this Book)

Although I use a pendulum, and you can learn to use one as well, here I suggest visualizing your energy centres. If you regularly, morning and night, practice this technique, you will feel better.

To heal your self, sit or lie down and breathe in and out slowly, feeling each breath for a period of 5-10 minutes.

Centreing Your Self with the Earth

Beginning with your feet, see golden light coming up from the earth and moving in a circular, clockwise motion into your base energy centre. Allow this light to continue as a warm water river rushing, swirling clockwise up through your soul/sacral, up into your solar plexus, then swishing and cleansing your heart, awakening your thymus, and lightening your throat. Continue allowing this light to swirl up into your third eye and out through your crown.

Accept God's Energy Renewal

Now see the brightest golden-white light energy come into your crown from above. Feel the energy swirl clockwise into the whole of your head, rushing through your brain, eyes, ears, nose bringing fresh new energies there.

Continue seeing white light swirl into your third eye. Feel it bring brightness to your being, circling clockwise. Feel warmth and a bright renewal that is as fresh as morning's first light, allowing you to see more than you ever have before. Clarity is now clearer than you ever dreamed.

See the energy continue its heavenly flow to your throat where it lingers while surging your voicebox into newfound honesty and courage to speak your truth.

Allow the white energy to splash into your thymus where it waterfalls into a clockwise pool of bright light energy, awakening your gifts to be energized to the max.

Bring the white light from the heavens into a swirl of warmth as comforting as all the love you can imagine into your heart. Allow the energy to swirl and swirl, freeing all the love you have into a torrent of joy for all you see.

Feel the white light electrify your centre, the solar plexus. Feel as if the sun now finds you its home where it can shine brighter than any noontime you've seen.

Let the Energy Source flow freely into your soul/ sacral, allowing you to swish out any sadness and negative memories in exchange for the positive, love-filled memories.

See the clarity that the white light brings to what you choose to remember.

Let your being fill to the brim and overflow into your base chakra, swirling clockwise and into the ground to keep you as a star on the earth, sparkling brighter than the highest, strongest star.

Now allow yourself to continue breathing and surging with newfound energy and light-brightness. You are renewed and ready to flow into your day or dreams as if an inner glow were lighting your way no matter how dark your surroundings.

Repeat bright light clockwise visions any and all ways, at any and all times, for increased healing of the self.

Healing Stories

Over the years I have worked with hundreds of people being healed by the Almighty through my hands. Allow me to share some results that may change your point of view concerning *your* body's healing potential.

**Professional Recommendation Letter
RE: David Cunningham, Master Healer
1992, London**

To Whom It May Concern:

In the hope that other doctors may be interested, I would like to record my experience of referring patients to a healer, David L. Cunningham, for treatment of various health problems.

My first referral was actually my own daughter who, on her return from a skiing holiday, was crippled with an acute exacerbation of chondromalacia (damage of the kneecap and cartilage), which was not helped by intensive physiotherapy or orthopedic consultations. Two healing sessions (with David Cunningham) completely relieved her pain; as a sceptic beforehand she was particularly impressed by the tremendous feeling of heat radiating from the hands of the healer. Even more dramatic was the experience of a trainee doctor in our practice who was losing three days per week from work because of severe chronic iritis (iris swelling, redness, tearing), which was not responding to treatment at Moorfields (rehab centre) but which was completely relieved by two sessions of healing and has remained in remission since.

Other patients treated included a man of 22 with chronic severe eczema who had complete relief, as did his mother with recurrent asthma. A man of 70 who was house-bound with a stroke recovered enough power in his affected arm and leg to allow him to do his own shopping. Another patient who had been unable to work for a year with severe lumbar disc problems was able to return to work after two sessions.

Results like these are difficult to credit, but observing the healer at work one is aware that something meaningful is happening to the patient and that a powerful source of energy is being channelled through the healer's hands.

It is well worthwhile to refer any patient for healing, particularly if they are not responding to normal treatment. It was made easier for me to make the first referral because of what I still think is a minor miracle which happened to a friend and patient of mine three years ago. I had tried every treatment I knew for her severe post-herpetic (herpes skin disorder) pain of two years standing, including acupuncture, local steroid injections and deep hypnosis, all without effect. She referred herself to the healer who produced a permanent cure in one half-hour session.

Of all these patients, the most abiding memory is of my trainee lady doctor crying with the pain of her iritis (iris damage and swelling) despite heavy doses of steroids and the next working day happily smiling in her morning surgery (rounds).

> Dr. S. E. Browne, 1992
> Kent, London
> United Kingdom

1960s From My (DLC) Personal Journal

*** One particularly vivid Monday night, my eyes bolted open to a rustling in my bed. A huge, muscular, hairy arm appeared wrapped around me. *OOOOh, what is going on here?* I swallowed hard and looked slowly from side to side, straining to see the rest of 'who' was holding me—but there was no one there—just the big, strong arm protecting me.

My heart raced wildly.

It vanished!

Suddenly, a calm blanketed my entire body and I sensed that an arm of the Almighty had been sent to make

me feel safe. Comforted, I fell fast asleep. Upon awaking I reflected on the midnight vision and realized the Infinite was with me and had shown me an actual symbol with which I could relate. This made me smile then, as it does to this day.

*** Jacqui, an American with schleroderma (sclerosis of the skin) came to my office in London's Hale Clinic. A woman of means, she had paid dearly for countless arrays of treatment over the years, yet still lived in daily pain. Her home had been adapted to allow her to eat, sleep and bathe all on one level because she could no longer climb stairs. Within three sessions, she was healed. Understandably, she was excited and wanted to tell the world of her relief! Jacqui flew back to share her news with California loved ones but always kept in touch. One day she called asking, "Why don't you come to California for a holiday and help people here?" Through Jacqui, I eventually moved to the U.S., a place I knew I would call my healing home. Miracles happen to clients and thereby miracles are sent my way!

*** A young mother, Nicole, presented herself with a massive case of eczema running up and down her arms and covering her back. The pendulum linked this physical malady to her repressed emotions. Within a span of two weeks and four sessions, her skin was completely healed and tanning nicely in the summer sun. Nicole was overjoyed, as the previous summer the skin was oozing so profusely, she was forced to stay indoors. Her five children are thrilled to have Mum back in the fun with them.

*** A little girl came with a broken wrist that was not healing properly, according to the physicians' X-rays. Maria was not old enough to understand the energy process completely, nor was it appropriate to go through the counselling portion of a session, so I simply did a hands-on. After a few 10-minute sessions, the X-rays showed the arm strong and well once again.

Part Two
Where Do We Go From Here?

Nothing is New,

Healing Stories

Reincarnation & Going Within

Spirit Stories

That Sixth Sense

Healing Stories

The New Millennium

Healing Stories

My Story

Nothing is New,
Simply Told in Differing Ways to Touch YOU

A Choice to Be a Messenger

I began hearing a voice very early on, but did not realize its importance. I simply received information openly in dreams, prayer and a knowing deep inside. I only shared this with friends and colleagues. Then one day I began to take note when I saw how my hands spontaneously healed. Ultimately, I faced a turning point: what do I do with my life and my gifts? I'd been working eighteen-hour days in the hotel industry, what now?

Events in my life, such as managing hotels in tribal Africa and being held hostage for three months by Saddam Hussein, helped me make a choice. I do healings full-time, focusing on a blend of intuition, counselling and energy through the hands. This mind-soul-body education during client sessions has been a powerful miracle in thousands of lives. Honestly, how could I stop this gifting? Each day I am compelled and overjoyed to do this blessed work.

I have read many works on reflection, contemplation, and inner healing and yet I cannot learn enough! In the next pages, I share with you some ideas melded together with the Lord's guidance. Enjoy!

Allow Your Tune to Play

A favourite gifted meditative channeler, Julie Soskins, shares a wealth of knowledge in her book, *The Cosmic Dance*. Her credo is simple: it is of utmost importance to be still and make time for inner peacefulness. This is not a new message and we need not spend twenty-four hours in solitude, but a little a day will help enlighten, balance and align us for renewal with Source's energies. In this work-a-day world, with beepers and cell phones we even

take to bed, quieting down will allow our own musical note—our unique tune—to surface. We will find it easier to harmonize with our neighbours. We all have favourite music. Ms. Soskins says our inner notes harmonize with our favourite music and that when we feel in sync with an individual, we are meant to work in concert for each other's higher good. Look around. Try peaceful harmony with a new person today!

Ms. Soskins also believes that the thymus chakra is awakening as our eighth energy centre. Isn't it exciting for us all to consider another energy source in which we receive even more of the Divine's lifeblood?

Caroline Myss, Ph.D.

As we evolve and grow, it is comforting to read that other people have received similar information about self-love healing and the power of reflection. Caroline Myss, Ph.D., author of *Anatomy of the Spirit,* shows us how to love in spite of the centuries old, cultural training we have experienced surrounding vengeance and 'an eye for an eye' mentality. Dr. Myss instructs us to regenerate an ample internal supply of love inside, ever-ready to give when we encounter a person who has offended us. Dr. Myss' groundbreaking work weaves the imagery and cultures of three faith systems (Judaism, Christianity & Hinduism) and uses their common symbolism to describe what millions feel we must do together: respect and love one another in peace.

Dr. Myss says we may bring in the white, light energy from the Deity any time. Daily, we can visualize this energy coming down from the heavens through the crown chakra and into the third eye, so we have the energy to say to any offender, "I send you love. You are in my life for a Divine reason and I chose to see that Godliness part of you and not focus on the shadow side." Dr. Myss calls this attitude "spiritual elegance", a way to look at the

choice to unconditionally love all beings. She suggests that we can be stuck and then ill, if we keep resenting some one or ANY one in our past.

Honour all.

Good health will be our reward.

The more I read, study and assimilate, the more I realize I do *not* know. I receive information through prayer and meditation, from books and messages from friends and strangers in telephone calls, letters and e-mail. These "guardian angels" are customized God helpers who aid in my understanding the Almighty. These guide-messages come in forms to which I easily relate, and help me continually develop a personalized relationship with the Divine. What a comfort.

> Jesus said healers can be used by the 'Higher Forces' when we love all of humanity. Healing is love energy used in the right way.

The Choice: Learn from Unlove or Love— Which Do You Choose?

Well, of course, we learn through the opposite of love, too, but *must* we continually live through unloving lessons to know love? **Must we** discover the centre of higher existence and rediscover what love is by its **opposite feelings**? If we look inside, we know the truth: **we do not have to be unloving** or keep experiencing unlove to comprehend what love is or is not. We might select only love. We **could** and we **can**.

The Infinite, through us, is born and reborn to forever experience unique ways to show and feel love. In every situation, there is **always** opportunity for love—new and fresh, yet constant and eternal—all at the same time. Each encounter with our neighbours can develop the fullness of what love can be. Every soul has opportunity

upon opportunity to attain the internal and external quality of total unconditional love:

> To be Love,
> to do It,
> to give It—
> to self and fellow man—
> this is the soul's ultimate goal.

Moving On From the Earth Plane

Once the soul has reached this height of wondrous all-loving existence, fully realizing itself as a love-filled likeness of the Creator, the soul can choose to spin off the earth plane (physical death). The higher soul can then become a teacher guide for others, either in the world of spirit or side by side with the other souls in physical bodies on earth again and again. Each soul's journey of discovery can take hundreds of lives to attain mastery. (Please see the diagram wheel in the reincarnation chapter, page 56.)

What is frequently missing in our current world is the teaching of this information. The majority of mankind goes about life haphazardly, some say unconsciously. Who teaches love? Who embodies non-judging behaviour? People do not model this behaviour, nor do our entertainment venues. We are most frequently taught to judge, separate and alienate from one another. Please consider how this truth affects us from the very beginning as children. Often our leaders teach one thing, but do and show something else. Few walk the talk.

As spiritualist, modern philosopher and teacher, Neale Donald Walsch, states in *Conversations with God,* a trilogy of books depicting an intense five-year journaling conversation with the Creator:

Yet here is the greatest Divine Dichotomy: The greatest complexity is the greatest simplicity. The more 'complex' a system is, the more simple is its design. Indeed, it is utterly elegant in its Simplicity. The master understands this. That is why highly evolved beings live in utter simplicity.
~Neale Donald Walsch,
Conversations with God,
Book Three, Chapter 19

Love.
It is that simple.

Healing Stories

*** An 8cm endometrial cyst was found in Althea's ovary and she was due for surgery when she called. We worked for three sessions in the three days before the scheduled operation. The doctors performed an ultrasound before operating and found the cyst reduced in size to the point that Althea was no longer in danger and cancelled the need for immediate surgery. In these cases, the follow-up chakra meditations described in your private healing section (pgs 23-24) help to continue and complete the healing process and most often eliminate the lumps or cysts altogether.

*** A British rugby player came with fifteen years of aches and now pains in his ankles and thumb (which he'd broken numerous times). After one session, his limping, aching and throbbing have been eliminated. Close to a year later, he is still pain-free. Since he uses computers and cameras in his business, he has a new lease on enjoying pain-free work and fun!

*** While I was living in America, I learned that, remarkably, senior citizens are as able and happy to shift their mindsets as any other age. John, age 68, flew in from Alabama for a weekend of intensive work. When he called, he had just been dismissed from the hospital and sent home to live out the rest of his days. We reserved three sessions in three days to help him cure the bone cancer. He used a cane, but carried it in his arms on the way to the hotel after our first session! By the end of the weekend, he stood taller and walked with no hesitation, nor pain anywhere. The hospital tested him immediately following our weekend and there was absolutely no trace of cancer. Of note, too, was the news that John decided to reunite with his sister, whom he'd not seen or spoken to for years. This was an extra joy. Healing energies frequently spill over into surrounding family members' and friends' lives.

*** Austelle, age six, developed poor eyesight. After one session, he no longer needed glasses.

*** Scotty had full body-joint pain from juvenile arthritis. Barely walking because of his stiff legs, he went to the physical therapist at least three times weekly. We decided to work in several short 5-10 minute hands-on sessions over a few weeks. Scotty no longer needs therapy and is running and fully participating in school sports.

1970s, Sedlescombe, UK From My Journal

*** The world of spirit voices was not very active in my teens and twenties, perhaps because I kept ignoring them. You know that voice inside you. Often the words just seemed an average and common part of my life. However, one particular night I had an astounding sixth sense event. My bedroom was directly above a friend's mother's quarters. After lights out I awoke exactly at 2 AM per my alarm clock and saw this mum come up through my bed and suspend above me. She said, "David, please tell my son that I am all right. There is nothing to worry about."

"Oh, okay," I said simply and she vanished. I sensed she was on her way to the world of the spirit and I fell back asleep. Remember, I was used to that sort of thing happening, although not quite as vividly! At breakfast I arrived to distressed faces. My friend, Hugh, said, "David, I have something to tell you." I interrupted, "Oh, Hugh, I know. Your mother died at 2 AM." He glared at me in disbelief. I continued, "She told to me to tell you not to worry, she is just fine." Everyone in the room sat very still, shocked.

*** At about the age of twenty, a significant healing through my hands was on a young boy named Len, who was jumping on a trampoline and fell, dislocating his knee. Instinctively, I settled him down, placed one hand on top of his kneecap and the other under his knee and gently straightened his leg. The pain was gone. Amazed and grateful to have helped him, I slept satisfied with my job that night. Could I heal many others on purpose and at will? I slept fitfully without worrying about it. I suppose I knew I could heal, if I chose.

1972, Brighton, England From My Journal

*** I was asked to visit a friend, Jean Brown. Upon arrival at her house, I was greeted by a neighbour and told that Jean was so unwell the doctor was also summoned. I waited with Jean, but as I sat with her, I realized she was in massive stomach pain. Intuitively I said, "Look, I know this may sound crazy, but may I place my hands on your pain?" Jean desperately agreed and I placed my hands directly on her tummy. Within minutes her pain completely disappeared. Jean and I were astonished.

1990s, English Countryside From My Journal

*** "Would you please come do some healing with my cat?" I heard a Mrs. McKenley say on the telephone. *Cat? I could, I supposed. Why not?* Pets are important friends and such loving souls to humans. "I'd be happy to, Madam," I replied. I drove the fifty miles to a small vintage, terraced house. Mrs. McKenley opened her home to me saying, "I know Inkie's nearing his end and I want his last days filled with more action, more energy, more fun!" Mrs. McKenley introduced me to a beautiful, old black cat who was her companion for almost two decades. I placed the cat on the coffee table and worked through

his chakras. He lay calmly and cooperatively for an hour-long hands-on, as I explained energy healing to Mrs. McKenley. I then bid farewell and asked her to ring, letting me know how things worked out. I made my way back home from the kitty session. The phone rang as I opened the door. "You'll never guess what happened after you left," Mrs. McKenley said, hardly able to contain her voice. "I let Inkie out for a bit of air and watched him jump right over the roof of my garage!" She giggled through more details, still laughing as she hung up. Ah, the power of God's love for all living souls.

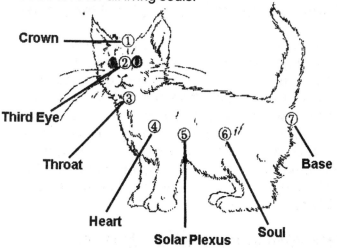

Crown
Third Eye
Throat
Heart
Solar Plexus
Soul
Base

© 1999 T. Christian Keane

*** Many clients bring in their dogs with a common arthritis ailment in their little hips and knee joints causing them to move slowly, obviously in pain. Robbie, who understands the energy centre healing system, owns nine dogs and was concerned for their comfort. After a couple of short, hands-on only sessions with several of his dogs, they are visibly walking and running in great relief. One of his dogs could not eliminate due to prostate problems and now urinates normally.

*** Petey, a thirteen-month-old boy, was brought to me by his parents, having suffered with diarrhea for several days. Since children cannot comprehend the counselling part of the session, I simply and gently gain the children's trust and lay hands on them for 5-15 minutes, depending on their attention span. The parents reported after one session Petey had no more intestinal troubles and was eliminating normally.

Reincarnation and Going Within

"…as to you, Life, I reckon you are the leavings of many deaths. (No doubt I have died myself ten thousand times before.)"

~Walt Whitman,
Song of Myself

> incarnation: the embodiment of a spirit or deity
> Incarnation: the union of divinity with humanity
> such as in Buddha and Christ
> reincarnation: a fresh embodiment; rebirth in new
> bodies of life; especially a rebirth of a soul into a
> new, human, physical body

Past lives are often revealed in client sessions, so I have studied it for decades. I discuss this here, to serve as a follow-up to your private healing. (Past lives might also mean a past stage of your life now.) You may think of reincarnation as a controversial topic, and you aren't alone. For thousands of years, people have wondered, debated, believed or not. Per the above definition, one cannot research reincarnation. In the context of our physical life on earth we cannot simply choose to die today, move about, then come right back and tell everyone.

I believe, at the moment of physical death, all we do is discard the body and carry on living in a different way. We may choose to come back as another individual or remain together as a combined and ever-changing vibration in God's world of spirit. We may be guardian angels to souls; we may 'study' with the Creator. Whatever you perceive this life-after-death place to be, it is. Your truth is your own reality.

There are intriguing books, television shows and Internet discussions centreed around people who have scientifically and technically died—what they saw,

experienced and are now sharing. This excites us to question—is their truth mine? We are here on this earth and we know little, or so it seems. To me, it is a question of faith because we cannot see 'life after death' clearly. If we surrender to the notion that life is a mystery, we can calm our curiosity or we can choose to explore evermore!

Going Within and Regression—
You Can Get Help or Do It on Your Own

Clients spontaneously recall past lives when they are on the healing table. By going within and addressing physical or mental ailments, things come into focus from the past. Anyone has the ability to tap into past lives without a healer or regression therapy, but therapists can help get you started. You can awaken and recall past experiences yourself by reading, studying and speaking with like-minded people.

For instance, a client from London came for help, already having recalled two of his past-life experiences. One life ended in a concentration camp in Germany where he remembers vividly being in a gas chamber with his mother. In a second life, he drowned at sea, which blocked his ability to swim in this life. He even tastes salt water whenever he relives that life in his memory. Through the aid of healings or regression therapy, one can rapidly access past lives, but often we have hints of remembering naturally without training. These powerful recalls can heal.

A remembered past may shed healing light when linked to a present-day phobia, such as this Londoner. Through visualization during the hands-on portion of my sessions, his phobia surfaced. By retracing the past-life, the basis for his recurrent, present-life fear of water stopped. Leftover phobias from a past trauma are rather common, and once released, clients go on to live freer and healthier lives.

Going Back in Time Can Be Fun

Personally, I have enjoyed going back in time under hypnosis and witnessed several of my own reincarnations. One remembrance was hovering over the cross of Christ—it was as real as my life today—colours, smells, everything! As I have mentioned, my angel guides tell me when we are born of this life we possess memories that we superficially forget. This forgetting creates a life that is fresh and new in our approaches to learning and experiencing love. We can find out more about our past lives in quiet times and dreams to bring back details to alleviate fear or re-live joy.

Encouraging Recall

A clear example of natural remembering of other soul experiences is in children. Their veil of forgetfulness is not fully learned or 'cultured-out' in their early years. Little ones remember a great deal of their past lives and can be nurtured to keep their memories present and helpful to them in this **now.**

One day, my niece Lynsey, at age two, toddled into the bathroom where her father, Jim, was shaving. Standing by his side looking up at him, Lynsey tugged on his trouser leg and said, "Daddy, Daddy!" Jim asked, "What is it, Lynsey?" Lynsey replied, "When I was a man before, I shaved just like you." My sister Margaret telephoned me and said, "David, Lynsey is weird just like you!" For several more weeks Lynsey recalled various incidents, which my sister reported. It seems Lynsey lived in a large house where she was served tea by servants. This was unsettling to my sister, because she is not inclined to study this past-life phenomena.

How can we better understand reincarnation, then, if we have not or cannot regress; if we cannot remember? Faith is the best solution here, not of any one religion, but faith in a larger dimension—faith in one's soul as it is part

of God. Most of us believe there is more to being human than what we see, smell, hear, touch, and taste. "Our essence or soul lives on" is a common thread throughout the millennia in most of the world's religions. Could we come out of nothingness to this life then back to nothingness? The mainstream in most societies say there is more.

A Divine Team

I am not a psychologist, but I understand the teamwork of the mind, body and soul. I come to the art of healing by way of the spiritual side rather than scientific level. 'Meditation' is a personal moving-away from the mind and it can take on any name if 'meditation' is not a comfortable term to you. Semantics do turn some of us off for reasons of personal history. Allow me to offer alternative names for looking within:

- praying	- talking to God
- thinking	- imagining
- talking to oneself	- exercise-induced peace
- runner's high	- feeling
- moving out of self	- communication with soul
- journal writing	- knowing
- artistic endeavours	- heaven's connections
- connecting	- knowings
- painting, sculpting	- experiencing
- listening to inner voice	
- allowing spirit to work with us and through us	
- personal conversations/relationship with Jesus, Yahweh, Buddha, angels, guides	

Name 'your time' whatever you like.
Keep all things simple for Truth is simplicity.

Adele Gerard Tinning

I enjoy Adele Gerard Tinning's work in *God's Way of Life* because we typically do not think of reincarnation as a part of Christ's teachings:

"Let me express myself through you, to the group (the world's audience), who are sincerely trying to bring forth my **new** teachings. Again I say, my teaching is **simple**. Keep it simple in your living it. You must first understand all experiences are for learning, for the soul's growth. Do not call it 'bad luck' or say, "God is punishing me for something I've done" when the reverse takes place. These are not reverses (negatives), but lessons. They may be reverse of what **you** would like but you would not learn this one phase of learning unless you experienced it first. Everything has its purpose and everyone has his purpose for being on your plane of existence. The experiences one goes through do not mean another has to go through them during this lifetime. He may have gone through them in a former life or former experience. Each one's soul growth is in different degrees of development. I say development because all will reach true perfection eventually. Your purpose is to help others understand why they are going through these so-called problems. If all could understand the growth they are gaining with each experience, their problem would become easier and joy would radiate from their countenance..."

Another Jesus Message:

"When I said, 'No man cometh unto the Father but **by** me,' I meant LIKE me. I was on earth many times before I was Jesus the Christ. I had to perfect

each stage of my perfection, the same as all of you are doing. My distinction was that I was the FIRST to reach the perfection of God. I had perfected the Christ or God in me.

Many have reached their perfection since that time and they also are one with God and are capable of doing what I am able to do—even greater things than I did, they are doing. These are all Master Teachers. They are helping other souls who are reaching their perfection with God. All are part of God. It is only when you reach perfection that you consciously recognize your oneness with God. I was but **an example** of the perfection each one of you **will attain** after your many incarnations. Knowing your ultimate goal is reaching this perfection is the secret to a happy life."

~Adele Gerard Tinning,
God's Way of Life
(Messages from the Christ)

Ms. Tinning explains that she received most of her book from her inner voice in meditations. Looking within to receive your own messages can take a variety of personal approaches and preferences. I use the classic, sitting in peace every morning and night. A ritual routine comforts me when I repeat the same things each day as I enter into private space. I pray a healing intention for people with whom I am focused on absent healings and finally I ask questions of my guides. I then listen and wait. Often I write down what I recall after the prayer session is over.

In addition, during any day or night—whenever or wherever I need help—I tune in to the Creator. Any time, any place, I ask the Deity for assistance. This is an everyday practice of what the Bible says, "Ask and ye

shall receive." Yet how many of us feel worthy of asking the Infinite for everything we need? This goes back to self-love. The Lord can hear all of us simultaneously. You are important. God can hear us any time and one at a time. It is not Santa Claus granting wishes, but it is you being a co-creator with the Almighty. You are worthy for you are part God.

Encouraging Words From A Client and Other Messengers

An affirming message addressing my own self-confidence-building stemmed from a series of healings I did with Mrs. Button, a 60-year-old lady with terminal cancer. After several sessions Mrs. Button passed away. Death of clients distressed me back in the 1960s because I did not fully understand what my healing work was all about. However, to assist and encourage me with the healing work, about six months after Mrs. Button's passing, I went to Josie, a clairvoyant. We were chatting when suddenly Josie exclaimed, "David, I have a soul identifying herself as Mrs. Button. She has come to tell you that the healings you did with her while she was in body helped make a peaceful and harmonious transition into the world of spirit." My heart sang with that news, for it was perfectly timed in days of self-doubt. I knew it came directly from Mrs. Button, because Josie had never met the lady!

On another occasion, a master teacher's voice rang in my ear and told me a major part of my work is helping souls transition to the world of spirit and bring them home to God. Yet another affirming reminder came in the form of a telephone call from my friend, Vick. "I have been hearing a voice saying 'call David, call David,' so I am calling," he said. "I am to remind you that a big part of your work is to bring people home to our Creator." I must require loads of reminders when I receive the same

message many times from all sorts of sources. Yes, God, I am listening and thank you!

Wayne Dyer, Ph.D.

To further illustrate the simple, joyous energy of quiet self-time, I turn to a modern Master, Dr. Wayne Dyer, who is notorious in crafting books that ask us to feel intuitively, listen to ourselves and know the power of God's healing energies. It is all a mere shift of our minds, says Dr. Dyer in Chapter Two, *Becoming a Spiritual Being,* in his best selling book, *Real Magic.* For just a day, he suggests forgetting all the negative judgements and putting aside total quiet space for yourself; then close your eyes and go within, leaving your thinking mind behind. This is your higher self, right there inside you, behind the busy, busy, never-stops-talking mind. Stop and listen. This is the you that never dies. You live on and on and on...

If We Plan Out Our Lives—
Why Do Some Have and Some Have Not?

Please consider this: "It is this inward sense of a wider self that we must trust, for it is in this direction that we can discover a (deeper) meaning for our surface (earth) selves." Arthur W. Osborn, a spiritual philosopher, in his classic book, *The Expansion of Awareness*, acknowledges a common feeling many have when considering the human condition: what about the seeming unfairness of physical conditions in which people subsist? From congenital disabilities to ravaging illnesses, Osborn tells us this is evidence that we are having more than a couple of lives for experiencing a variety of love-settings in a "cyclic series of expressions of our deeper self(ves)" until we realize our evolutionary highest spiritual self. The present life is not all, **and** no matter what the conditions, we can love and be loved.

Mr. Osborn continues his logic by highlighting two elements of his evolutionary law: *The Logic of Multi-Existence* and *The Mechanism of Karma*. It is fascinating that in any given decade and century the world's philosophers have believed in this reincarnation issue time and again, yet many still resist even the concept! We still balk at the idea of multiple lives or dimensional living called reincarnation, incarnation, past lives and living beyond the veil. Why? Is it fear because we cannot 'see'? Go back to the statement above, perhaps look back at your religion; we all have the common belief, no matter what the religious persuasion, that *there is more*.

We are where we are for the good of personal, higher development within the bigger picture of our world's cosmic drama. Mr. Osborn, in *The Mechanism of Karma,* describes the physicality of our bodies as the locomotives of Karma. Our earthly form gives us the physical sympathetic means to come to the planet. Then we form relationships with groups of people while excluding others because of an innate sense of absence of vibrational response (this can be called lack of chemistry or not feeling comfortable around someone). Mr. Osborn says this is our destiny plan, not to be born in perfect tune with *everyone*, but with the ones who will help us on our sacred path to higher self.

Karmic Recall
The re-membering or carry-over from one life to the next can come to us as a feeling of the familiar. Even in new situations, *deja vu's* and hauntingly repetitive phenomena give us the sense, much like the movie *Groundhog Day*, that a day's events can happen over and over until enlightenment is achieved. People who are open often feel these familiar sensations and act on them. Osborn states it so: "(our current)...bodies would be seed-pods from which stem forth the successive incarnations."

Nature has cyclical rhythm; it would be odd if our souls did not participate in this universal process of 'recycling'! By virtue of our birthplace within certain families and communities, we live out our plan without even 'knowing' the plan—unless we choose to try and recall why we're here. Who says it's only one shot, one plan?

You know the answer.

So do I.

We have hopes, dreams and knowings that...**we will live on**. This is paramount when we look at reincarnation: "The present is growing into the future, which we ourselves inherit...We also participate in the fate or Karma of our group or country," Osborn says, and I agree. That is one explanation behind huge quantities of people sharing in disasters and benefits if the energies of the separate souls require that special group experience. Nothing is accidental. We are right this very moment moving and generating energies for manifestation in creation of our futures. Doesn't this give you a tremendous surge of Divine hopefulness?

It literally brightens my life.

We co-create. We shift. We grow. We heal. We never die!

Love lived well within this life reaps tremendous futures for us all.

Interconnectedness

Do you see how intricately woven are the three concepts: going within, reincarnation and the so-called sixth sense? For simplicity, I concentrated on each in separate sections in this book, but they are intimately interwoven. Focusing on the individual concepts will help us along in understanding and clarity. Each is a subject worth studying for years. (You may wish to read further; selections have been provided in our resource section.)

Goal of Reincarnation

Remember the main purpose of revolving souls through reincarnation is: To attain, give, and be unconditional LOVE to self first (without ego, without vanity) then to fellow man and woman.

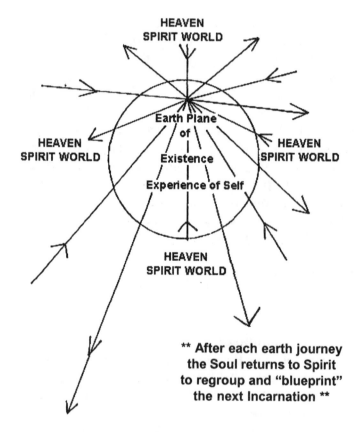

** After each earth journey the Soul returns to Spirit to regroup and "blueprint" the next Incarnation **

>> At completion of
**TOTAL, UNCONDITIONAL LOVE ACCEPTANCE
the Soul returns (to Heaven & the Spirit World)
to carry on with Spiritual Life, or chooses
to Incarnate to be a Teacher of Love**

What to Do with Our Daily Choices—
Love, Revenge, Fear?

So we have this life to live. How do we use all of this information? Allow this example to go deep within your consciousness: If someone slaps me across the face I know immediately who I am. I will either hate and seek revenge with that person or I will lift my vibration and love that person anyway, unconditionally. Again, this type of 'choosing moment' shows me exactly who I am and at what stage I am living along my journey to attaining a higher, more loving self. If I am being always loving, I understand the balance of life, the pros and cons and still I choose **love.**

Ponder this ancient Chinese proverb:

Before seeking revenge
First dig two graves
The first for yourself
—Because part of you will die by revenge—
And the second for your victim.

If the evolution of the soul and the eternalness of the self, along with the credo that love **is** our purpose, were taught to our children at a very early age, our human race would evolve higher. If children were shown this love in our word and deed then they, in turn, would act no other way. Love and respect must be taught and lived-out in our churches, temples, homes and schools. Rather, now in place of love, there are a great number of fear-based teachings.

Fearing the Almighty and feeling guilty about our lives is not teaching love. If leaders would go to their podiums saying, "We need to change. We've made a mistake. We may have needed these societal rules and regulations long ago, but now as we embark on the dawning of a

new era of energy, **we must teach loving all without judgements**. Love and respect one another. That is it, the ALL." If this became a daily teaching through word, deed and thought from every single being we met, our communities would all flourish. The truth of the great Masters is LOVE, pure and simple.

Love Thy Neighbour as Thy Self or You Can Get Sick

Be at peace with God's gift: your physical body, mind and soul. Love your self and partake of your gift of self. Notice that when we are at peace and harmony with those around us we are well and healthy. When we have discord—fears, guilt and uncommunicated notions of hurts kept inside—all can form dis-ease.

Did you ever look forward to a sick day just to be alone and quiet?

Do you have to be ill to rest and enjoy stillness?

When we are still, allowing hurts to fly freely into God's arms, we have room to let the Divine energies flow inside us. Allow the bright light in and use it to shine as it was meant to be. We are often not taught how to deal with our emotions by explaining, expressing, and sharing with others. Pent-up feelings block our loving energy from God.

Be still.

See.

Listen.

Act.

Give your past hurts and pains to the Almighty for freedom to live in health. To help you release buried emotional pain, please allow me to re-suggest this form of therapy noted in your private healing session: With pen and paper write down names of individuals and the situations that you feel have harmed you. Then write a personal letter to the person or situation, in total honesty, stating how you have been affected. Without guilt use any

language (four-letter words are acceptable). When you have finished the letter, sign it to affirm and confirm that it is you on paper, then tear it into three pieces and, in a safe place, set fire to it. As it burns state: *Please Lord remove this from my soul and deliver this letter with love.* A letter-writing exercise can be done several times until you feel free of the burden that is buried pain.

LET GO.
LET GOD.
BE.

Some Are Teaching Children (and Adults) Well!

Madeleine L'Engle, Newbery award-winning children's book author, wrote *Trailing Clouds of Glory, Spiritual Values in Children's Books*, a discussion of her children's works. The book's conclusion includes Wordsworth's eloquent confirmation of incarnation and reincarnation. Ms. L'Engle wrote: "Only as I keep in touch with the child within my very grown-up body, can I keep open enough to recognize the God who is Love itself, as that Love is revealed in story...and if they (my stories) do no more than remind us that we can't help loving God, for God is Love itself, then that will be enough.... For Wordsworth, as for most of us, the things which I have seen I now can see no more...stories (ones with spiritual values)...my stories...are reminders of that Celestial Light, and what Wordsworth means by: "trailing clouds of glory do we come from God, who is our home." Here is the actual poetry:

There was a time when meadow, grove and stream,
The Earth, and every common sight,
To me did seem
Apparell'd in Celestial Light.

Not in entire forgetfulness,
And not in utter nakedness,
But trailing clouds of glory do we come
From God, who is our home:
Heaven lies about us in our infancy!

~William Wordsworth
Intimations of Immortality

"We live in succession, in division, in parts, in particles. Meantime, within man is the soul of the whole; the wise silence; the universal beauty to which every part and particle is equally related; the Eternal One."

~Ralph Waldo Emerson
The Over-Soul

Spirit Stories

<u>1960s, England</u> <u>From My Journal</u>

*** One Christmas a group of a dozen friends and I drove down to the southeastern coast of Britain to a favourite old estate and vacation area. We pulled into the grand and gardened drive of a vintage mansion, circa 1800s, for the Christmas party and overnight. As the host showed us to our rooms, we climbed to an unlit floor landing. "Sorry," the host apologized, "that light has never worked since I bought the place." We didn't think much of it, although as I opened the room in the darkened hall I felt an atmosphere of heavy electricity. I didn't say anything, but I knew I felt SOMEthing as I entered and set my suitcase down. After lights out and deep into the night, I awoke to a knocking at my bedroom door. "Yes, who's there?" I called. The door opened with a loud, slow creeeeeeeek but no one entered. Suddenly all four walls were banged—bam, bam, bam, bam! The door closed. I'd recently been getting more and more spirit contacts and shrugged it off as a simple ghost visitation and fell fast asleep.

The next morning I mentioned this to our host. "Yes, no one ever wants to sleep a second night in that room," he explained. I nodded, understanding, and decided I'd sleep there anyway. No more disturbances showed themselves—the next night, anyway.

During that Christmas respite, I did a little thing I'd been known to do with my friends—play with my psychic intuition. I sat with a fellow guest who was an artistic film director, Peter Howitt, known for the British *Carry-On* films. During our impromptu psychic reading, I saw a vision: numerous people clad in period costume around a grand old estate. "I don't know what is coming up in your future or if this is from your past, but I see a very lavish scene of the Elizabethan era," I shared. Peter said it was all very interesting and we parted, Peter deep in

thought. A few weeks after the intriguing Christmas vacation, he rang, "Cunningham, you are a witch!" "Yeah, yeah," I said, laughing. He continued, "You remember what you told me over Christmas?" I acknowledged I did. "Well, I've signed a contract to do an Elizabethan script entitled *Anne of a Thousand Days!*" I was delighted for Peter and that my clairvoyance was lucid and correct.

(Another "coincidence" in my life to assure I have support and encouragement was meeting Peter again. Thirty years later, in 2003, Peter and I bumped into one another, when I moved to Malta for a period of healing there. It turned out that I stayed in Peter's old house! Try taking a look at your own life—who keeps coming into it? What can you learn from them? These people are important to our personal evolution.)

That next spring my friends and I planned a trip to a different manor house, so I researched about the house's past. I discovered that Lady Hamilton was the previous owner. Lady Hamilton was documented as the mistress of Vice Admiral Horatio Lord Nelson, a renowned 18th century British Navy leader. With an historical perspective in mind, three of us journeyed back to the grand house. After our arrival we perched on the balcony taking in the ocean's mist. Salty breezes sprayed us lightly with the sea. As we pondered life, a cloud moved directly and intentionally toward us. We sat dumbfounded as it wafted straight through us and past the open French doors of the mansion's dining room. We followed the mist cloud and witnessed the materialization of Lord Nelson and Lady Hamilton in elegant formal dining attire! They had a little romantic liaison right in front of us by the very dining table they'd used in their earlier lifetime. (We'd read in the brochure that it was Lady Hamilton's original furniture.) In wonder, we three gazed as the two intimately spoke to one another. We could not hear what they were saying but it was obvious they were most pleased to be together.

Suddenly, Lady Hamilton glanced right into my eyes, causing a fright that moved me to run right out of the room!

Strange events continued throughout that day. For instance, the parlour's hand-painted, cream-coloured grand piano had been transformed by the new owners into a cocktail cabinet which housed a record player. While we played music, the record either stopped, the needle scratched over its surface or the turntable speeded-up and slowed-down at will. After those three episodes happened one right after the other, we wondered aloud if we'd unintentionally upset the spirits.

Bedtime arrived and as we went to our rooms set to sleep, there came a crashing of glass, doors slamming and things breaking. The following morning we realized the Lady and her Lord had actually broken some of the mansion-hotel's prized lamps. I thought we'd be blamed somehow and couldn't afford to replace high-end antiques. How was I going to explain that *spirits* had damaged the owner's property? To our surprise, the host shrugged off the breakage saying, "It happens often."

1995, Ireland From My Journal

*** One day I received a phone call from a lady in Cork County, Ireland. She and her husband had read press on my spiritual energy healing and asked if I'd come to their son, who was ill with cancer. Daniel was seventeen and far too sick to travel. "Surely! If you can cover my fare and put me up, I'll clear my schedule as soon as possible," was my reply.

I rearranged the healing schedule at London's Hale Clinic and flew to Ireland. The moment I first stepped foot on Irish soil, I felt wonderful energy and a spirituality I'd not known. Seeing Dan, I also knew I was sent for peace in his life. He was a mere skeleton, obviously struck hard

by cancer and, although I felt for the young man, I never promise a family that life will be restored. Each soul has a free will to stay or go. I do healings for peace and tranquil energy flows, no matter what the patient's condition. Dan was in high spirits in spite of his symptoms and his parents were focused on my help, so I immediately began explaining the healing process. The weekend was filled with incredible healing sessions and the family asked that I return the following weekend. Although Daniel's love shone through, he was not very well, in spite of our work together over the course of the next successive weekends.

As I drove to the Hale Clinic one morning, my cell phone rang. "Dan has passed on," his mother stated through her tears. "I'll be out to see you this weekend," I promised. Dan's parents greeted my return with intense blame for his passing. I explained that even our own subconscious will is not always known to the conscious level in any of us. Dan taught us love and was still learning and teaching as he moved back into spirit. Physical death is sad for those remaining on earth who miss the cherished body-presence of loved ones.

This boy touched me deeply by helping me understand that we are not responsible for the choices other souls make. Dan had a plan which he was fulfilling both here and after he left the planet. I bid farewell and told the couple I was there should they decide they needed me.

They've not spoken to me since. (I had a house in Cork for years and even when we passed on the street, they had no conversation for me.) I heal in this life and help make the transition into the next dimension peaceful. Of this I know, but for some people it is difficult to comprehend amid their personal loss and grief. So it is.

Understanding the Spirit of the Land

*** My ex-wife, Petra, a hypnotherapist, organized a team of healing professionals in our new Irish homeland (1995-6). The group developed a full-week healing regime offered to clients as a getaway time for private inner work and reflection. People came from around the world for healing of all types: aromatherapy, hypnotherapy, massage, reflexology, clairvoyant readings and reincarnation regressions. Tig Na Gile was the name of our farmhouse. It was a dream place for healing where we thrilled in helping others make enormous shifts in their lives.

Historically, the Tig Na Gile house was built on beautiful earth energy and has a wonderful feeling about it—pure tranquillity. This is one of the reasons healing work was always so comfortable, almost familiar to us there. One weekend just after we settled into the house, a clairvoyant friend, Anne, agreed to do past life regression about the land's history, in conjunction with Petra. Anne chose a stone from our land to keep in her hand and together we went to the healing room. First, I did a healing session with Anne, assuring all the chakras were in alignment. Petra then took over regressing as she does in hypnotherapy, taking Anne back in time through the house's ancestry.

The first message was that the name *Tig Na Gile* means 'House of Light'. Then came a vision during the first part of the 1900s; the clairvoyant witnessed a British army invasion when the people living on our property were killed by the soldiers. The Irish Republican Army took over and the house was used for gun running. Further back into the 15th Century there was a shack built on the land where the house stands now. Anne and Petra both saw

a married couple with a child wrapped in sackcloth. The woman was a healer who, apart from her spiritual healings, stitched wounds with salmon bone needles.

Further regression went back to 1201 where a hermit lived in a cave on the site. (The cave forms part of the house's current utility room.) He was seen as I now am, travelling and healing extensively. Anne and Petra realized that the hermit and the 15th Century mother were two of my previous reincarnations. Suddenly, I understood why I had been drawn back to Ireland for some sort of continuation, growth and full circle completion. This is why the land felt so welcoming from the moment I set foot on it.

Our house was dedicated to healing and loving care of people. We loved knowing that the house and its land have for centuries been used for healing! Except for the brief interval with the IRA, there has been little negativity. The low point in its history has been cleansed and the healing energies have been most profound in us and in our guests.

That Sixth Sense:
Intuition, ESP, Clairvoyance, and Perception

As far back as 1882, research was being formally conducted for a British professional society on what was termed 'supernatural powers'. The Society of Psychical Research was the early version of London's College of Psychic Studies, which I attended in the 1960s.

Professor William A. Hovey and his colleagues set up mind experiments and documented them in the book, *Mind-Reading and Beyond*, published in 1885. These studies encompassed a groundbreaking series of regimes, including the scientific approach to untainted study, which they hoped would clear up facts about mind activities and foster debate. Their goals were: 1) a scientific method examination of the nature and extent of any influence which may be exerted by one mind upon another, apart from any recognized mode of perception; 2) the study of hypnotism and the forms of so-called mesmeric trance with its alleged insensibility to pain, clairvoyance, and other allied phenomena; 3) a critical review of certain organizations called 'sensitive' and an inquiry whether such organizations possess any power of perception beyond a highly exalted sensibility of the recognized sensory organs; 4) a careful investigation of any reports, resting on strong testimony, regarding apparitions at the moment of death or otherwise regarding disturbances in houses reputed to be haunted; 5) an inquiry into the various physical phenomena commonly called 'spiritual' with an attempt to discover their causes and general laws; and 6) collect and collate existing materials bearing on the history of these subjects.

Professor Hovey's premise was that **no one is supernatural or we all have sixth-sense potential**. What is shown in some individuals as highly developed

senses is actually all part of Almighty's physical/ mental/ spiritual gifting; nothing is abnormal or normal, it just is and therefore not to be feared. This was important work because often people fear something they do not understand or cannot see, such as the working of the mind. As far as we've come in over a century, there still exists fear of the subjects in this very book.

Back in the early 1960s, I enrolled in a course at this same College of Psychic Studies to develop my sixth sense abilities studying under the tutelage of Don Galloway, a gifted teacher carrying on Dr. Hovey's earlier work. Don taught me how to use my psychic gifts to help people. Throughout my life, he has served as a powerful mentor and guiding light. To this day, we correspond regularly.

The Bus Comes Around More Than Once

A further personal connection with the College of Psychic Studies revealed itself later in my career. "Coincidentally" (though I believe everything happens for a perfect reason), I went to work in one of London's Park Lane hotels, where my boss was David F. Northey. During conversation, David informed me that his ancestor was none other than Sir Arthur Conan Doyle! It is such a small world. We, too, have remained lifelong friends. It seems that my angel guides made sure if I did not choose to connect with The College back in my early twenties, I would have surely found out about The College through my good friend, David, later in my life. If you, out of your own free will, do not choose to take one of the God's 'busses', if the event is important enough for your soul's development the 'bus' will come around for another try with you! Our Karmic, previously blueprinted lessons to be learned in this life will be communicated. The question is: will we listen?

Currently, numerous studies are continuing the College's work and are being performed throughout the world in revolutionary institutions such as University of California at Davis, Harvard, Princeton, and the Institute for Noetic Sciences. The refined research is specifically on the mind and its focus-power, the energy of prayer, distant healers, and resulting healings. Often the reported healing rate percentage with concentrated prayer as a healing modality is 10-40% faster than with people not held in prayer. Larry Dossey, MD's *Reinventing Medicine* (1999) chronicles this groundbreaking shift in modern science. There is a worldwide network of communities where members are asked to pray or concentrate mental energies, anonymously, for patients called-in by their healthcare professionals. Collective critical mass of healthy, uplifting heart and mind-energies are being documented and reported around the globe by hospitals, medical and rehabilitation centres in concert with all denominations of spiritual and healing groups.

Perception or Premonition: A Knowing

My extra sense sometimes tells me things I do not like to hear. One year, I found out (or knew from inner messages, dreams and my journaling) that the earth would have massive disasters...in the span of just two years time...

*** In early 1999, my angel guides gave me a message: "In English Time on the 11th day of August 1999, in the 11th hour and 11th minute, there will be a total eclipse of the sun; from that moment on, things—life on Earth— will never be the same. That moment will spark of the final stage of the Spiritual Awakening for Mankind." After this message the guide stated: "Then there will be a crack in the earth."

*** On August 16, 1999, a horrific earthquake in Turkey took thousands of lives. Another earthquake took hundreds more Turkish lives the following week.

*** September 1999, Hurricane season is the worst it has ever been, demolishing many Bahamian villages; half of some islands are still under water; I'd done some healings in a home on one of the islands and that house was saved.

*** September 1999, Eastern U.S. seaboard, N.C. and S.C.,·thousands of animals die as tens of thousands of acres stay underwater for several weeks; dozens of people perish, thousands left homeless.

*** September 1999, Taiwan, earthquake hit the island devasting over 10,000 homes, killing close to 4,000 people.

*** October 1999, Mexico, earthquake and subsequent mudslide covered entire villages, hundreds die, accurate count of people difficult.

*** December 1999, Venezuela, some 60,000 people drown in floods and mudslides.

*** Spring-Summer, 2001, over 400 tremors are recorded in California seismographs alone.

*** September 11, 2001, the World Trade Centres destroyed and part of Washington Pentagon devastated, thousands lost.

Disasters and earth changes happen continually, you may say. Yes, and I feel most of them before they happen. I have worked hard not to allow the potential devastation to take over my days.

I have always been extremely sensitive when perceiving things outside the realm of the standard five senses. I am also sensitive to spirit souls on all planes, any dimension. Often I receive messages ahead of earth events, which have proven time and again as truthful as the ones you've read in news reports. My sister, Margaret, is sensitive along with me and often families can trace this sixth sense gift through generations. Margaret and I frequently communicate across the planet without a telephone.

I struggle with feelings of compassion when a premonition, or Divine message, comes true and numerous people perish. In my prayers and meditations I've asked Source: *Why have so many people died?* My guides have spoken specifically to answer why numerous people passed away into the spirit: "They chose it. As part of their soul growth and progression, they choose to leave the earth collectively as a group. They may have wanted to be in the soul dimension during the next stronger energy age. Perhaps they will be guides or they had so much fear of what they were feeling as the millennium energies raise and they could not live on this plane facing their fears." Choosing not to be on earth feels foreign to us, yet not so strange if one looks at the whole of the spirit world.

Remember: Think of Death as a Passing, Not an Ending

I do not claim to know all, nor every person's thoughts by any means. I merely pass on information I receive to help others. I have much in common with countless people in the past. Historians have documented stories— for thousands of years—about people who see what is to be. We are referred to as: psychics, premonitionists, intuitives, sensitives, previsionists, preceptors, and many more names you may or may not have heard.

Arthur Osborn, mentioned previously, wrote in *The Expansion of Awareness*, One Man's Search for Meaning, about spiritual and past lives connection after his own dynamic personal experience when first meeting his mate. Before I tell his story, let me say that I realize we all know that some foreshadowing and assumptions are easy to make if we are close to someone or pay attention to an individual's character traits, habits and style. One could predict, for example, what types of jobs, homes, even food a person will most likely choose if he or she is closely studied as in a close friend or lover.

Mr. Osborn encountered a profoundly higher call, a message from a complete stranger. This was beyond 'normal' human assumption power. A passerby stated emphatically that Osborn was meant to travel to a region of the world not even imagined, let alone on his itinerary. When Osborn followed the clairvoyant advice and travelled to said country, he met a woman who was told in a loud clairvoyant voice to wait in this country for an important person in her life. Osborn tells, "... when I met the person in question there was an almost visual flash of recognition with a certainty which seemed born of prior knowledge." They later married.

Is this predestination?

Is this remembering from a past life?

What is this feeling of prior knowing—sixth sense, intuition or a reincarnation reconnection?

Edgar Cayce

One of modern time's pre-eminent psychics and a gifted medium*, Edgar Cayce, experienced a lifetime of continual, channelled information from Spirit Source. Over 14,000 readings, Mr. Cayce heard prescriptive remedies

* <u>medium</u>: person assumed to be a messenger between spirits and living persons; a sensitive spiritualist; seer; clairvoyant; having to do with supernaturalism and telepathy.

and shared secrets of lasting, inner peace and increased health. Through written records of his readings, chronicled at The Edgar Cayce Foundation in Virginia Beach, Virginia, he still sheds light and love on the real reason one is born with psychic ability—to teach others that our 'original and always' home is with our Creator; we never die but simply change forms.

Hugh Cayce is editor of *Story of Attitudes & Emotions* and writes that his father was a practitioner of "the whole man (woman) with an inter-involvement of all ramifications of man's past/present/future body/mind/spirit." The book sites a cadre of readings, spanning forty years and is a fascinating healing subset of Edgar's life work. He passed on the same message, in countless and differing ways, that it does not matter **what** we call or see or symbolize as representing the Almighty Him/Her. To awaken spiritually is to see and claim our heritage as **part** of what Edgar termed "First Cause" or God. We are part of God because S/He is the All.

An Edgar Cayce reading (#4021-1), from Hugh's Chapters IX and X: *Health and Healing* and *Love and Forgiveness,* tells how to heal ourselves by looking within. If all healing ultimately and completely comes from the Creator, we should be looking at our attitudes toward self and how these attitudes shift cells and create unwellness… "…how well do ye wish to be?…As ye give others, not hating them (but aiding them), to know more of the Universal Forces, so may ye have the more, for God is Love."

Illness Welcome Mat

How well have our cultures evolved to welcome dis-ease with our attitude training? Inordinate quantities of thought-free traditions teach small boys: *Don't cry. Men do not show emotions. Don't talk of feelings, they are signs of weakness. Be Tough.* Do we have to be unwell

to receive hugs or people's love? Most of my clients crave the love and respect I give. It seems rudimentary and simple, yet rare is the treatment from our fellow man.

You Deserve Love

We do not have to be sick or feeling awful or in grief to ask for and receive the attentions of those who care. My guides in meditation are shouting in the quietest, yet persistent ways: "Take heed: teach love. Talk and communicate with one another, especially our children. Allow feelings to flow, modelling this to everyone. Healing and wellness are our rewards."

Louise L. Hay, Ph.D.

Pre-eminent teacher and author of numerous inspired works including *Heal Your Body* and *You Can Heal Your Life*, Louise L. Hay phrases and rephrases these same messages masterfully: **Now is the time, here is the power**. No matter how long (perhaps even from past life patterns) we've behaved in unhealthy and destructive ways, we can shift and change NOW. If you are in a health crisis, you have the inner power to heal. In place of the old and ugly mental tapes we keep mindlessly replaying, Dr. Hay teaches us by offering countless affirmations to reprogram unhealthy thought patterns. I believe in Louise Hay's work, my work and our work together. I have seen minds shift into positive new attitudes, miraculously curing people in the gravest of conditions.

Bernie S. Siegel, MD

Dr. Siegel comes to the healing of people through traditional modern medicine. However, his spiritual journey is the editorial stream of his books. He ventured forth in healing after U.S. university medical training and found his scientific knowledge needed some filling-in—some colouring-in, if you will. Dr. Siegel teaches at Yale and practices surgery in New Haven where he helps heal, in

majority, cancer patients. His ground-breaking work surpasses that particular disease. His wellness mind-body teachings are the same, no matter what the malady. He melds human spirit and modern medicine into powerful healing practices.

A Physician's Personal Note

Dr. Siegel is an exquisite example of healthy personal and professional balance when he teaches wellness workshops with his wife, Bobbie. They embody a marvellous blend of what most of us have difficulty accomplishing in this world—balancing. During a seminar in Atlanta in which they taught jointly, Dr. Siegel told a story paraphrased as follows:

Bobbie and I try very hard to meet during the days I am in town. We actually make appointments with each other. One fine day, we'd made a date to have lunch at a favourite spot in New Haven (Connecticut). Now you must understand that Bobbie and I are quite close. Any couple that has five children can't help it. Bobbie has been instrumental in my life journey and in educating physicians and patients about the obvious connection between the mind and the body in treatment regimes. No kidding, you might say now. Believe it or not, not too long ago it was **big** news that the head is connected by the neck to the rest of the old body! It's huge news for people who spent their formative adult lives studying the anatomy of the human body but never studied the mind. Believe it or not.

I had a jump start being a pediatrician because, by definition, I connected with more than just the dis-ease but with the parents, the family unit and how they were dealing with it all. There was always a relationship in which to pay attention. Let's face it, a baby can't talk much, although I have been known to listen to babies, too.

To get back to our story—true to Bernie Siegel form, a patient was needing my time in such magnitude that I was running late. I did not have to call Bobbie. As I was rushing to the restaurant, I met her on the crossroads to lunch. At exactly the same time, we simply met-up (perfectly late together) and continued on to our meal together. Pretty good without a telephone call, right?

What's my point? People communicate. People who love each other and spend loads of time together communicate without speaking. If you care, you can communicate. This is being telepathic. Life is. Has any one done this in their lives with someone? (numerous people raised their hands without hesitation…) Ah-ha, see?

There you have it. We are connected. We simply have to listen. I concentrate my efforts on listening to my patients and their family members then tune in to them. I tell them what I know for sure. Their heads/minds ARE attached to their bodies and God gives us the free will to heal ourselves with healthy thoughts, visual pictures of wellness and hope for the future. With me as their partner in healing, I try to get patient families to see that they can improve by switching their inner tape recordings to Peace, Love and then Healing.

> (RE: Atlanta Workshop, St. Joseph's Hospital, 1994
> respectfully retold from LLR's personal notes)

Jane Roberts, Clairvoyant

In addition, *The Seth Material* written and channelled* by Jane Roberts (1970s) covers and magnifies the almost unfathomable power of our inner potential to self heal. Try reading Ms. Roberts' chapters: *Health* and *Dreams,* which explains how to use dream-time effectively to answer your innermost questions. There is much to learn

* channeler: one who hears or knows messages and information from an inner or outer source that seems not to be the person herself.

about our dream state and how we can replenish ourselves through self-directed dreams.

Dream What You Need

One Dream Tip: Before going to bed, write down a question you'd like answered, then as you lay comfortably to sleep, concentrate on your question, clearing your mind of all other things. When you awaken, write down all you remember. Do not wait; upon arising, write phases and words to trigger your memory. Do this for a month or more. When you read back on your dreams, you'll experience amazing insights.

Guides and my senses tell me: **Know dear ones that if you look, you will see what cannot be seen easily, yet has been there all along.** The immune system is yet another micro-miniature example of God's greatness in the physical plane. I can't see it but I know it's there… As Dr. Wayne Dyer suggests: you've always known it was there, that you of you's. Dr. Dyer is an exceptional speaker with lighthearted wit and wrote a book entitled: *You'll See It When You Believe.*

Perhaps it could be subtitled: *I'll Believe It When I Can't See What I Know Is There If I Look.* It's all in the vantage point we take. Nurture what you have been given. Healing, wellness and peace are our rewards.

Healing Stories

*** Lynn had been suffering from migraines for twenty years. She came to me through a friend, her husband, Mike. I laid my hands on her head and she instantly felt well. She described her healing experience: "I felt as if you drilled a hole in my head and the pressure was relieved. The pain is gone!" This one powerful experience eliminated her migraines. She has had slight headaches from time to time since, but no migraines to date, which is some four years.

*** Carol, in her early twenties, had been in a terrible road accident and used crutches, suffering with a high quantity of body pain. We discussed her accident, the energy centres and then had her first hands-on session. She aroused from the healing table and walked out of the room without the crutches! After a few more sessions, Carol is still pain free in all parts of her body.

*** Louisa, a rape victim in her early twenties, was brought to me by her mother. She had been in a full year of rape counselling with little constructive communication or progress. She lived with her mother, could not work or be alone, and generally was completely disabled in her life. I sat with her and explained my healing work, speaking quietly in a gentle, informational tone about the eight chakras and how they can become blocked by emotional and physical trauma. She was quite at ease talking with me. There was an amazing and uplifting change after the first session. It took seven sessions, but she is now living on her own and is a productive, vital young woman once again.

*** Bella, a friend of mine, lived in Hawaii where one day a kitten turned up on her doorstep. Bella was in the process of moving back to the mainland but rescued the homeless cat, named him Pineapple and moved the feline

with her. After settling in San Diego, Pineapple was hit by a car. He dragged himself back to Bella's doorstep where she scooped the tabby into her arms and rushed him to the veterinarian. Hundreds of dollars worth of X-rays later, the news was grave: Pineapple had a broken jaw and pelvis and the vet recommended putting the cat to sleep. Bella took Pineapple home where she tried nursing and feeding him with an eyedropper. All he did was lie in his basket, so Bella asked that I come to her home for a healing session. During one of a few visits to Bella's there was an astounding change: Pineapple awoke upon my touch, stood up and walked on all four paws to his feeding dish. Bella and Pineapple are still enjoying one another.

 *** Jacqueline was still experiencing severe chest pains, even after she had tried numerous medical therapies. Finally, she was willing to try energy healing. Before I conclude a session, I always explain that the healing can have far-reaching and surprising effects on the client over the next days, weeks, and perhaps years. Jacqueline felt much better after our first time together and scheduled another session. She shared that in between these two visits she'd had black liquid coughing up from her chest. "I am feeling good but what do you think of the discharge?" she asked. I told her, "You are being cleansed. I do not know all the answers, I admit; but the Almighty does." For three weeks this process continued as her healing energies worked toward wellness. Then one day she said the discharge stopped and she's feeling great now.

Dear Mr. Cunningham, 15 February, 1997

I would be grateful if you could take Gordon Thorpe's name off your healing list as he has passed into the world of the Spirit on the 13th of February. I know that the healing helped him mentally prepare for his transition, which was peacefully in his sleep, and you have our thanks.

God Bless you in your work.

Yours, Wendy

A Client, David's Story

I fell off a fifteen-foot ladder while painting my porch and cracked both wrists and ankles, fracturing one ankle and one wrist pretty bad. After the casts and slings were gone and any long day of physical activity, I developed a limp, favouring the leg. It was really bugging me because I love yard work. After every week at my regular job, I love spending the weekend tending my grass, trees, flowers, vegetables, and lake, but my ankle throbbed by the end of every week. Gardening was not fun any more.

David did a healing session with me I'd like to describe. After the initial counselling I learned more about the chakra energy points than I'd previously known. I'm a scientist. Everything is made of energy; it's basic Physics 101. It all made sense. So I asked Cunningham to concentrate his hands on my ankle for the hands-on part. As I laid down and closed my eyes, I saw so many beautiful colours swirling around, better than any movie. I felt David's heat above each energy centre even though he wasn't touching me. Then he placed his hands on my ankle. Immediately, I felt the electricity of his energy. I was really relaxed and wondered if I was asleep when I saw little tiny bubbles—like in champagne—flying up into the air. It was then that I felt no more pain. It's been over three years and I haven't felt one bit of ache or pain. I don't understand it, nor his gift, but he's made my life better for knowing him.

The New Millennium and
The Higher Collective Consciousness

Deepak Chopra, MD, is a physician and modern master teacher of health, healing and wellness living. In *Ageless Body, Timeless Mind,* Dr. Chopra addresses the electrifying field of quantum physics. He states that all is energy and our bodies are energetically/physically attached to our soul energy. Dr. Chopra's analogy brings all this to a personal, cellular level: If we touch a flower, it truly is only one set of energy molecules (the finger) touching another set of energy molecules (the flower). These energies are but grains of sand in the universe. But to us, our thoughts and individual energies are *our* universe.

Look further.

Is our immediate world or the individual body so difficult to change when all it takes is a little movement of molecules? Dr. Chopra reminds us that these concepts are not mysteries, but the very stuff of which our days consist. We move sets of energies all the time, why not change them all for the good? He tells us that we can choose to move our thoughts and actions (which are only energies moving around), to experience peace and harmony in concert with all beings every single day. "…in unity consciousness, the world can be explained as a flow of Spirit (Energy), which is awareness to establish an intimate relationship with Self as Spirit (Energy)," says Dr. Chopra.

This beautiful prose illustrates the timelessness and interconnectedness of ourselves with the Infinite. From the sages of India to the Bible, Koran and Bhagadva Gita, to Hovey's 1800s research in mental telepathy to Carl Jung's 1950s and 60s philosophical thoughts on collections of people and scientific subatomic research, all point to our ONENESS.

As energy entities, we are separate only until we realize that we are not. So too, our minds are not separate from our bodies. What we think is integral to our bodies, therefore our thoughts most certainly affect our health state. Scientists have realized the chemistry of feelings and thoughts in on-going experimentation for years, if you need 'physical evidence' of the mind-body connection. Most medical journals site studies involving electrodes attached to the skin to chart the chemical differences in emotions and in various exercise states. Our feelings move and change molecules!

The Bridge Between Reincarnation and Heightened Sixth Sense

Dr. Chopra's work segues reincarnation and the sixth sense quite naturally as he explains the energy flow of the earth plane consciousness. If we have commonalities with the smallest set of energies in a rose for instance, then how can we *not* see the unity of all living souls with the Almighty One forever? In this present now, we have already chosen to be here together and we are already one! This is why you are reading this book; you are questioning, thinking, wondering, and awakening to the realities we cannot see but *know in our souls are there*. The truth is that we can choose to gather together with like-minded, pro-health people and change our present collective negativity from the energy cell level on up. This switch of intentions will change and uplift our futures. Humankind does not have to be sick; we can choose to see that we are of the Divine. See the context of your present life and pick love out of the choices available. The positive shift and healing consequences are higher than our highest imaginings.

We are in a new age—2000 AD—when the energy is **heightened**. It is a time of renewal with intensified, more powerful energy available to us. It is merely a thought

away. Now is an opportunity for mankind to grow in love not fear.

It is a time to:
- honour all life—starting with self
- cleanse past hurts
- love and forgive
- respect self and fellow man
- intend peace and so shall it be
- 'remember' that we are one with the Deity
- take care of each other and our planet

It is a matter of simple thought. Gently shift your mind into thinking LOVE ONLY. If another looks, acts or does something hurtful, move above it and show understanding for the other's viewpoint. Love that view as his, maybe not yours, but it is his view through his own glasses. Then show only love and care for him. This approach never weighs you down. It lifts both of you. This *is* higher energy for you and the other soul.

In unity the lives on the earth plane have chosen 'now here'. Together, our spirits can surpass any loving conditions we have ever experienced. It is not for man or woman to question who we are not, but who we ARE in relationship to God. Man is soul connected to the next soul, and to the next. Our energies meander, rush forward and flow, then contagiously surge into one another. The six billion of us on this planet can be looked upon as one composite Energy Soul, which is the Infinite, never dying, forever and ever, Amen! Let us flow in the river of love.

It is mere illusion to think we are separate from anything, let alone the Divine. Isn't this a powerful and uplifting notion? Dear reader, if you feel alone, just let me reassure you that you are *never* alone. As part of the energy force presence, we are surrounded by the Infinite. Our angelic hosts, guides, teachers, and loved ones are

here to assist and guide us in daily life without interfering in our free will. When you feel lonely, sit still and tune in to the atmosphere of love energy around you. Listen and feel what comes to you. In *Conversations with God*, by Neale Donald Walsch, God says: "I talk to all my children all the time, but who listens to me?"

Consciously, together—a collection—let us listen.

This is 'The Collective Consciousness'. It is not so foreign to your everyday existence. Examples of soul-groups loving and working together on this earth are:

- church
- school
- family
- work unit
- friends

You Are a Collective Free Will-er!

Please stop for a moment and consider a group in which you work, live and love. Jot down their names. These are small clusters of souls with whom you have great caring, respect, common energies, and a knowing, warm partnership. Remember that when you are with this special group and all are one in a project or a cause. Delight in the high, the joyous feelings you have together when a job is well-done. This is a mini-collective consciousness, a heightened example of free will choosing to live for a common purpose and revelling in that loving, productive, creative accomplishment which enriches and energizes. It *is* your life.

Now you've also created a small list of some of your guides on earth with whom you are sharing love experientially. Highlighting the names of your close ones is key to touching the personal part you play in 'The Collective Consciousness'.

Same Thought Around the Globe

Another example of collective, like-kind intentions are those stories everyone has heard about: when a scientist in one country of the world discovers or invents a 'new find' only to learn that someone across the seas has accomplished a similar feat. This is frustrating, surely, to the one who wants to own the patent or invention. However, this mutual level of awareness for a new concept raises the energies and interests of the entire planet. Dr. Dossey's *Reinventing Medicine* also documents this phenomenon extensively. Quietly the world is awakening!

Can your decision to love above all else, day or night, in each of your weeks and multitudes of years, change the world? Of course! Love collections raise the world's level of Spirit + Thought + Awakening, as we have seen in our everyday community groups. Certainly it is easy to see that the reverse is true: when just one negative person decides to send out blocks to free-flowing energies, things change rapidly, too. It all starts with one person then pulses to his or her clusters of soulmates.

Angels have sent me the same communication in various wordings for years: positive, pro-loving actions and deeds ***matter***. Love changes things. Everyone knows these messages if we stop and reflect. Some religions *tell* their members to love one another: it's just doing it that is lacking. Poetry, lyrics, scriptures, and prose by the planet's time-honoured masters say what modern singers do:

> "All you need is love, love. All you need is love."
> ~The Beatles

This new age of energy, this next millennium after Christ's presence, has been referred to as The Age of Aquarius. What does this mean? The power is in the remembering. Together, our energies can choose to

remember that we are the Creator's creations. We are now manifest, trying to achieve remembering and when we do recall, we flow into the Light. All the time, minute-by-minute, love personified is always in our daily life intentions, if we try. This is rising to meet the Divine's hope for us: that we live the perfection we were born to live. What a dream, one worthy for each and every soul equally.

Uplifting and Healing Elsie

When I was working in the Midlands, England, a glorious lady, Elsie, was a frequent client. She had sustained a back injury in WW II by a doodlebug. She and I built a nice rapport, as I learned of her numerous gifts and talents. Many people in her village would come to her for advice. She shared this with me, making every session interesting. I am as much for healing myself through my patients as they are with me. On one occasion, after Elsie had opened her eyes from our healing session, she gasped, "Wow, David, that was impressive." I asked her to tell me what went on. I love hearing what has moved people.

Elsie explained, "Whilst you were working, my spirit guide took me by the hand and out of body. We flew together, connected above the earth plane. When we were far above, my guide said, 'Now turn around, look at earth and tell me what you see.' I looked carefully. First I saw clearly the oceans and lands. 'All I can see is the Earth and its colours. I can't see people. I do see a black ring hovering around the earth,' I said. 'Do you know what that is?' my guide asked. 'No, I have no idea,' I said, wondering how would I know? My guide was the one I relied on to know these things. 'That's man's negativity, over thousands and thousands of years. That's what will happen to the earth plane, if not changed. So shall you sow, you shall reap. Whatever you give out, will come

back to you. Not as a punishment, nothing from God, but what mankind has given to one another over the hundreds and hundreds of years of un-loving'."

Elsie and I hugged, intent on changing our world with her profound advice.

We Can Save the World, Together

This heavenly planet we call Mother Earth can be refreshed by sending out beams and beams of love into the atmosphere, into the land and directly into each soul. This can replace anger, greed, war, and destruction. These acts of loving can rid us of the black cloud around the earth. It has all been going on too long, this judgemental and habitually deconstructive way of thinking that has run its course.

It is time.
Stop it with me.
We are in charge of this.
We can save the Creator's earth.
Let us begin.

Neale Donald Walsch in *Conversations with God (CwG)*, shares the following message in all his books, in a variety of semantics: there is one main soul that reinvents itself into individual souls to experience all of what love can and will forever be. Mr. Walsch terms this idea as 'A Collective', rather than just one 'Father' or one 'Creator' to illustrate the all-encompassing nature of God. Mr. Walsch encourages us to think beyond our traditional or even so-called new age philosophies and thought patterns. Think past these to an Infinite God who is The All, encompassing everyone. "By the process through which energy becomes matter, spirit is embodied in physicality. This is done by the energy literally slowing itself down—changing its oscillation, or what you call vibration." It is all God, only in variant forms, Mr. Walsch says in the CwG book trilogy.

Carl G. Jung, Psychiatrist & Philosopher

In *Modern Man in Search of a Soul*, (1933) Carl Jung explains the challenges of collective consciousness and collective **un**consciousness. Man must decide individually to break out of the mold, out of collective UNconsciousness and move forth in self-love. Then he must bring along his collective group. This is not difficult, if we take heed and resolve that this day is truly the first day of the rest of our lives. Forget the predictable, comfortable but unconscious ways. Act on what you know in your heart, soul and gut.

Jung says the antithesis or opposite of 'Individual' is 'Collective'. The word 'collective' means any like kind of grouping: church, community, town, club, family, or member unit. Jung's term 'modern man' means one who is awake spiritually and conscious of his inner soul and spirit. The problem is, Jung says, that the modern person is rather alone in a sea of unconscious people. Even in his own micro-collectives and community groups, he is often the only one who is bored with what goes on and on. He knows there is more. The conscious man can barely speak of his consciousness for fear of others ousting him from his various groupings. Ultimately, however, Jung posits that the conscious person seems destined to choose isolation and estrangement. Granted this is written in 1933, but can we think of situations such as Jung's *Modern Man* today?

Don't we all feel alone at times?

Listen, my beloved sisters and brothers. We do not have to be unconscious, or alone. The true reality is the precise opposite. If you are reading this book you are awakening and changing your commonly known traditional way of thought. Now test the truth of these new thought patterns and love by being a living example. This is not in conflict with your old traditional thought. Love harmonizes with all beliefs! Try the change. You will be drawn to others of like-consciousness.

Gerald Jampolsky, MD

Dr. Jampolsky writes in his wildly successful book *Teach Only Love,* the essence of just this: do not talk of love—**be** love.

The Example of Love: To me, Mary epitomizes attitudinal healing. She did her utmost to not just *think* about God but to allow God's light to pour through her for all to behold and partake. She chose not to identify with her body, not to identify with her ego personality. She demonstrated that as long as we are breathing we are here on earth to be a channel of God's blessing, to be centreed in love, and in that way be of service to others.

Mary made alive two simple statements from *A Course in Miracles* that have become of central importance to me:

1. Awaken and forget all thoughts about death, and you will find that you have the peace of God.

2. Today I will let the Christ vision look upon all things for me and judge them not, but I will give each one the miracle of love instead.

~Gerald Jampolsky, MD,
Teach Only Love, Epilogue

Whether it is a Christ with whom you identify, or Buddha, Ghandi, Mother Theresa, Mother Maya, or some other soul-close-to-perfection, live well in positiveness. Know that God wants us to utilize our freewill gift to enjoy all facets of love. Choose to love and see your mind, heart, soul, and body change into the Light of peaceful, harmonious, energized wellness. Then pass this on to raise the earth's consciousness and if you are rejected remember:

FOR THOSE WHO BELIEVE,
NO EXPLANATION IS NEEDED.
FOR THOSE WHO DO NOT,
THERE IS NEVER ENOUGH.

In the end we must all walk in faith of what we cannot see but know.

Healing Stories

*** One gentleman came for help oppressed from work. Only in his thirties, he had extensive allopecia with not a hair on his head and was worried about keeping his job. After only one session he returned the following week with hair growing in again.

*** I was called to East England by a woman whose husband had major surgery but awoke paralyzed. John had one of the first aortic replacements with early side effects of pain down one leg and paralyzation in his other leg. I drove to their home on the sea where the garage had been remodelled to accommodate his condition. John desperately wanted to get well. "Look," he told me, "I don't believe in your kind of stuff but my wife called you so I'll try anything. Get on with it."

I cautiously explained my work and found that all of his chakras were blocked. His left side energy was stagnant, making the leg appear dead. I worked on re-flowing his energy, particularly focusing on his left side with my energized hands. He opened his eyes and said, "David, I can feel my left leg. It isn't dead!" His wife stood with us and we all cried with elation. This was one of the most powerful sessions and the first time a paralyzed limb awoke in my hands. Tears still come when I think of John.

I later travelled back to see him and focused on his painful right leg. The last word was that John walks with crutches. He's learned to drive with a specially equipped car, no less! (An interesting aside: John remains sceptical of my work and tells no one of our teaming-up to help him heal.)

***Jacob, a man in his late forties, had a malignant tumour in his chest and was sent home to die because the tumour was too large and invasive for surgery. I scheduled four sessions with him and between the third and fourth session he went back to the medical doctors

for tests. "My tumour is completely gone, David. It was not just shrunk, it is all gone! They still suggested surgery in case there's any tumour left. They don't believe the test results," Jacob laughed into the phone, beside himself. I asked what he was going to do. Jacob was covering all bases and going ahead with surgery. He visited after the surgery to tell me the news in person: when they cut him open, not one doctor could find a trace of the tumour.

*** The wife of a British soccer player visited with a large tumour in her breast. She was scheduled for a mastectomy but heard of my work and wanted desperately to save her breast and get well again. I suggested we do intensive work together in several sessions during the three weeks before her scheduled operation. When she went for surgery, the physician could not find the lump on her films. They decided to go in anyway where they found nothing but a little black seed covered in skin. Her surgeon wrote 'miracle' upon her file in red ink.

The lady's famous husband had numerous pains from ball playing injuries, so she asked me to schedule several sessions with him. He was too sceptical to discuss his troubles with me and cancelled our appointments. Later that year the ball player, who was only in his early thirties, passed away.

His wife phoned and told me of the day when she came home and found him slumped in his chair. He was rushed to the hospital but by 6 PM he passed away. They discovered he had a significant brain tumour. She was crying and I suggested talking another time when she was less upset.

She continued, needing to tell me more, "I've something special to share with you, David. I went to a church the week after my husband's funeral. During the evening, a person next to me, apparently a clairvoyant,

said, "Your husband is here with me! He says he has only been in the world of spirit a short time and he wants to tell you what happened." The clairvoyant then passed on his message, "When I was lying in the hospital bed and you were sitting around loving me, I floated above, seeing my body and the whole family. I saw the tubes and machinery attached to my body. Then... then I was shown what my life would be like if I remained on the earth plane: a life like a vegetable. I decided to detach myself from my body and go on with my journey." She waited for my comments.

I assured her that he was happy and still with us in many ways, for no one dies, we only pass out of physical bodies back into Spirit. I could almost see her smiling over the telephone wires. Her subsequent telephone calls confirmed an ongoing spiritual relationship with her husband that was fulfilling to them both. I feel absolute joy that this doubting man realized his loving spirit has been energized by helping his wife develop her soul with him!

*** Debra came, after having a benign cyst removed, for increased awareness and healthy future attitudes. We had a beautiful counselling and hands-on session in which she virtually floated away in a sea of colours. She told me that first the colours were angular, almost chiselled. As the time continued, the colours melded together in a vividness she found hard to describe. She promptly went home with the intention of painting what she saw.

True to our discussion that writing letters and burning them is a wonderful releasing mechanism and daily practice, Debra wrote a long letter for some residual pains, and placed it in her fireplace to burn. It would not burn. Over and over, she held the lighter to it to no avail. She gave it an extra send-off prayer filled with love to the person she felt had wronged her and it finally burned. When she awoke the next morning, the ashes were shaped in the form of a heart! She also produced an

exquisite painting of her session that bursts with colour. You can actually feel the colours when you see the painting, even from a far distance.

1995, South London From My Journal

*** Before our move to Ireland, my wife and I moved into a four-story Victorian house with wonderfully big rooms. We planned on dual healing practices out of our home. Hours after our move I looked up the centre staircase and witnessed a man hanging himself. Obviously, it was a spirit manifestation and I did not tell Petra, at first, as I wanted our life together to begin on a bright note. I wondered about the shocking vision nonetheless, especially with travelling and being away healing almost every week.

Time marched on and more incidents occurred. We realized the troubled spirit ways of our new home when hearing and seeing noises, items falling and even footsteps were heard running in every room of the house, up and down the stairs. We invited psychic friends to speak to the souls because wild things kept us on edge. For example, all at once the four gas stove burners would alight. We'd iron and the plug would shoot out of the wall. Doors slammed when my wife and I knew we were the only physical bodies in the house.

Christine, a talented clairvoyant and friend, was finally solicited to help us tune into the history of our grand abode. Christine meditated in various rooms and gave us the following history from her inner voice and guides: A little girl was burned alive in the top right bedroom. Her guardian uncle was unable to save his niece and in his grief hanged himself from the fourth story banister. Christine's reading solved the puzzle and gave us a plan to move forward in the house peacefully. Through the following months we tried connecting with and releasing

the poor souls by befriending them and placing them in a more peaceful state with our love and care. Souls sometimes are not ready to go back home into Spirit because of their traumatic connections with this life. Understanding the karma of one's life allows us to move back home peacefully. Petra and I helped many souls from that house find peace.

In addition, I read the energy of the house and land on which it was built. The art of healing is not only for humans and animals but also for the earth. Running in a myriad of criss-cross lines, throughout the land masses of the planet are energies called *ley lines*. The energy streams manifest as either negative or positive vibrations. If a building was constructed on a piece of property with a negative ley line, activity within the structure may be affected. This is why some buildings can have a strange, off-putting feeling, unsettling the people in it. Relationships may go awry or health problems occur. Our home's ley lines were neutral, but the Victorian Spirits who had lived in it had remained in disharmony until we inhabited it and released them.

*** Ben came with a cyst on his back that kept flaring-up. Several years ago, he even spent two days of his vacation in the emergency room with such a swollen back. The physician lanced it and placed a drain in it and Ben could not enjoy the swimming he loved while staying on the beach.

Every few months since, the cyst would either get hot or swell, on and on. When he came to see me it was in an irritated, swollen state. Ben was keenly aware of the energy work I do, so I simply laid hands-on the spot for several minutes. Less than a week later he notified me that the cyst had drained and was absolutely healed. It has been six months and the usual heat and swelling has not occurred again.

My Story

How do I come to this lifework of healing?

Since my teens, I have known my hands help people. From the inner voice within saying loudly, "Touch the pain," and the pain disappeared or the knee or leg break healed, I have known.

Here is an example of the hints God has given me over the years, yet I did not heed and take full notice for years:

1970, London My Dream Journal Entry

I awoke within my dream in the backseat of a car driven by two people.* As we drove, in the distance on the left hand side of the road was a figure clad in Arabic dress with long hair and beard. We approached the figure and I looked out of the car window. I could not believe who I saw. I shouted, **"That's Jesus Christ!"** As we drove away, I turned to look out the back window and savour another glimpse of Him. Shockingly, the entire back window had become His face: light, bright and shining a smile at me.

When I woke and for the following three days I could not walk the same—I felt light as a feather. Looking back, I now understand the power of the Spirit's Energy. At the time, I could not figure out what had happened to my walking. To this day that glowing, joyful, smiling face and warm, glowing eyes are still embedded in my third eye. I feel His companionship. His kindness and love warms me as I see Him whenever I turn my attentions inward for reflection.

* I discovered later they were my guardian angels at the time, who took me on a journey across the desert for the purpose of this remarkable experience.

It took me some forty years to put it all together and awaken to my gifts.

What was the turning point?

In 1990, I was captured and held hostage in a bomb making plant in Baghdad. I was a hotel manager in Kuwait when the Kuwaiti war erupted. That's when our Creator grabbed my attention and held it until I remembered what was inside. Through the some hundred days of captivity, I was guided, blessed and given a chance to love even my captors. The results were astonishing—I made it home alive.

What now?

While in that Iraqi prison, I pledged my life to counselling and healing others.

I am free and listen intently to my inner voice most every moment.

From becoming certified as a Spiritual Healer in the United Kingdom to practicing in the monarchy-endorsed Hale Clinic in London, I listened to my inner guides. The messages have been countless, the theme utterly clear:

Teach people Love no matter what.

I moved to the USA in 1999, always knowing I was meant to work in the States. I am now a U.S. certified Minister of Healing and practice my gift throughout the world in private sessions, seminars and workshops. I am blessed to help heal neighbours and friends, royalty and movie stars. I pray this book touches your heart so you may rejoin the family, the Divine family that is humankind. We've much higher good to experience as One.

Certificate of Ministry

This certifies that

David L. Cunningham

Having fulfilled the requirements as set forth in the Word of God in regards to ministry gifts is hereby called to serve as

Minister of Healing

And is licensed to function in ministry of the Gospel of Jesus Christ and to exercise God-given gifts and talents, as the privileges allow.

On the 11th day of June in the year of our Lord 1999

By the Ordination Council of
Christ Life Fellowship
San Diego County, California

Witness: _____ Ordained By: _____

"You did not choose Me, but I chose you and appointed you."

"Let your light so shine before men, that they might glorify God."

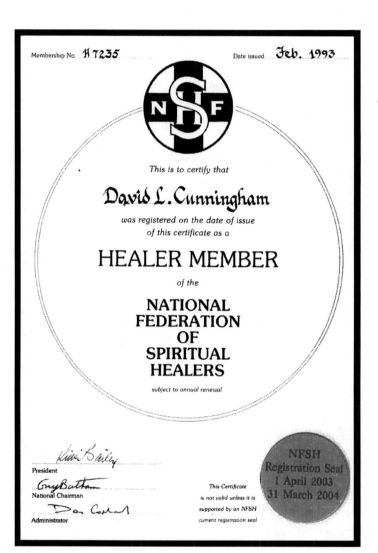

Membership No. *H* 7235

Date issued *Feb. 1993*

This is to certify that

David L. Cunningham

was registered on the date of issue
of this certificate as a

HEALER MEMBER

of the

NATIONAL
FEDERATION
OF
SPIRITUAL
HEALERS

subject to annual renewal

President

National Chairman

Administrator

This Certificate
is not valid unless it is
supported by an NFSH
current registration seal

NFSH
Registration Seal
1 April 2003
31 March 2004

Appendix

Sampling of **WISDOM FROM MY GUARDIAN ANGELS**

Master Teacher Messages from the Spirit Guides to YOU!

Eight Stages of Perfection
(Each Soul Must Achieve)

1. TOLERANCE
2. TRUTH
3. PRAISE
4. PATIENCE
5. LOVE
6. KINDNESS
7. UNDERSTANDING
8. FORGIVENESS

In 1994, this was given to me by Spirit: I was told to write down the word LOVE then follow the instructions:

L O V E

reverse it:

E V O L

add: **V E**

bring it
down to

E V O L V E

Spirit said, "This is the SECRET OF ALL LIFE.
Nothing else is reality."

Prayer

Dear God
I am Light
I radiate the light throughout my being
I radiate the light to everyone
I radiate the light to everything
I am in a bubble of light and only light can come to me
And only light can be here
I thank you God for everything
May I help people to protect themselves
By Being in the Light.

~David L. Cunningham, 1999

Hayley Mills Article

The Daily Mail
Monday, December 2, 1996, page 33

"My Alternative Life"
Spiritual Healing Has Given Me Such a Positive Outlook

by Hayley Mills
Daughter of the actor Sir John Mills

Hayley Mills began her film career at the age of 12, when she starred in Tiger Bay. Now aged 50, she lives a healthy lifestyle thanks, she believes, to vegetarianism and spiritual healing.

"...A girlfriend who owns stables in Surrey told me about healer David Cunningham. They had called him in as a last resort to help a horse that had a badly injured leg. David was so successful that they also asked him to give healing to their groom who had an ankle injury. I intuitively felt that David might be able to help me and decided to meet him...David explained that he would help to unblock energy points in my body much the same way as acupressure massage or acupuncture would—but without touching me. After my first treatment I still felt very tired, but I was much calmer and more able to cope. It was like having my batteries charged. As the treatments progressed, extraordinary things started to happen. An old whiplash injury was causing me considerable pain in my upper arm, neck and shoulders. I asked David to

concentrate on this area and suddenly, even though he was not touching me, I could feel the heat from his hands; it felt as though two fingers were pushing my shoulder and neck back into place...But it does not matter what people's beliefs are—the healing often works wonders. There is no reason to fear healing. It feels like a very natural form of therapy and cannot harm anyone...I know it might not work for everyone—but healing has given me a positive new outlook on life. These days I feel altogether better..."

About the Authors

 David L. Cunningham hasn't always filled his days by applying his healing touch to the physical and emotional pain of his fellow man. The pivotal juncture in David's life came in 1990 while he was a captive of Saddam Hussein for 100 days during the Gulf War. He was one of many "human shields" strategically placed in prisons adjacent to the Iraqi military's armament facilities. It was during this critical time that David Cunningham, a highly successful manager of international hotels and five star restaurants, made his personal peace with God and pledged to use his spiritual healing "gifts" to heal others, if and when he was allowed to live and be released from captivity.

Upon his return to England, David Cunningham left his previous career behind and dedicated himself to learning the ancient art of healing. He worked with a medical doctor who was an HIV specialist and during the day, David drew blood and counselled HIV and AIDS patients. At night, he began his spiritual healing ministry by working with patients who had no hope for a medical cure and nowhere else to turn for help. Many of the terminally ill patients died, yet there were successes, and eventually, David's reputation for healing reached <u>Hayley Mills</u>, the international actress and daughter of Sir John Mills. It was Ms. Mills' incredible life-altering experience and the publicity of her story that launched David Cunningham's career on both sides of the Atlantic Ocean.

While working at the prestigious Hale Clinic in London, David Cunningham healed people from all walks of life—royalty and commoners, alike—all equals in the eyes of God's love. Tumours and migraines disappeared, paralyzed legs once again found life, and blurry vision came to blind eyes. There were disappointments, of course, but many, many successes.

David L. Cunningham has been an accredited <u>Healer Member</u> of The National Federation of Spiritual Healers, a European-based organization, since February of 1993. In mid-1999, David Cunningham became an ordained <u>Minister of Healing</u> in the United States. He presently helps heal patients and clients from his home in England.

From his humble beginnings to sixth sense realities...from touching a person's life with his tremendous insight and counsel to energizing a tremendous healing power from his own hands...David Cunningham has lived a remarkable life. He survived tyranny to dedicate his life to others. He is serene, yet intense. He is a kind listener, yet an insightful negotiator for God's love. He's a natural leader who speaks from his heart and soul, fully aware of his commitment to honour his pledge to heal others with his God-given gifts. He welcomes your inquires and is available to travel on a limited basis.

LINDA LEE RATTO, Ed.M., is an educator, counselor and international speaker with decades of experience in the education, rehabilitation and self-development fields. She has served as a classroom teacher, corporate CEO, co-founder of a learning system, private school program consultant, and guest professor. Ms. Ratto has authored six books: this biographical, spiritually-based self-help book, two counselling titles on families living with disability, two young peoples' books highlighting inner-spirit strength and the power of dreams, and a non-fiction overview of the highly successful Youth Challenge Academy, a boarding school system for at-risk youth. She has written articles and columns in several newspapers, most notably for the *Atlanta Journal/Constitution* covering such topics as the Paralympics and healthcare.

Ms. Ratto's writing technique is centreed on personal relationships and interviews with children and adults. She then sculpts a storybook about their gifts and miracle-making. Her books are available on-line through **www.amazon.com**.

You may contact her directly via:

Linda Lee Ratto, Ed.M.
Post Office Box 622
Tyrone, Georgia 30290
USA
Ratto@mindspring.com

RESOURCES

WWW.SPIRITUALHEALINGCENTRE.COM
RATTO@MINDSPRING.COM

Works Mentioned in *Shift!* Your Life

Ageless Body, Timeless Mind, Deepak Chopra, MD
Attitudes and Emotions, The Story of, Cayce and Cayce
Anatomy of the Spirit, Caroline Myss, Ph.D.
Conversations with God, Neale Donald Walsch
Cosmic Dance, Julie Soskins
Daily Mail Newspaper, London, England
Expansion of Awareness, Arthur W. Osborn
God's Way of Life, Adele Gerard Tinning
Happiness is a Choice, Barry Neil Kauffman
Heal Your Body, Louise Hay
"Intimation of Mortality" poem, William Wordsworth
Love, Medicine and Miracles, Bernie Siegel, MD
Mechanism of Karma, Arthur Osborn
Mind Reading and Beyond, William A. Hovey
Modern Man in Search of a Soul, Carl G. Jung
"OverSoul" poem, Ralph Waldo Emerson
Power of Positive Thinking, Norman Vincent Peale
Reinventing Medicine, Larry Dossey, MD
Real Magic, Wayne Dyer, Ph.D.
Road Less Travelled, M. Scott Peck, MD
Seth Material, Jane Roberts
Story of Attitudes and Emotions, Edgar and Hugh Cayce
Trailing Clouds of Glory, Spiritual Values in Children's Books, Madeleine L'Engle
Teach Only Love, Gerald Jampolsky, MD
You Can Heal Your Life, Louise L. Hay, Ph.D.
You'll See It When You Believe It, Wayne Dyer, Ph.D.

Index

A

A Course in Miracles 94
Age of Aquarius 90, 119
Atlanta Workshop 78

B

Beatles 90
Bhagadva Gita 86
Bible 21, 51, 86
Browne, S.E. 28
Buddha 46, 49, 94

C

cancer 41, 52, 65, 76
Carry-On! movies *63–72*
cat 43
Cayce, Edgar 74, 75
Chakras 1, 2, 14, 15, 19, 44, 67, 83, 99
 definitions 17
Chinese proverb 57
Choice 8, 14, 33, 35, 57, 66, 117
Chopra, Deepak 86, 87, 117
Christ 46, 48, 50, 51, 90, 94, 105
clairvoyant 52, 67, 74, 78, 100, 102
Collective Consciousness 86, 89, 93
communication 5, 20, 49, 83, 90
consciousness 22, 57, 86, 87, 89, 93, 94
Crown 15, 19, 20, 21, 23, 34
cyst 41, 101, 103

D

death 36, 46, 52, 66, 69, 73, 94
dis - ease 2, 6, 9, 19, 20, 21, 58, 75, 77
Dossey, Larry 70, 90
dreams 20, 24, 33, 48, 55, 71, 78
Dyer, Dr. Wayne 53, 79, 117

E

eczema 27, 29
Eighth Chakra 14
Emerson, Ralph Waldo 60, 117
Emotional Body 7, 19
Energy 1, 2, 5, 9, 14, 15, 19, 20, 21, 23, 24, 28, 29, 33
 34, 34, 35, 43, 53, 58, 65, 67, 70, 84, 85, 86, 87,
 88, 89, 90, 99, 103, 105, 113
Energy Center 1, 2, 14, 15, 21, 23, 34, 44, 83, 85
 blockage 1, 15
 chakras 1, 2, 14
ESP 69

F

Fear 8, 47, 48, 54, 57, 58, 70, 73, 88, 93, 114
Free Will 8, 65, 70, 78, 89

G

Ghandi, Mahatma 94
ghost 63
Going Within 31, 46, 47, 55
Groundhog Day, the movie 54
Guardian Angel 7, 35, 46, 109
Guides 79, 109
Guides 48, 49, 51, 70, 71, 73, 75, 79, 88, 89, 106, 109

H

Hale Clinic 29, 65, 106, 115
Happiness 14, 117
Hay, Louise 76
Hayley Mills 113, 115
House of Light 67
Hypnotherapist 66

I

Incarnation 46, 51, 54, 59
Institute for Noetic Sciences 70

N

O

P

Q

R

S